digital masters:
b&w printing

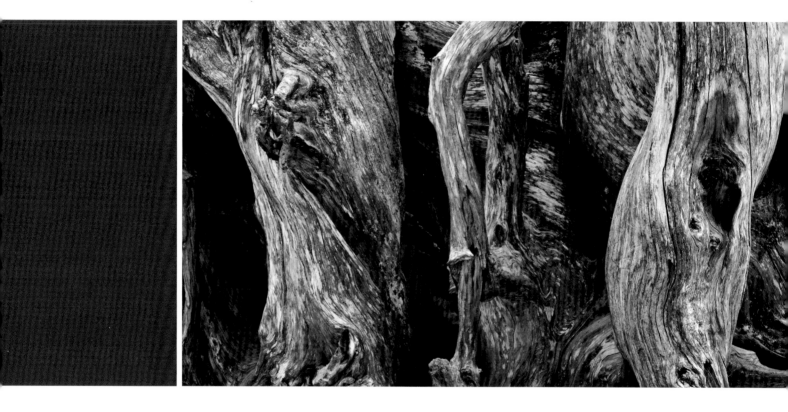

digital masters:
b&w printing

creating the digital master print

by George DeWolfe

LARK BOOKS

A Division of Sterling Publishing Co., Inc.
New York / London

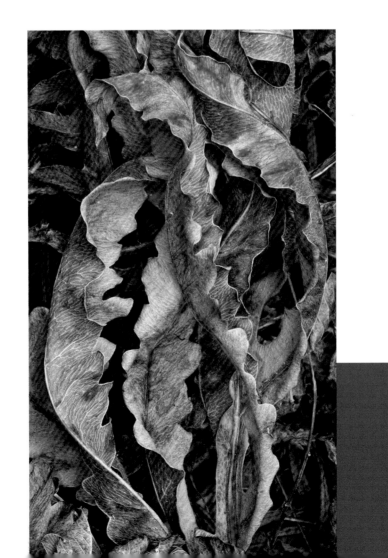

Editor: Haley Pritchard
Art Director: Tom Metcalf / tommetcalfdesigns
Cover Designer: Thom Gaines

Library of Congress Cataloging-in-Publication Data

DeWolfe, George.
 Digital masters : B & W printing : creating the digital master print /
George Edward DeWolfe. -- 1st ed.
 p. cm.
 Includes bibliographical references and index.
 ISBN 978-1-60059-165-5 (pbk. : alk. paper)
 1. Black-and-white photography. 2. Photography--Digital techniques. 3.
Digitally printed materials. I. Title.
 TR267.D483 2009
 775--dc22

 2008049170

10 9 8 7 6 5 4 3 2 1

First Edition

Published by Lark Books, A Division of
Sterling Publishing Co., Inc.
387 Park Avenue South, New York, N.Y. 10016

Distributed in Canada by Sterling Publishing,
c/o Canadian Manda Group, 165 Dufferin Street
Toronto, Ontario, Canada M6K 3H6

Distributed in the United Kingdom by GMC Distribution Services,
Castle Place, 166 High Street, Lewes, East Sussex, England BN7 1XU

Distributed in Australia by Capricorn Link (Australia) Pty Ltd.,
P.O. Box 704, Windsor, NSW 2756 Australia

If you have questions or comments about this book, please contact:

Lark Books
67 Broadway
Asheville, NC 28801
(828) 253-0467

Manufactured in China

ISBN 13: 978-1-60059-165-5

For information about custom editions, special sales, premium and corporate purchases, please contact Sterling Special Sales Department at 800-805-5489 or specialsales@sterlingpub.com.

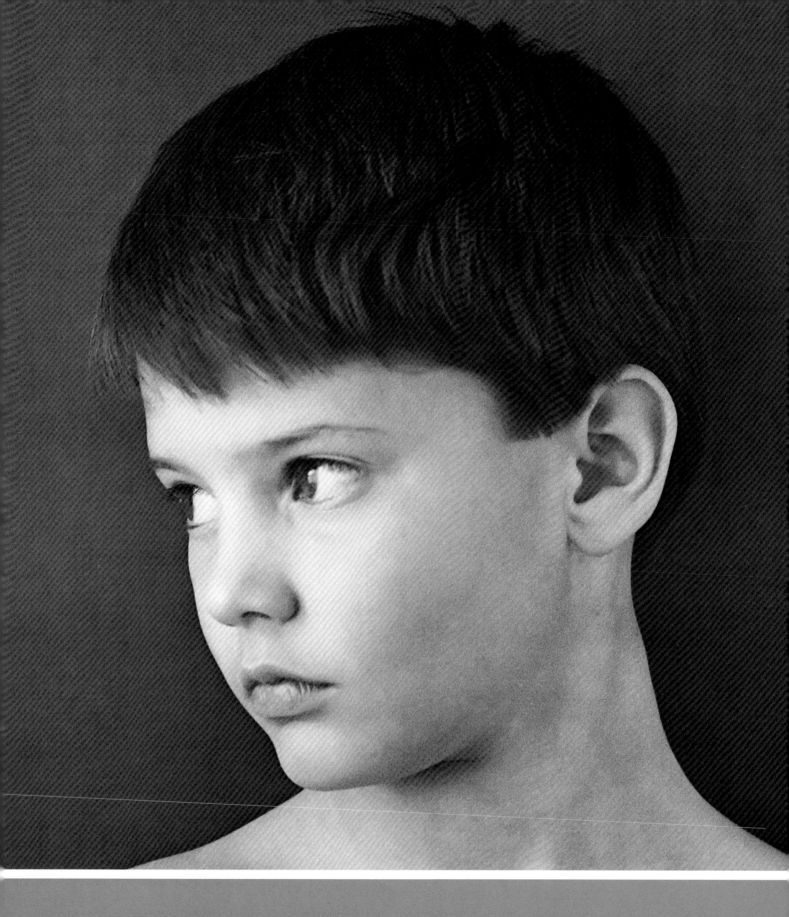

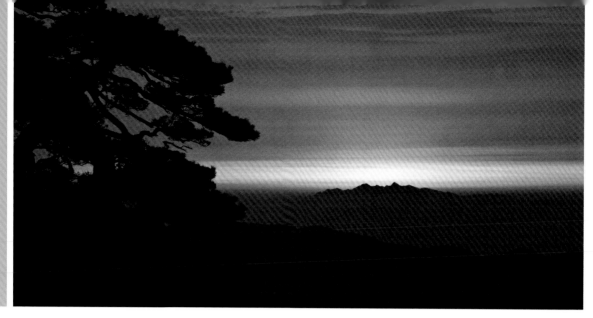

Contents

Acknowledgements

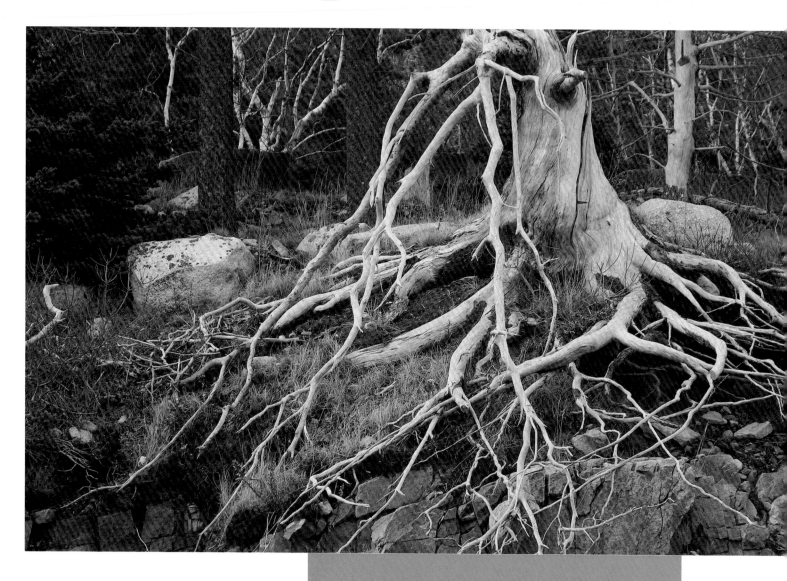

This book is dedicated to Walt and Betty Elling and Ken and Christina Perry, friends and photographers who took me in, in good times and bad.

No book like this is the effort of one person. I could not have accomplished this project without the help of many outstanding individuals, companies, and workshops, including:

Epson America, Hewlett-Packard, X-rite, Polaroid, Nik Software, Hahnemühle, Microtek, Tiffen, Bowhaus, ErgoSoft, ColorByte, Cone Editions Press, Media Street, GTI Lite, Lexjet, the photographers on the Adobe Lightroom alpha team, and especially to Melissa Gaul (who genuinely saved my sanity one dreary day), Santa Fe Workshops, Rocky Mountain School of Photography, Palm Beach Photographic Center, Maine Media Workshops, Charleston Center for Photography, Adirondack Photo Institute, and College of the Atlantic. And of course, to all my workshop students who now use the B&W Master Print workflow.

There are also some special individuals I'd like to highlight: John Panazzo of ColorByte, Rob Lester, Alan Gilhrist of Princeton University, and my compatriot for many years, Chris Russ. I could not have written this book without the help of these four men.

Special praise for: Lynn Weyand, Clyde Butcher, Dana Strout, Lydia Goetze, Rob Lester, Huntington Witherill, Tim Cooper, Beate Sass, and Maria Lloyd for donating their prints for this book. Also, thanks to Dee Peppe, Jack Alterman, Dan Bailey, and Alice Keeney for allowing me to use photographs I made of them.

Thanks to my outstanding editorial team at Lark Books, Marti Saltzman and Haley Pritchard.

Lastly, singular praise goes to my partner Lydia Goetze.

Glossary

I created this particular glossary of terms to make my interpretations of difficult industry jargon available to you for a better understanding of this book. More technically accurate definitions can be found elsewhere, but the definitions I have provided here will offer insight into the way in which I use these terms to detail the explanations in this text. Please read this glossary before you read the book.

Note:

Many of these terms have additional meanings in other contexts, but are defined here as they relate to the science of lightness perception.

anchoring

Anchoring takes the highest relative luminance in a framework and maps it to white. Global anchoring anchors all frameworks in a picture to the highest value in the picture, whereas local anchoring anchors all values within itself to the highest luminance within the framework. Local anchoring produces good constancy (presence). Global anchoring produces a failure of constancy (failure of presence).

articulation

This refers to the number of tonal values within a framework. According to lightness perception science, the more articulation, the better the constancy, or presence.

brightness

Also called luminosity, brightness refers to perceived luminance. Brightness is a neurally processed attribute of visual perception. In other words, it is our perception of the luminance of a visual object—our subjective visual experience of the object.

contrast

Contrast is defined in lightness perception science as a luminance ratio, which in photographic terms means the difference between two values.

constancy

In the context of this book, constancy refers to brightness constancy. Our perception of objects is far more constant or stable than our actual retinal images. Retinal images change with the movement of the eyes, the position of the head, changing light, and many other factors. If we relied only on retinal images for visual perception, we would always be conscious of people growing physically bigger when they came closer, objects changing their shapes whenever we moved, and colors changing with every shift in lighting conditions. To counteract the chaos of continuously changing retinal images, the perceived visual properties of objects tend to remain constant.

depth cues

These are edge patterns used by the brain to detect depth. Our ordinary depth perception works only out to about 10 feet (3 meters) from us. From there, depth cues take over. They mostly occur with overlapping (occluding) edges and corners, but may also work in conjunction with size constancy, linear perspective, atmospheric haze, and other depth indicators.

distal stimulus

This term refers to the physical environment or object photographed.

framework

A framework is a basic structure used to define and group visual elements such as highlights, shadows, midtones, depth indicators, and edges. In a print, we distinguish two different kinds of frameworks: global and local. Global frameworks group all the local frameworks, and local frameworks make up the smaller groupings of individual visual elements such as highlights, midtones, depth cues. The strength of a local framework depends on three things: size, grouping, and articulation.

fundamental error

The fundamental error in lightness perception is that objects on dark backgrounds appear lighter and objects on light backgrounds appear darker. This is the old brightness constancy illusion. The way this manifests itself in photography is that the luminance image of the retina and in the camera is not the same as our perception of that image. Correcting this problem leads to good constancy, or presence.

gamut compression

This is a perceptual compression of the grayscale that occurs when the range of luminance values is greater than a 1:30 highlight to shadow ratio.

gamut expansion

This is a perceptual broadening of the grayscale that occurs when the range of luminance values within a framework is greater than a 1:30 highlight to shadow ratio.

Gestalt principles of visual organization

The Gestalt principles of visual organization are proximity, similarity, closure, continuation, and belongingness. These refer to the different ways the brain groups objects as we see them. Check out Richard Zakia's marvelous book Perception and Imaging for a complete discussion of Gestalt visual principles and their relation to photography.

grouping

This refers to the grouping of certain visual attributes such as tonal values, edges, depth boundaries, corners, and the Gestalt principles of visual organization (see definition) in a local framework. Note that each of these attributes would have their own grouping. In other words, groupings do not include multiple visual attributes.

illuminance

Also called illumination, illuminance is the total perceived amount of light falling on a surface (incident light).

illuminance edge

This is an actual edge in an image that is revealed by a change in illumination.

intrinsic image

There are basically two kinds of intrinsic images: reflectance images and illuminance images. Together, these two types make up the luminance image seen by the retina of the eye and the camera sensor.

lightness

Lightness is perceived reflectance. Note that the definition in color science says that lightness is perceived luminance. In this book, however, I call perceived luminance "luminosity" (see definition below) in keeping with lightness perception science.

luminance

Also called intensity, luminance is the combined emission of illuminance (incident light) and reflectance (reflected light) from diffuse surfaces. It is an objective and measurable quantity. Luminance images are characteristic of what the human retina and a camera's sensor see.

luminosity

Also called brightness, luminosity is the subjective quality of luminance as processed and perceived by the visual cortex of the brain.

percept

Percept is an individual's visual experience of something external to themselves; more specifically, it is the result of perceiving, a complex process in the visual cortex of the brain that processes the luminance information from the retina.

presence

Presence is the word I use to describe the quality of good brightness constancy and high articulation of black-and-white values in an image. There is also an intuitive and emotional aspect to presence.

proximal stimulus

This term refers to the image received by the retina in the human eye.

reflectance

Reflectance is a measure of the percentage of incident light reflected from a surface. (The rest is absorbed.) A bright white surface will reflect almost all of the light falling on it, perhaps having a reflectance of over 99%, while a very deep black will reflect less than 1%. A middle gray surface reflects around 18% of the light falling on it, thus absorbing about 82%. The darkest known substance has a reflectance of only 0.045%.

reflectance edge

This is an actual edge in an image that is revealed by a change in reflectance.

scale normalization rule

The perceived range of grays within a framework shifts to a 30:1 range (in brightness) from highlight to shadow relative to the actual physical range given in the framework. The Gradient Map Tool in Photoshop employs a scale normalization algorithm to achieve a grayscale closer to our perception.

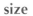

size

The greater the size of a local framework, the more important it is in the image.

value

Value refers to where a black, white, or gray tone lies along a light to dark continuum. In black-and-white photography, this is referred to as tonal value.

visual perception

Visual perception is the process of acquiring, interpreting, selecting, and organizing what we see, from the initial viewing by the retina of the eye through processing the image with the visual cortex of the brain.

Black-and-White Photography

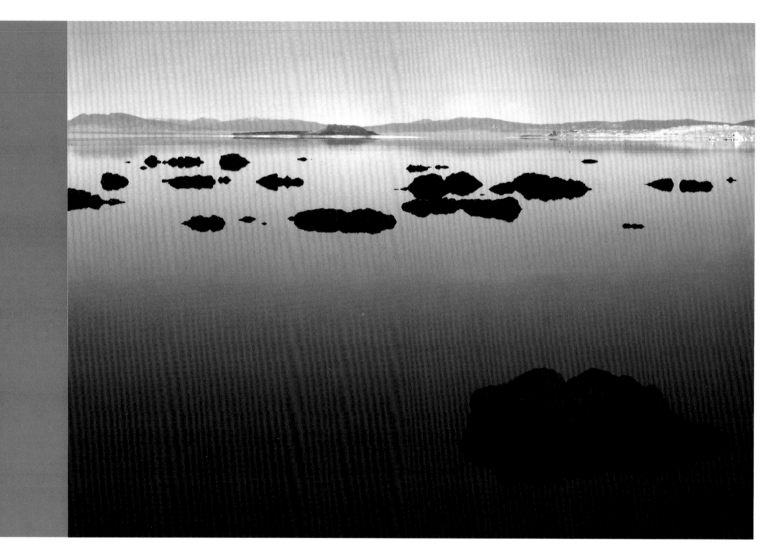

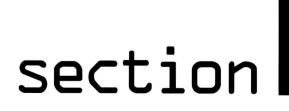

section1

What is a Masterpiece?

In his small book, What is a Masterpiece, art historian Kenneth Clark calls a masterpiece the "creation of an individual artist's authentic genius." I have not found a better description. And like many phrases, it elicits a number of ideas for us to discuss, and paths to take, that we as artists might follow in the creation of our own masterworks.

Firstly, a masterpiece is a creation. It is a picture that is not borrowed or stolen, and though it is perhaps derivative in nature, it is made out of the stuff of the universe, unique and often unbidden. Secondly, a masterpiece is the creation of an individual artist, not a collaboration or committee. The work comes solely from an individual creating from a solitary position. Thirdly, and most importantly, a masterpiece is the result of the individual artist's authentic genius. It is this authenticity, and its technical and aesthetic manifestations in the work of a master photographer, that is behind much of the content in this book.

Whenever I visit a museum, there is a game I play. Since it is impossible to see and appreciate all the exhibits in one day, I go with an agenda. Ten years ago, I had a day to burn in Washington, D.C. and went to the National Gallery. My agenda, knowing that the museum had such a large collection of portraits, was to determine, for myself, who the greatest portrait painter in history was. At the end of the day I had picked nine painters who I thought might be contenders for the prize. Among my selections were Rembrandt, with his luminous and mystical images of ordinary people; Rubens, who painted human lustiness like no one else; and Renoir, whose women are so compelling and beautiful. There was one artist in particular, however, that really caught my eye. As I sat in front of the life-size portraits by Anthony van Dyck, I felt a presence that did not exist in the others' work. The people he painted seemed to leap off the canvas and became real.

The authentic representation of light working on the forms of an object or scene is what creates presence in a work of art, and it was this presence that I noticed in van Dyck's portraits. If we examine the works of great master painters and photographers, the work clearly illustrates that the relationship of light on form is the key element to creating an authentic masterpiece. In this book, we will explore this relationship, as well as the perceptual and technical skills necessary to practice and achieve presence. To start, I will offer a detailed explanation of presence and show how it operates in both old master paintings and photographs.

The practice of making a masterpiece encompasses very advanced perceptual practice with simple tools. We, as artists and photographers, must hone our perceptual abilities in order to create masterpieces of our own. The tools available to us are simple, elegant, and few, yet complete enough to create any effect of light and form we need to produce presence.

Integrating authenticity into your own work, a process that some may call passion, can best be achieved through learning from someone who is familiar with the process—a mentor, a master, an experienced teacher and practitioner of the craft. This book won't take the place of that kind of one-on-one learning, but it can serve as a great first step to understanding what perceptual elements and tools of the trade go into refining one's own ability to represent the world with authenticity.

This book lays out a simple foundation for the creation of presence in a black-and-white print. It begins with the tools of perception—our eyes and brain—and continues on to the importance of a simple and masterful workflow. The discussion of aesthetic and technical issues is evenly distributed throughout the text so that you can get a "big picture" sense of the craft of black-and-white printing.

Simply applying a technical trick like some magic wand that one can wave over paper and ink will not, in itself, produce a masterpiece. If we look at the history of black-and-white photography and the great pictures it has given us, it is truly the honesty of presence through the articulation of the black-and-white scale that has given credence to black-and-white masterpieces. Luminosity creates our world as photographers, and it is this understanding and portrayal of light that ultimately produces presence—in the portraits of Anthony van Dyck, or in the field beyond your door...

George DeWolfe
Southwest Harbor, Maine

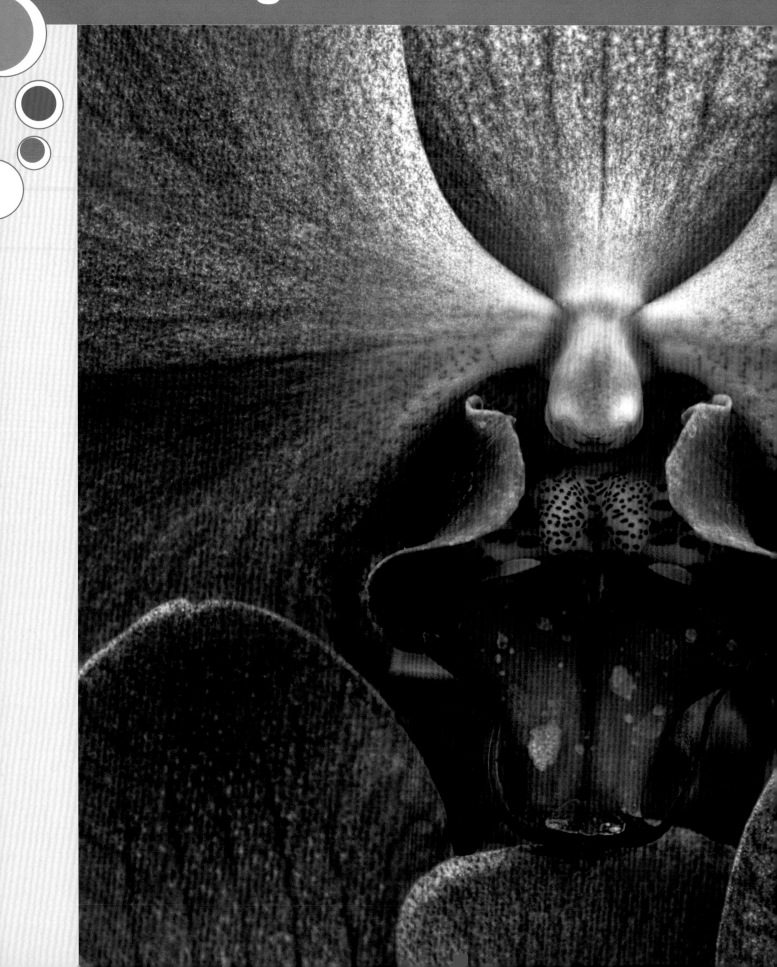

Creating Presence

chapter | one

In my estimation, seeing, representing, and expressing the black-and-white scale of a scene is the single most important skill a painter or a photographer can possess. This skill, when applied with experience and mastery, is the key element in creating presence in a work of art, and presence is the cornerstone of all masterpieces.

Presence as the key to masterful artworks has a history that spans the practice of art since Leonardo da Vinci popularized the technique of chiaroscuro, a skill borrowed from Flemish manuscript painting. Chiaroscuro is the modulation of highlight and shadow and the attendant color saturation (what we today call shading). It immediately caused a sensation; shadows and highlights looked more real and colors more vivid than before. Chiaroscuro achieved a sense of volume in modeling three-dimensional objects that painters were unable to create before. The technique brought artists closer to creating what they saw and felt in a subject, changing painting forever.

The invention of the camera obscura enabled painters such as Johannes Vermeer to create paintings with even more astonishing realism. The camera obscura, a dark box with a hole or lens in one end that projected an image of the scene on the opposite wall of the box, enabled artists to draw an outline of their subject and make a more accurate painting from it. Artists frequently added "corrections" or little touches here and there, however, because the projected image didn't seem exactly real for some unknown and perhaps intuitive reason. After the invention of photography in 1839, the camera replaced painting as the "pencil of nature" as William Henry Fox-Talbot, one of photography's inventors, called it. Painters, feeling appropriated and maligned by the new technology, went on to expand their medium to forms such as Impressionism, Cubism, Abstract Expressionism, and more current derivations.

Exploring Tonal Values

Behind all the inventions, techniques, and movements in painting and photography lies a fundamental truth about the inherent degree of visual perception involved in each: What the painter represents on canvas is a representation of what is visually perceived, while what the photographer represents in an unaltered image is only what is actually seen, not what it visually perceived. What is seen by the retina of your eye or the sensor of your digital camera represents a quantity of light as it falls on a subject or scene. This quantity of light is known as luminance. Luminance combines both the surface reflective nature of the scene being photographed as well as the illumination falling on the scene. What is visually perceived (and painted by a painter) is a many faceted neural operation that separates reflection and illumination and combines them with edge definition, depth, form, and wholeness—a process that, for the artist, is inherently more "real" than what we take for realism in a photograph.

The irony of this situation is that photography was invented to depict reality, but some might argue that a great representational painting is more real than a photograph because it takes human perception into account rather than just the raw act of seeing. Great photographers in history have often expressed their intuitive sense of this discrepancy between seeing and perceiving. These masters sought to manipulate the image to correspond to their perception of reality rather than take what is given to them by the camera. This effort by the great masters of the medium of photography to go from seeing to perceiving is manifested by the strong presence in their prints.

Many years ago, I was searching for a way to intrinsically understand the compositional structure of Paul Cézanne's still life and landscape works. After weeding through several large format books, it occurred to me to photocopy the pages in black and white to eliminate any color and see the bare compositional structure. What I saw, even in those days of really bad copy machines, was a hint at not only the structure, but (and most importantly for us here) the beauty of the grayscale image underlying the color. I was astonished at the textured highlight values, the full shadow areas, and the clear separation of the midtone grays. I can remember being soberly impressed by the skill of this great artist and his manipulation of the grayscale alone. The thing is, he did it without any reference to tonal values. This seemed to me even more of a miracle. How could he perceive the value scale from the color and make it so beautiful?

When the computer age arrived for photographers in the early 1990s and Adobe pioneered its Photoshop software, I used the program to digitally convert the images of the great master painters into grayscale and further study their intriguing mastery of tonal values. Over the past 12 years, I have downloaded and converted thousands of these great masters' paintings, I have not found one, from da Vinci to Pollack that did not exhibit an outstanding grayscale in both the grouping of values and in the separation of those values. The masterful articulation of the grayscale in these paintings is not only the key to good color, but also the essential key to creating presence in the work—the foundational element of a masterpiece.

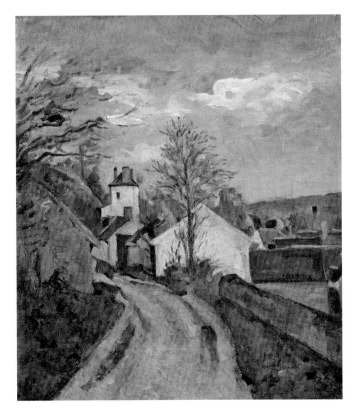

Looking at black-and-white images of great master paintings is, for me, a feast for the eyes and a continual learning experience. It is the ultimate expression of how grayscale can be manipulated, much more so than is achieved in the traditional black-and-white print (although black-and-white silver printing was mastered by some—Paul Strand, Ansel Adams, Minor White, Edward Weston, W. Eugene Smith, Paul Caponigro, and a handful of others who represent the epitome of this craft). Only a few photographers have achieved this mastery of grayscale, and I have always wondered why.

Cezanne, Paul (1839-1906)
The house of Dr. Gachet at Auvers, c.1873. Musee d'Orsay, Paris, France
Photo Credit: Erich Lessing / Art Resource, NY

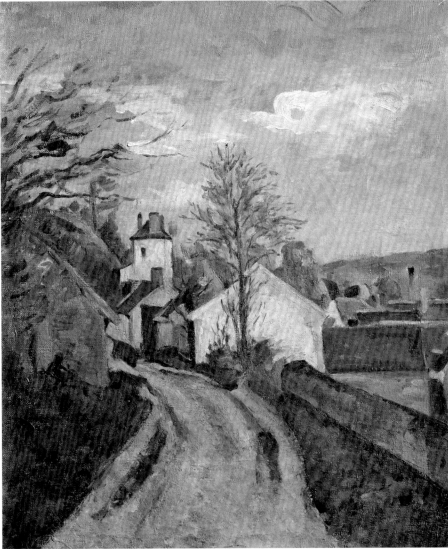

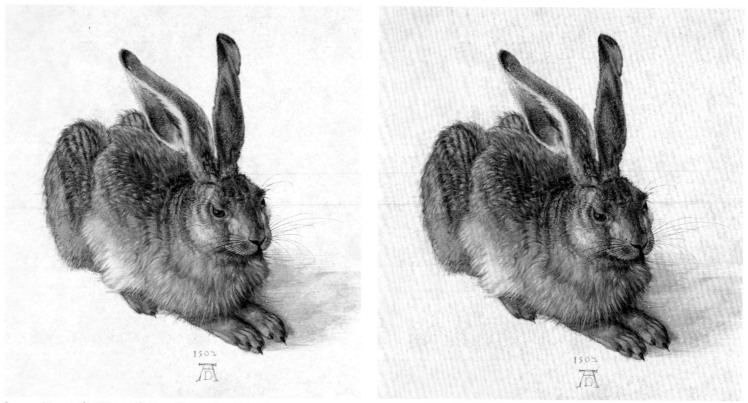

Duerer, Albrecht (1471-1528). Hare. Watercolor, 1502. Graphische Sammlung Albertina, Vienna, Austria. Photo Credit: Erich Lessing / Art Resource, NY

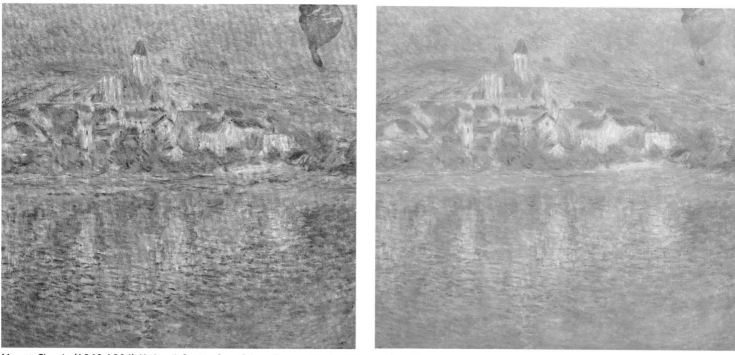

Monet, Claude (1840-1926). Vetheuil, Setting Sun. Oil on Canvas. Photo: H. Lewandowski. Musee d'Orsay, Paris, France. Photo Credit: Erich Lessing / Art Resource, NY

In 1978, Dr. Edwin Land published his "Chairman's Letter" in the Polaroid Annual Report. This powerful, yet little known writing, lays out the reasons for the profound difference between the master photographer and the ordinary one. Here is an encapsulation of that essay:

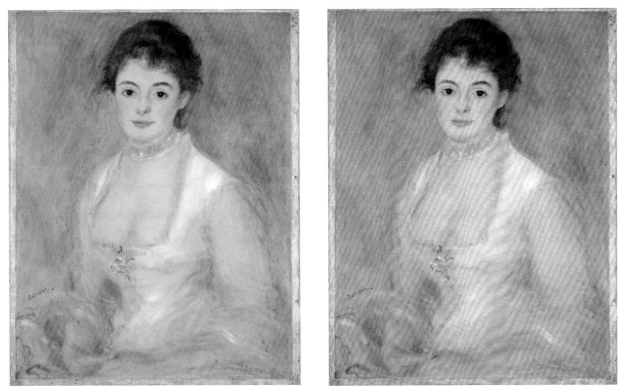

Renoir, Auguste. Madame Henriot, c.1876. Gift of the Adele R. Levy Fund, Inc. Image courtesy of the Board of Trustees, National Gallery of Art, Washington.

The most extraordinary of man's artifacts in the reconstruction of reality is the black and white image comprising, of course, a series of grays. It can be shown that in seeing color, objects are separated out from each other by the preferential efficiency of the surface of one object or another for reflecting light of one wavelength or another and that this preferentially remains intact irrespective of the variation in time and place of the illumination on the object from the world around it. Black and white photography generates, as it were, a substitute world: light of the same wavelength composition comes to the eye from any part of the scene. This preferentially for reflecting at different wavelengths (colors) is absent and cannot be used to designate objects. Rather only the difference from object to object in the efficiency for reflecting a uniform mixture of wavelengths can be used.

Here comes the miracle. The enormous variations in illumination of the objects by the world around them have led to enormous variations in the amount of light reaching one object or another in a random way, so that portions of the photograph delineating dark objects may send to the eye more light than portions of the photograph delineating white objects. In short, the photograph is two entirely different kinds of report transmitted to us by what appear to be mixed languages, the language for delineating objects and the language for displaying illumination.

There have not been many great photographers in history, but the great ones usually turn out to be masters of the vocabulary of these two utterly different languages in black and white photography. For most would-be photographers these languages are mixed together and never disentangle, like the babble of voices at a cocktail party. The breathtaking competence of the great photographer is to cause the object of his choice to be revealed with symphonic grandeur, meticulous in detail, majestic in illumination.

~Dr. Edwin Land~

That passage has haunted me for thirty years. It is the sole (I almost wrote soul) reason behind this book. To understand what Edwin Land was talking about, you have to understand his interests. Although he considered himself primarily a research scientist, he was Chairman of the Board, Chief Executive Officer, and Director of Research for Polaroid Corporation. He was one of the richest men in America, with a net worth of over $500,000,000 and he had over 500 patents. His interests in research carried him from the invention of Polaroid film materials, to the first instant cameras, to the Retinex Theory of Color Vision, to black-and-white peel-apart large format film. Of primary interest to us here is his research with lightness perception and his decades long association with Ansel Adams.

The substance of the Land essay highlights the subject of a photographic masterpiece and the overall process by which one is made. As Land so eloquently puts it in what, in my estimation, are the key passages of the essay, "the photograph is two entirely different kinds of report transmitted to us by what appear to be mixed languages, the language for delineating objects and the language for displaying illumination." He then goes on to note that, "There have not been many great photographers in history, but the great ones usually turn out to be masters of the vocabulary of these two utterly different languages in black and white photography. For most would-be photographers these languages are mixed together and never disentangle, like the babble of voices at a cocktail party. The breathtaking competence of the great photographer is to cause the object of his choice to be revealed with symphonic grandeur, meticulous in detail, majestic in illumination."

From Luminance to Luminosity

The camera and the retina see the same luminance in an image, which is a combination of reflection (in the words of Land, "the language for delineating objects") and illumination ("the language for displaying illumination"). The visual cortex in the rear of the brain processes this luminance signal from the retina, separates reflection and illumination, and recombines them in a very special way to show us the world as it truly is, visually. The brain first detects edges, separating those edges into illumination edges and reflection edges. Then, it uses complicated algorithms to process the image into our perception of luminance, called luminosity or brightness. This is an important point, and bears repeating: Be mindful of the difference between actual luminance and our perception of luminance, called luminosity. An unprocessed image direct from the camera is a straight luminance image, hence the disparity between what we visually perceive and what we get in a photograph.

What painters have been able to do since the invention of chiaroscuro (see page 17) is to "fool" the observer's eye by taking a straight luminance image and adding elements of visual perception to the canvas to create that artist's subjective interpretation of luminosity. So, painters are involved in a secondary process that most photographers don't ever go through, except, as Land hints, in the greatest masterpieces, which have been dodged and burned extensively (a form of secondary processing that, when done well, mimics this secondary step that painters employ).

John Sexton, a contemporary master printer in traditional black-and-white silver photography, uses a very complicated burning and dodging procedure that mimics what the painters do to a canvas. The black-and-white photography masters (such as Ansel Adams, Minor White, and Gene Smith) also burned and dodged in very complicated

ways. Someone once asked Gene Smith how he made a print and he replied, "I go into the darkroom in the morning with a gallon of Dektol in one hand, a package of 11x14 Polycontrast J under my arm, and a fifth of scotch in the other hand, and come out twelve hours later with a print."

Great photographers are able to transform the raw luminance of the captured image into something that expresses their own unique perception of the world. Learning this skill of transforming luminance into luminosity takes time and practice. In terms of our discussion, changing luminance into luminosity is creating what lightness perception scientists call "good constancy." We, as artists and photographers, recognize that as presence. Visually, here's how the luminance problem (the "gaggle of voices") presents itself:

In looking at these images (right), you can see how the reflection image and the illumination image combine into luminance. The result looks startlingly lifelike until you compare it to the luminosity image. This set of images illustrates the difference between what we think is real (the image direct from the camera) and the image as it is processed through visual perception. This is the difference between luminance and luminosity, respectively. What we get from the camera needs that secondary processing step for it to look like what we visually perceive and feel. The following image sets are some real photographic examples of this process.

Reflection

Illumination

Luminance

Luminosity

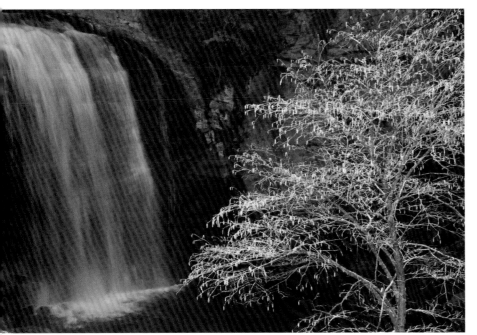

The first image in each set is a RAW file converted to black and white in Adobe Lightroom software using the grayscale button in the Develop module. These initial grayscale images are otherwise unprocessed, and they represent a basic luminance image. The second image in each set was converted in Adobe Photoshop using the PercepTool plugin. The differences you see in each pair will depend upon the inherent depth and tonal spread each has to begin with. For this reason, the effect of the PercepTool plugin is more pronounced in some of the luminosity transformations.

Luminance

Here, the major change from the luminance image is the separation of the bright tree in the foreground of the luminosity image. While parts of the background need to be lightened for an ideal presentation of the scene, the major effect of the PercepTool plugin is to separate depth boundaries, as shown clearly in the luminosity image.

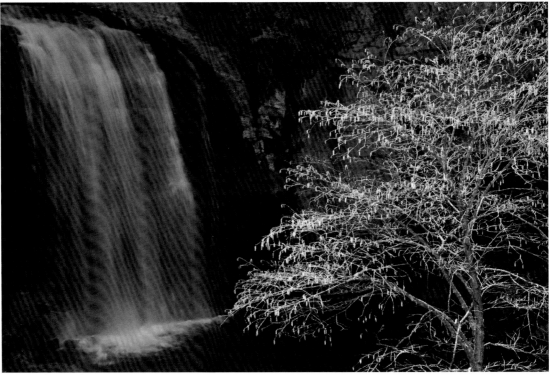

Luminosity

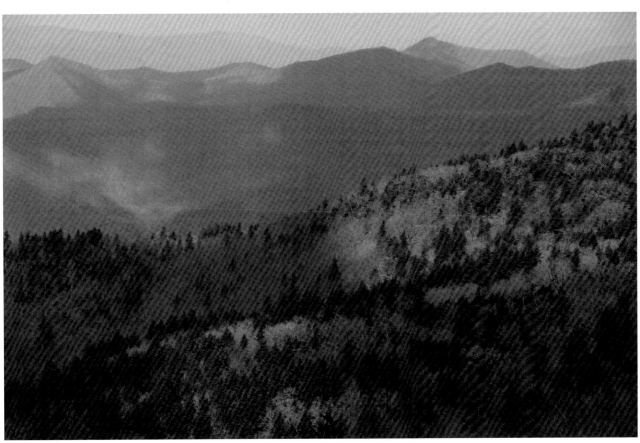

Luminance

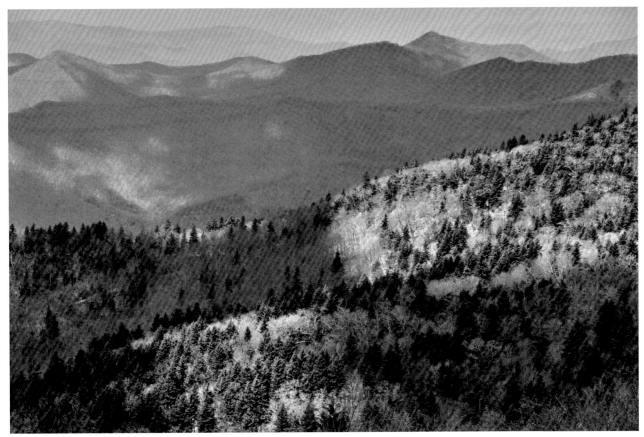

Luminosity

In this image set, we see that the flat luminance image is enhanced by the articulation of the grayscale and framework grouping capabilities of the PercepTool plugin applied to the luminosity image. The luminosity image also shows definite depth boundary enhancement from the well-lit foreground to the background.

The separation of the trees from the background was paramount in this image, and the depth boundary enhancements and articulation enabled by PercepTool aid in this immensely.

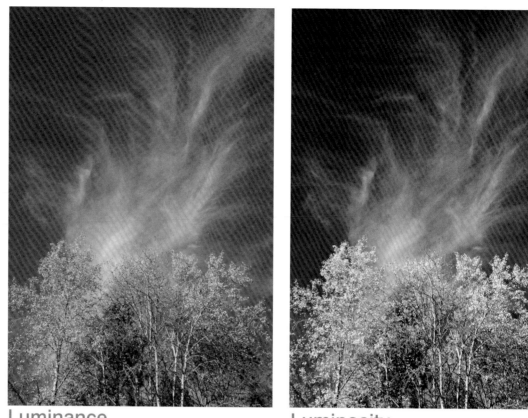

Luminance

Luminosity

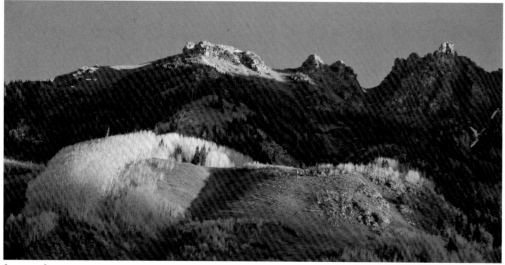

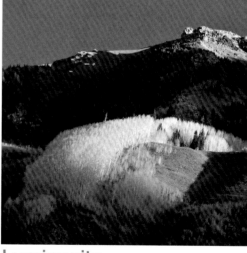

Luminance

Luminosity

While the effect of the PercepTool on this image seems slight (the only real change being overall contrast enhancement), notice that the luminance image looks flat against the rock whereas the luminosity image is much more three dimensional. The PercepTool combines differential contrast and edge effects to obtain this marvelous sense of being there.

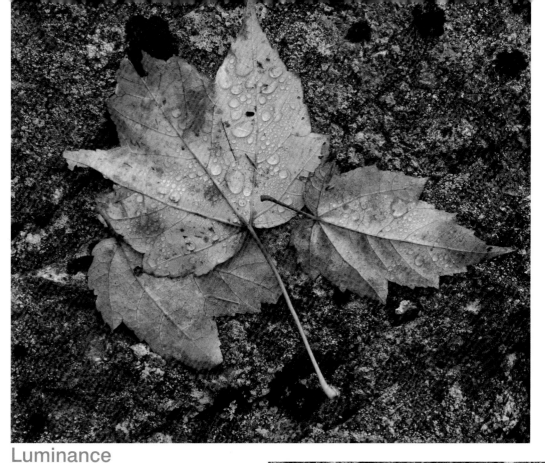

Luminance

There are many depth boundaries in this image and the PercepTool did a great job at enhancing them. The corrected luminosity image may seem darker in the shadows, but remember that the effect is a perceptual one, and a print would show all the detail in the lower gray areas.

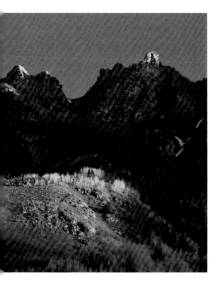

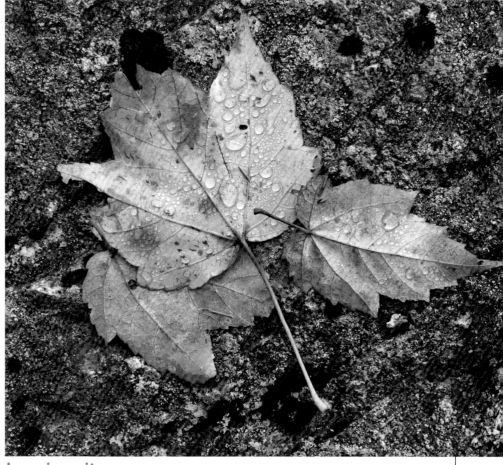

Luminosity

What are depth boundaries?

Our eyes communicate information about depth to the brain through identification of depth boundaries in the world around us. To illustrate this, hold up a hand in front of you. Now place your other hand directly behind it so they are touching. Using depth perception, our eyes recognize that one hand is closer than the other. The depth boundary is the place where the two hands meet—the point at which the depth changes.

Luminance

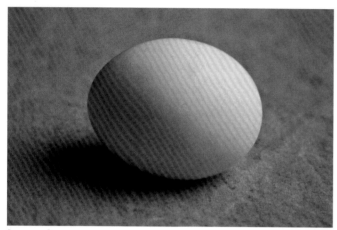

Luminance

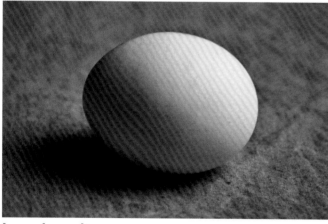

Luminosity

The PercepTool effect on the egg is startling. It seems to jump right off the page due to the increased modeling and edge definition.

Here, the luminosity image shows another incredible transformation. The number of edge enhancements, framework, and tonal articulation details are too numerous to count.

Luminosity

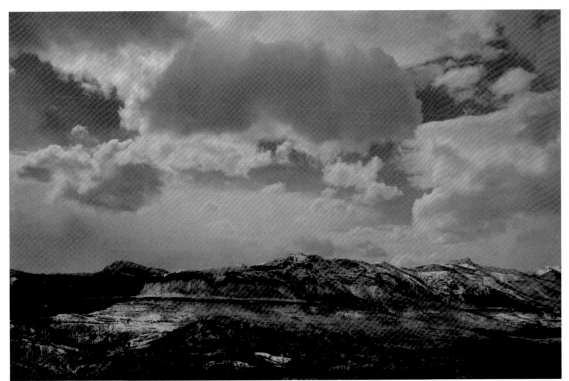

Luminance

Even in a landscape with little depth like this one, the PercepTool plugin finds the boundaries. Look how the central gray cloud advances forward and the mountain in the rear appears more distant in the luminosity image because of the edge enhancement and articulation of the tonal values.

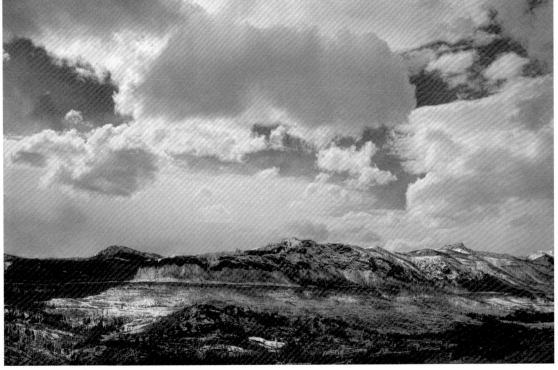

Luminosity

Distal Stimulus

Proximal Stimulus

Percept

Perceptual Processing

So far, I have said little about black-and-white printing. However, the information included here is the groundwork necessary to understand and solve the deepest and most profound mystery of art itself: "How do we represent what we see?" This is the domain of a little known science: the science of lightness perception.

I will not use these pages to recount the full history, research, and practice of lightness perception (a task which others have done so well, most notably Alan Gilchrist in his book *Seeing Black and White*). The fact remains that we still do not know everything about visual perception, and much needs to be discovered before machines can see like humans, which is the goal of the lightness perception community. Painters figured this all out intuitively over 500 years ago, and science has been slow to follow. That said, what I would like to share with you in this book is a method for practicing artistic black-and-white inkjet printing that is inspired both by the intuitive sense of lightness perception achieved long ago by the great masters and the scientific interpretation of lightness perception today.

Science is interested in what is called veridical, or truthful, correspondence from a real object to the perception of that object. As artists and photographers, we are interested in making an image—be it on canvas or paper—look and feel like a true representation of our perception of the subject matter. In order for us to understand how to make a black-and-white inkjet print into a masterpiece, we need to look briefly at the basics of perceptual processing. Otherwise, we are completely at the mercy of technology and the endless parade of equipment we neither understand nor enjoy.

The perceptual process begins with an object or environment outside of the human visual system, called the distal stimulus. The distal stimulus sends luminance values to the lens of the eye, which projects that luminance onto the retina; this projected luminance is called the proximal stimulus. The retina then sends the luminance signals via the optic nerve and the lateral gangliate nucleus to the visual cortex in the rear of the brain where luminance is processed into the image we see. This processed image is called the percept. Note that the retina, just like the camera, sees only the luminance image, not the one perceived after processing by the visual cortex (see diagram, above).

The functions of the eye and the retina are well known to the scientific community, but the understanding the visual processing of luminance as it passes from the retina to the visual cortex is still a work in progress. The following is a simple explanation of how the luminance image is transformed during perceptual encoding according to the latest science on the subject. (I will update this information periodically on my website at www.georgedewolfe.com.)

Frameworks

Frameworks are a key recent development in the understanding of how the perceptual process works. Introduced by the Gestalt psychologist Lajos Kardos in 1934 in his book *Ding und Schatten* (*Object and Shadow*) and expanded and refined by Alan Gilchrist in 2006 in his book *Seeing Black and White*, a framework is a group of surfaces that belong together, like the highlights, midtones, and shadows of a black-and-white image. The overall picture is referred to as a global framework, and it contains all the other local frameworks within. A local framework is composed of tonal values like highlights or overlapping (occluding) depth boundaries (see the sidebar on page 28 for details). The visual cortex processes the image from the retina something like this:

1. The visual cortex finds the edges in the luminance image and separates those edges into two categories: reflected edges and illuminated edges. (Remember that luminance is a combination of the surface reflective nature of the scene being photographed as the illumination falling on that scene.)

2. The image is then spatially processed to create a perception of depth (called scale normalization).

3. Based on edge and depth classification, the tonal values are filled in to complete frameworks (highlights, midtones, and shadows). In each framework, the image is anchored to the highest value within it. The strength of a framework depends on three factors:

Size — This relates to the size of the framework relative to the other frameworks in the image. The larger the framework, the greater its relevance in the image.

Articulation — This is the number of distinct black and white tonal values in the framework. The greater the articulation, the stronger the image.

Grouping factors — Grouping factors are the visual grouping principles of edges, patterns, and the similarity and proximity of tonal values to one another. Anything that groups in a local framework strengthens the overall image.

4. The final percept (luminosity) image is created by adding the illumination image (perceived directly by the retina and separated at the beginning of the process) back into the mix.

This gives us some insight into Dr. Edwin Land's two types of visual report (illumination and reflection—see page 21) and shows how they are separated in the visual cortex, grouped into frameworks based on edges, depth, and tonal values, and then consolidated by anchoring local and global values to create the perceptual image that we see and that, as photographers, we must learn to recreate in our images to produce presence. In the next chapter, we will take these concepts and apply them to digital photography to discover how to do just that.

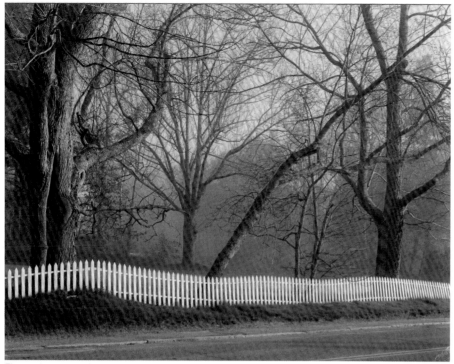
This is the original scan of my negative.

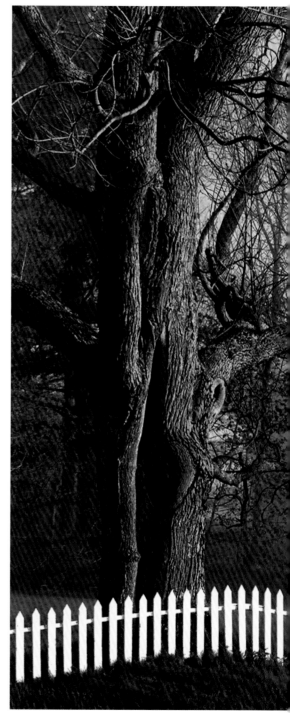

The Somesville Fence

This is probably my best-known photograph. In the spring of 1997, I was driving my son, Luc, to school. As we passed Somesville, a small village five miles north of Southwest Harbor, Maine, I glanced to my left and saw this photograph developing before my eyes. "Lucien," I said, "You're going to be late for school today. Don't worry, I'll write a note." I pulled out my 4x5 Wista with a 150mm Protar lens and made four negatives on good old Tri-X film. The photograph shows a fairly common type of fog condition that occurs in spring and early summer mornings along the Maine coast. This morning, the sun was glancing through the fog at a very low angle, adding to the beautiful nature of the light in the image.

Recently, I scanned the original negative with my Epson V750 Pro and achieved excellent results scanning at 100% and the maximum optical resolution of the scanner. I then cropped out the very bottom of the image, which showed part of the road. Next, I followed a routine workflow of global, broad, and local adjustments similar to the workflow I utilize in the latter part of this book.

The most difficult part of getting this image to match my perception of the scene was darkening the sky to just the right amount using the History Brush tool in Photoshop and selecting Multiply. This allowed me to blow out the fence posts so they were completely white (where the values were clipped off in the histogram). This extreme whitening of the fence makes the print glow. Other local controls helped to separate the midtones, all of which needed to be suppressed so I darkened them as an entire group. Such visual challenges take time to see in order to bring out the mood of any subject, and this one was perceptually more difficult than most because of the intricate local grayscale manipulation.

Here is the final image I produced from the scan.

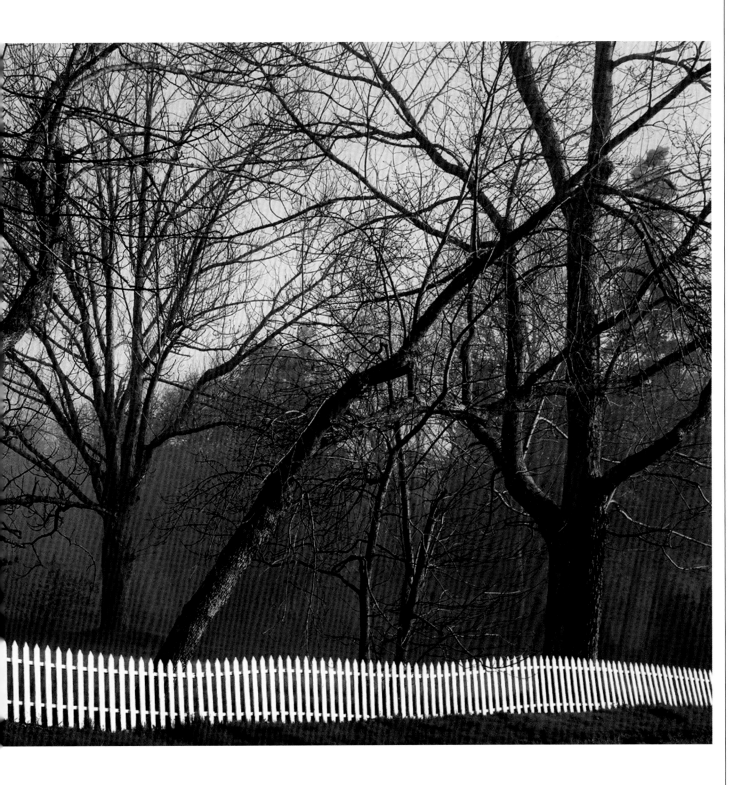

Qualities of a
Black-and-White Photograph

chapter | two

The fundamental error in what both the sensor of a camera and the retina of the eye see is that it is not what is perceived in the brain as visually real. In the last chapter, we explored this through examining this process through the lens of current lightness perception science and through the way in which painters solve the problem intuitively. Now it's time to focus on how photographers can address this issue.

In order to find out what we need to correct in a photographic image to create a print that reflects what we perceive as visually real, we need to understand the qualities of that image as they relate to our visual perception and the technical tools at hand. We have two essential problems to solve:

1. We need to see like the camera sees in order to capture an accurate two-dimensional luminance image. Remember that the camera sees like the eye's retina, but the brain doesn't "see" that same image, so we have to train ourselves firstly to see what the camera/retina sees.

2. Next, we need to manipulate the luminance image to conform to our perception of the subject or scene, thereby creating luminosity. In other words, we want to change the image we captured in-camera into something that looks like the world the way our brain organizes and interprets it.

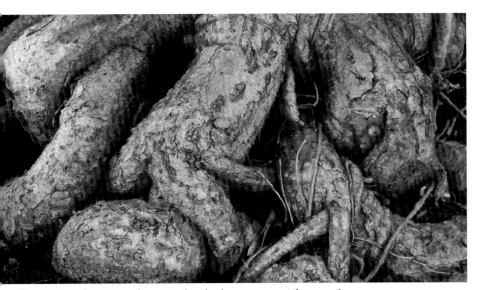

The positive shapes are the roots; the shadows represent the negative space.

This is the very simplest example of negative space. The chair is the shape and the wall is the negative space.

Seeing Like a Camera

In order to take a good photograph, we first have to see two-dimensional space, the space of the retina and camera sensor. It is a flat world, very different from the one we perceive. The easiest way I know to learn to see two-dimensional space is through the art of drawing.

Now that everyone has had a chance to cringe, relax. Drawing is actually a skill that is easily learned in a week—at least well enough for our purposes of learning how to see in two dimensions, that is. I taught drawing for seven years to beginning photographers and I can tell you that everyone who did the exercises learned the skill needed to see like the camera sees. Many were angry and uncooperative at first about the prospect of learning drawing, but after the first few lessons, everyone learned the skill and went on to translate their newfound ability to photography. There is a structured and fail proof way to accomplish this.

Almost thirty years ago now, Betty Edwards wrote a book called *Drawing on the Right Side of the Brain*. The methodology in this book changed the way people learned to draw. Instead of teaching a technical drawing skill, Betty teaches drawing as a perceptual skill, so anyone with a normal perceptual apparatus can learn drawing. The reason Betty was so successful is that she realized that drawing is the direct result of seeing, not pushing a pencil. And the same is true for photography; it is the result of seeing, not of manipulating a lot of technical equipment.

I suggest you pick up a copy of Edwards' book, along with the accompanying workbook (*The New Drawing on the Right Side of the Brain Workbook*). Read the book and work through the exercises at your own pace. It will be one of the best things you do for your photography in your lifetime. I do some of the negative space exercises included there as a routine part of my advanced mentoring program. Even if you only worked through the exercises in negative space, you'd be

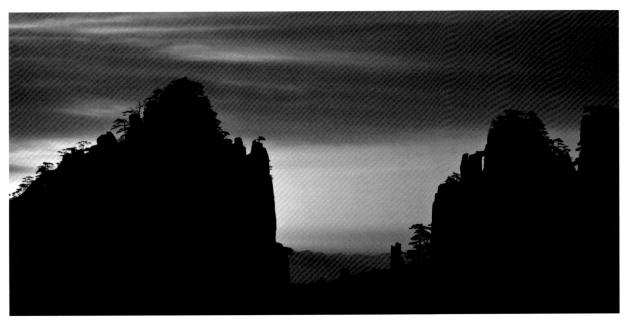

Here, the pinnacles are representing the positive shape of the image and the sky is the negative space that surrounds them.

light years ahead of those who have never explored this way of seeing. I have literally seen photographer's images change in less than a week because of this training.

The secret to seeing two-dimensional space is to see only the results of what light does to a subject or an environment. Light creates tones of black and white in the subject, and these tones create shapes and spaces. What we have to do is train ourselves to see just the spaces, and shapes formed by them, in order to see the two-dimensional image the camera will photograph. *Drawing on the Right Side of the Brain* teaches this skill. Edwards suggests the use of a frame to practice seeing negative spaces. Photographers have used blank slide mounts and cutout cards for years to aid in this process, a practice she recommends highly in her book. If you want to get started learning shapes and spaces right away, here is an easy shortcut:

1. Take a small piece of clear packing tape, smear a very thin coat of petroleum jelly on it, then attach it to the viewfinder of your camera. The world should look fuzzy, but you should still be able to discern major spaces and shapes.

2. Go out and take 50 – 100 photographs with the tape on the viewfinder, paying attention only to the major shapes and spaces you see.

3. Convert the images to black-and-white using an image-processing software such as Lightroom or Photoshop. Look at the images on the computer and notice how important those shapes and spaces are to the image. The detail you could not see in the viewfinder is now visible, but it is organized by the shapes and spaces. This is not as good a learning tool as drawing spaces and shapes, but many of you will be able to pick up the skill doing this instead because it is a natural thing for photographers to learn.

You must learn to see this way every time you photograph if you want to see the two-dimensional luminance image that the camera sees. It is the first step towards making a good photograph, it is essential for making any image with presence, and it is manifestly important for creating a masterpiece. It is a door though which you must pass.

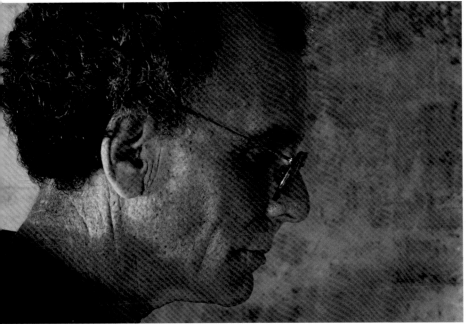

Jack's head and shoulders make up the shape and the wall makes the negative space.

Here, the spaces and shapes are almost equal, but the white leaves still show more definitively as the shapes.

This middle range gray image still shows good separation of shapes due to slight changes in tonal value and overlapping (occluding) edges.

In this example, the spaces and shapes are almost indistinguishable from one another. There are competing shapes and spaces in both the sky and in the mill.

Another device I use to help me see two-dimensional images in grayscale is the #1 B&W viewing filter from Tiffen. This type of viewing filter has been around for many years in many forms. Ansel Adams used to hand them out at his famous workshops in Yosemite, and Fred Picker sold a really handy one through Zone VI Studios. The latest iteration of this filter is made by Tiffen and is composed of a Kodak Wratten 90 monochromatic viewing filter sandwiched inside a glass holder. It's an amber colored gel that turns the world into monochrome and mimics what a black-and-white image will look like when taken by the camera.

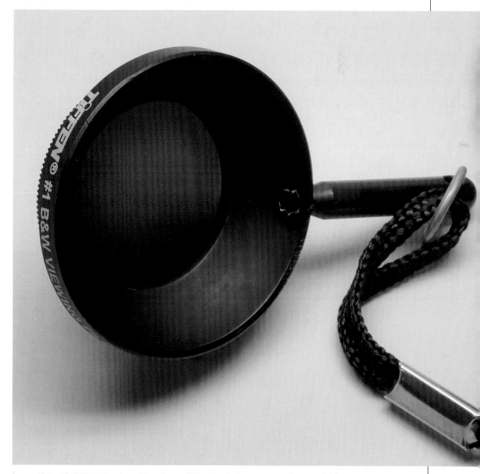

I use this #1 B&W viewing filter from Tiffen to help me see the world in grayscale the way a camera would.

This is the color of the Kodak
Wratten 90 filter from which the
Tiffen #1 B&W viewing filter is made.

To observe the effects of the B&W viewing filter, first take a look at this original color image.

Here is the same scene viewed through the B&W viewing filter.

This is what the image looks like after I applied a black-and-white conversion in Lightroom.

These two images illustrate content oriented seeing. Notice the haphazard arrangement of the negative space and the vision centered on the subject. (Images © Beate Sass)

By looking through this filter at the scene in front of you (with your eye—don't put it on the camera), you can see tonal merges, low or high contrast, and well separated middle values. This ability to see in black-and-white before you click the shutter button is essential for anyone wishing to photograph and produce black-and-white prints. The Tiffen #1 B&W viewing filter aids this practice considerably.

Most photographers tend to photograph "things" rather than the shapes and spaces that make up those things. The camera does not differentiate between a person's face and the shapes and spaces that make it up. We are the ones who label our subjects. The camera has no idea of anything but spatial attributes. I call this "the content problem."

I can tell instantly if a student is "content oriented" or "image oriented." These pages show some examples from one of my advanced mentoring students.

Ansel Adams once said that great excitement for a subject often veils a clear image of it. He was speaking of "the content problem." The content of your image can be your worst enemy when you're trying to represent the world in a photograph. Learn the skill of recognizing negative and positive space and free yourself from the shackles of the subject.

Here, we see an entirely different story. The same photographer went back to the same spot a week later with instructions to look only at the negative space, and her photographs improved tremendously. She almost instantly weaned herself from the typical content oriented photograph. (Images © Beate Sass)

Transforming the Luminance Image

Transforming the luminance image from the camera into something that resembles what we saw and felt in reality is, and always will be, to me, a miracle. Over the centuries, artists have labored to reproduce the presence that exists in the world in their work, and their greatest attempts are recognized as masterpieces. What I have learned from studying the work of great master painters is that their grayscales are the most important aspect of their paintings (see pages 19 – 21). The grayscale not only creates the presence, but also lays the foundation for the color overlay. While these artists weren't actually working in grayscale, they intuitively knew the importance of tonal value.

By transforming the work of these masters into black and white, I study their grayscales as though I have found a map to some long-buried treasure. I search for three basic things: tonal values, the way the tones are organized, and how the tones are bound at their edges to create depth and separation. Each artist is different, and each has a distinct gray signature. This is how we should look at a grayscale photograph: We need to delineate its tonal scale, its tonal structure, and how depth and separation are created by the edges.

Tonal Scale

The tonal scale refers to the number of black, white, and gray tones in the image and how they are distributed. For instance, there may be a predominance of gray tonal values, indicating a midscale oriented mage; a greater number of high tonal values (closer to white) means that an image is high key; a greater number of low tonal values (closer to black) denotes an image as being low key. These, of course, are not the only designations; there can be infinite combinations.

A recognizable pattern in the tonal scale in a photographer's images indicates a sophisticated level of seeing. Often, this pattern can be roughly discerned by looking at histograms of the images. If in examining histograms of several images by one artist, a discernable trend is observed, it reveals a real maturity in vision. The histograms of the black-and-white conversions of the French Impressionist painter Pissaro, for example, show remarkable consistency in their distribution of tonal values. Ansel Adams is known for his fabulous array of tonal values, from complete black to complete white. Roy DeCarava is famous for his low key photographs of African Americans.

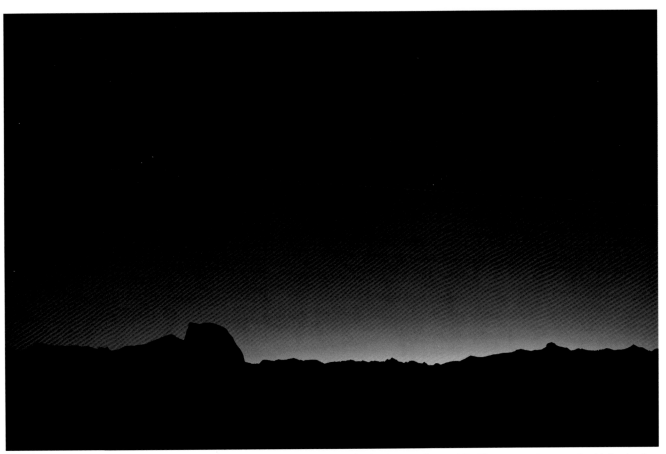

This image is very low key. The values actually go only to middle gray at the horizon and not white. The eye anchors on the highest value in the global framework of the image, creating an illusion in which the brain "sees" that highest value as white.

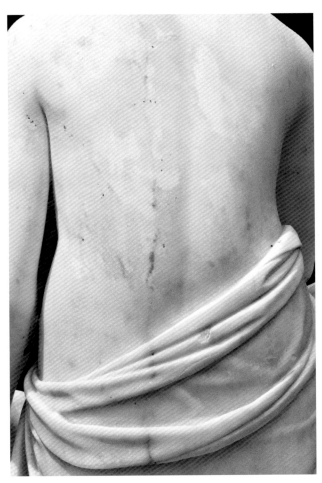

Notice how the values in this high key image go from about middle gray to white (not counting the black background), with good separation of values in between.

A good middle key photograph is based on very good separation of tonal values. Otherwise it looks too "muddy," like this one does. If you practice working with middle gray images, you'll get really good at seeing and separating those midtone values—the greatest challenge to overcome for beginning printers. The problem is fixable, but you have to be able to see it first.

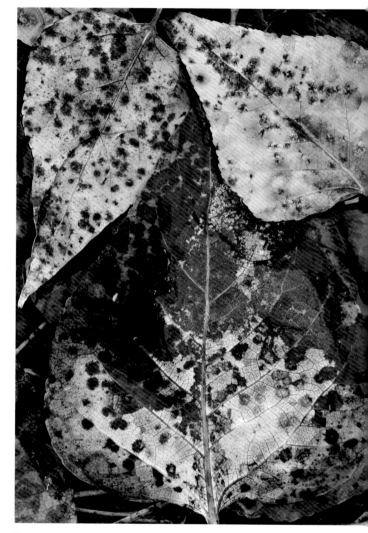

Here is another middle key image with good separation of tonal values. The great Impressionist painter Claude Monet relished in being able to see how subtly he could make his midtone grays without them all blending together. Take a look at his work in black and white sometime.

Here is the same middle key image optimized for midtone contrast. I adjusted only the midtone values, and the adjustments really make the image pop.

Tonal Structure

The structure of tones in a grayscale image is composed of frameworks, patterns, or groups of tones. Tonal values are separated in the brain into highlight, midtone, and shadow frameworks. This is one way of looking at the tonal structure of a photograph. Another way is to identify tonal values by the patterns they make in the picture, a so-called "web of light" that acts to bind the image together. The structure of the tonal values in these ways and others enables us to better enhance black-and-white articulation and create presence.

Edges

Depth in a photograph is formed by edges (illuminance or reflectance edges—see definitions in the glossary, which starts on page 10). These edges are distributed roughly into near, middle, and far distance frameworks. The visual reconstruction process in the perceiving brain starts with finding edges. The luminance image from the retina is presented to the visual cortex, then it gets torn apart (into illuminance and reflectance intrinsic images) and reassembled into the image we "see." Once the image is torn apart, it is quickly and systematically analyzed into a skeleton of edges (groupings) based on whether these edges are illumination edges or reflectance edges. These edges form groups of planes based on the arrangement and number of illumination and reflectance edges relative to one another. For instance, a flat wall is only one plane and would generally be represented by a reflectance edge and look flat to us. A landscape of mountains would have three dimensional planes consisting of both types of edges.

There is no depth in this photograph. All you are seeing is the effect of reflection edges and tonal value.

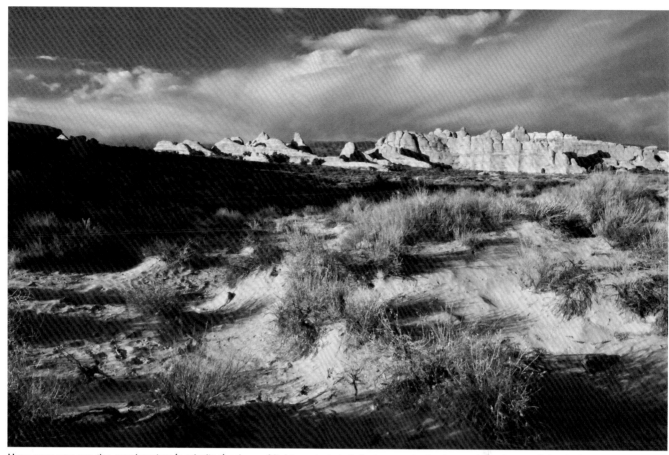

Here, you can see the overlapping (occluding) edges of light against dark that separate the image into planes of depth. As you look farther into the distance, notice how the edges become softer, an indication of their being farther away from us.

The process in the brain's visual cortex then fills in the edges with normalized reflectance values (a process where our brain compresses all of the reflectance values toward middle gray) and then the illumination image is added back into the mix. Tonal groups are formed into highlights, midtones, and shadows (there is still theoretical debate as to whether the image is composed of a shadow/highlight groups or shadow/midtone/highlight groups). Contrast enhancement (sharpening) is applied according to each group, the highlights and midtones receiving the most and shadows the least. Depth is assigned to edges based on whether that edge is an illuminance or reflectance edge and grouped into near, middle, and background depth frameworks. The tonal values are then anchored to the lightest value in each framework (highlights, midtones, or shadows). All of this happens, literally, in the blink of an eye.

The explanation of how this process of transforming the luminance image into luminosity occurs is a work in progress. As new discoveries in lightness perception are unveiled, our view of the process changes. However, the general facts are now known, and we should proceed as artists in using this recent research to create our masterpieces.

Here, then, after considering all we've discussed so far, is a breakdown of the qualities we need to address to make an excellent black-and-white print into a masterpiece, and the specific general tools we need to use to adjust those qualities. Based on what we know today, we need to create multifaceted edge/depth effects, and tonal value articulation to create presence.

Edges and Depth

Edges are hard, soft, or somewhere in between. This may sound like I'm stating the obvious, but it is truly very involved. Most of us think of global sharpness in an image as the holy grail of quality. We also tend to think of sharpness in terms of planes of focus as photographers. For example, a background may be blurred, or not.

The truth is that edge definition is local not global in nature. Our perceptual apparatus makes objects in shadow less defined than in the highlights and the midtones. So, if you make all objects in the image equally sharp, the image does not read as perceptually true. And, of course, just as great images are not globally sharp, they are not globally soft (blurry). Sharpness and softness tend to be related to important areas like the highlights and the midtones, but an edge also has to account for depth as well as definition. For example, objects, like the front brim of a hat, should be sharp, but the back of the hat should be soft.

A camera does not see horizontal depth from highlight to shadow, near to far; it only sees in one vertical plane of sharpest focus, with everything else less being sharp on either side. If you want to represent an image as the brain sees it, you have to represent sharpness and softness on a local level, not a global one. Painters have known this for 500 years. James Bama, the great American western painter, once told me on a personal visit to his ranch in Wyoming, "It's all about edges, George. It's all about edges." (See page 174 for an example of Bama's work.) Sharp edges in an image represent nearness and soft edges represent planes that are farther away. Sharpness creates definition and separation, while softness creates blurred detail and blending.

In this version of the portrait, I have only applied global adjustments in Lightroom.

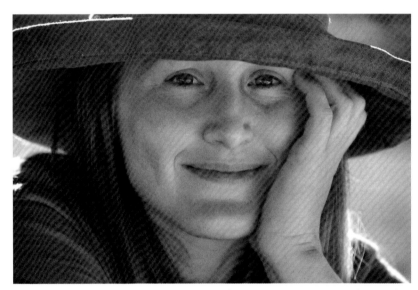

Look carefully at the edges in this rendition of the portrait and compare them with the image above. I have increased the softness of most of the edges that are farther away and sharpened the edges in the foreground. The effect is subtle, but effective. I also applied the PercepTool. You can clearly see the difference between the luminance image above and this luminosity image.

This is a really good example of a hard-edged foreground and a misty soft background.

In addition to differential local edge sharpness, the brain translates depth with a number of different cues. The most important of these is overlap, or occlusion, where one object breaks the outline of another, thus making it appear in front of the object behind it. These occlusion boundaries, as they are called, are part of the mix that helps the brain create depth from the luminance image it gets from the eye in order to create the luminosity image. Other depth cues are available, but overlap and differential local edge sharpness are the most important. Many will argue that an effect like receding atmospheric haze is another depth indicator, but its effect is nothing more than an image to which many soft local edges and low contrast have been applied. Look back at the image of the Buddhist tablets on page 38 for a good example of many of the ideas presented here. For that image, however, everything was sharp because it was a relatively flat plane with lots of edges and detail.

This image is an excellent example of receding sharpness and overlap causing depth. The foreground, middle ground, and background are clearly separated by overlapping edges, and the image gets softer as you look into the distance. This was a classic technique of the Hudson River School painters in the 19th Century.

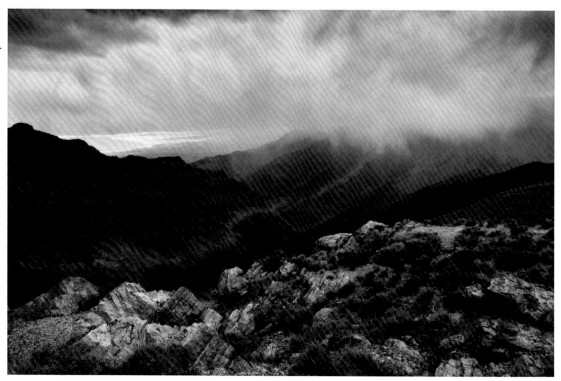

Manipulating Tonal Values

Tonal values are the heart of a great masterpiece regardless of its depth. The photograph may be completely flat with no depth at all, but have a multitude of black, white, and gray tones. This articulation of tonal values represents what we saw and felt in the original scene and is the single greatest factor that creates presence in an image. As illustrated in the last chapter, this is both a centuries old artistic truth and a scientific fact.

The tonal values in a photograph are made up of spaces and shapes that represent different degrees of brightness from black to white, separated by edges. It is important to accept that this is all an image is composed of. Everything you do to a black-and-white image revolves around manipulating these values and their edges. Our only controls over this manipulation are brightness, contrast, and sharpness (including softness or blur).

You must gain complete mastery over these three simple controls. You must learn every thing about them. You must master all three instruments as if your very life depended upon them if there is to be any presence in your work.

Brightness

The term brightness as we use it in Lightroom and Photoshop has the same meaning as luminance as used in lightness perception science. It is a casual word that has crept its way into the glossary of photographers over many years. Lightroom has a Brightness slider under the Basic tab in the Develop module. It becomes a bit more confusing when we go down to the HSL sliders in the Develop module—Hue, Saturation, and Luminance. You might expect the word lightness to be used here instead of luminance, but actually, luminance is the correct term and has the same meaning as it does in lightness perception terminology. In truth, the Brightness slider in the Basic tab has the same function as the Luminance slider down below in the HSL slider group, so don't hesitate to use either slider for a brightness adjustment.

For all intents and purposes, the word brightness as used in the Lightroom and Photoshop equals luminance. Now that we've cleared that up, making adjustments to luminance (aka brightness) is very simple. If a photograph, or part of it, is too light or too dark, use these adjustment tools to make it right. Saying part of an image is "too" light or dark is, of course, relative, not absolute. Increasing brightness affects the entire image (or the area selected) with the same amount of light, and shadows and highlights are increased or decreased by the same amount.

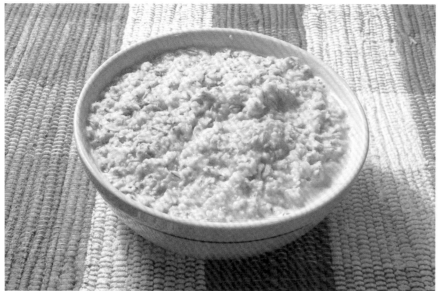

In this rendition, the porridge is too light.

Now, it's too dark.

Contrast

Brightness and contrast are not the same thing. Contrast adjustments affect each tonal value differently rather than affecting them all similarly as brightness adjustments do. Photographers and painters often have a tough time seeing the difference in these two concepts. Contrast is simply the difference in value between the highest tone in the image (or an area of the image) and the lowest tone.

An area of high contrast looks as though the high values are too high and the dark areas are too dark. A low contrast (or flat) image is one where the high values don't look high enough and the low values look too high. The separation of values is a key concept in the adjustment of contrast. Good separation shows the tonal values as clear and distinct, whereas bad separation shows little distinction between values, often causing the image to appear "muddy."

This image has normal contrast with a beautiful range of tones. Only local adjustments were needed.

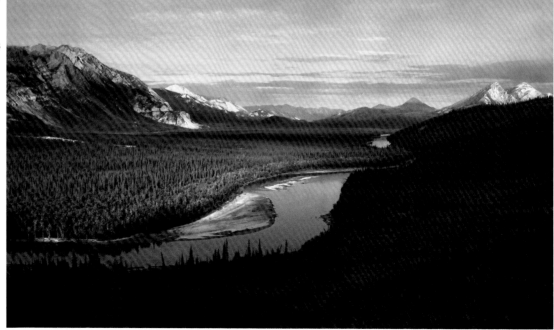

This porridge is just right.

Here, the subject looks totally flat.

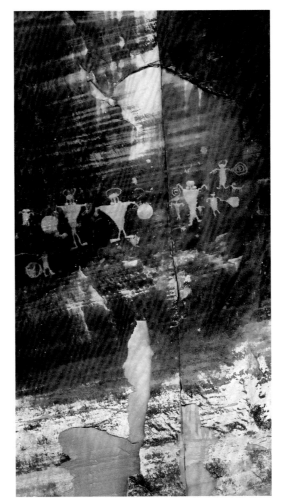

To fix the contrast issues in the image at left, I applied an increase of global contrast as well as local contrast enhancements and edge definition.

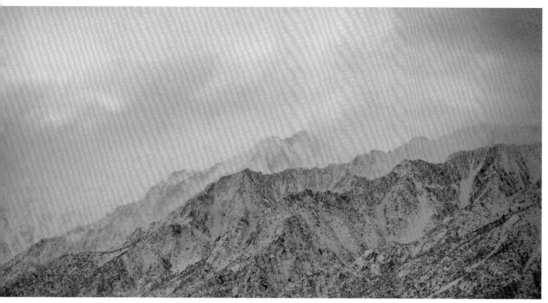

This image clearly needs a boost in contrast, but going overboard with the contrast enhancement would make the scene look too stark and lose its mood.

I applied a very slight global contrast increase to bring out the mood rather than detract from it.

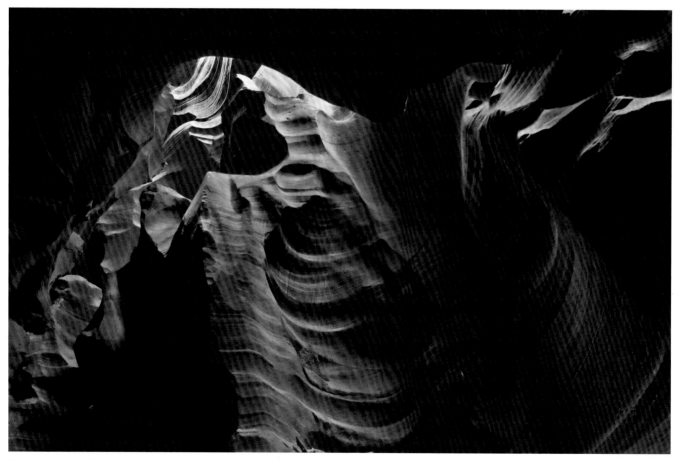

Anyone who has been to Antelope Canyon can attest to the extreme contrast of the place, but I came prepared to tackle the problem. For each image I took, I bracketed seven f/stops in one stop increments and combined the exposures in Photoshop using Optipix software into the one image that you see here. The image needs a lot more work, but combining the exposures in this way did give me a fairly decent image to work from that is (mostly) not clipped in the highlight and shadow areas. (You can also combine exposures to accomplish this technique using 32-bit HDR Merge software. See pages 114–117 for more information.)

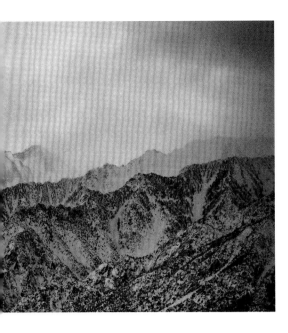

This image required little manipulation other than midtone separation and enhancement. The scene looked a little flat through the B&W viewer (see pages 39–43), so I knew I was going to have to increase the contrast slightly in the final image.

Eureka Dunes is a beautiful, often mystical place. This image was high key, yet the tones were well separated, so all I had to do was convert the color image to grayscale in Lightroom to achieve this look. It is absolutely marvelous to see hanging on the wall. Sometimes you really do get lucky.

Sharpness and Softness

The sharpening I want to deal with here is not the type of sharpening digital photographers talk about. The sharpening and softening of an image the way the brain perceives it is vastly different than the global image sharpening and final print sharpening that digital photographers employ. The brain not only sharpens edges differentially in the highlights, midtones, and shadows (applying more sharpness in the highlights and less in the shadows), it also uses alternate softening and sharpening to create depth along depth edge boundaries. This kind of sharpness is local, not global. There are several dimensions to consider.

Hard and Soft: Some objects are hard-edged and others soft-edged. A ball or a cylinder is, by its visible nature, "soft." A box or a book is visually "hard." And there are all sorts of objects in between. Human anatomy, for instance, tends to be hard in places where bones show, and soft where only muscles or fat are present underneath the skin.

Space: A sense of space can be created in even the smallest dimension by adding the softness of "spatial air" between and among objects. One of the best examples of this kind of art is represented in the paintings of Walter Tandy Murch. Spatial atmosphere is created by soft edges and low contrast. The image at the top of page 50 is a perfect example of this.

Near and Far: The nearest object to us in a photograph should have the sharpest edges, while one farther away should be soft. A person's ear in a head and shoulder portrait, for instance, should be softer than the frontal plane of the face and eyes because it is farther away. The difference here should be subtle, not overwhelming. See the portrait on page 49 for an example of this.

Overlap: Overlap is created by edge contrast more than hardness or softness. One typical technique is to outline an object so that it appears to be in front of another. The edge itself can be soft or hard; it is the outlining that separates objects by creating contrast. The Buddhist tablets on page 38 are a good example of this.

All of these effects can be created using local controls in Lightroom and Photoshop to manipulate the luminance image into becoming the luminosity that our brain perceives in the world. Accomplishing these effects takes time, practice, and keen visual awareness. Applied successfully, these effects bring a photograph to life and create presence.

PercepTool

I invented PercepTool to solve many of the problems mentioned in this chapter. Basically, the tool works with the luminance image we get from the camera and corrects it to look like the luminosity percept produced by the visual cortex of the brain. The idea behind PercepTool originated in 1978 with Ed Land's essay (see page 21) and continues with my ongoing research in lightness perception. At this point it is nearly impossible to create this percept effect manually in Photoshop. So, I set out to make a Photoshop plugin that would accomplish this difficult task with the most sophisticated tools available to us in digital imaging science. In the action and software, one click changes the luminance image into the luminosity percept of the visual cortex. For those of you making that one click, remember that the development time and research involved behind that click took 30 years. It is available as a plugin on my website: www.georgedewolfe.com.

Manual Controls

The PercepTool accomplishes the major task of creating an image that we actually experience in the world, but artists and photographers always want to fuss over their images. In this section, I'll describe specific ways of working with both global and local controls in Lightroom and Photoshop that help enhance the image using a consistent workflow. The local techniques lighten and darken local shapes and spaces, assist in creating overlap, depth boundaries, near/far relationships, and others. The techniques outlined here especially allow for differentiating gray values in each of the tonal frameworks.

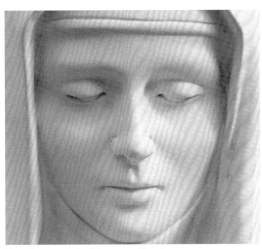

Here is an original image without any adjustments applied.

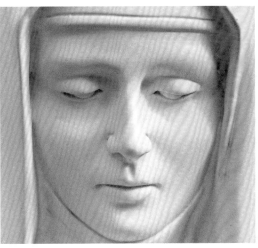

Here is the same image after applying the PercepTool plugin.

"Tonerobics"

Minor White, the great 20th Century black-and-white photographer, was my mentor for two years when I was teaching at the New England School of Photography in the early 1970s. I learned many valuable things about photography and its practice from him, and one of the most valuable was the tone exercise he used to give students. Basically, we made sets of gray, white, and black patches in the enlarger, each with a just barely perceptible difference from one another. Beginning printers usually only made about 25 – 30 tones, but advanced printers made

upwards of 55 – 60. At the time, I made 48. I had been in photography for about 10 years. The discrepancy between how many tones a beginner can make and how many an experienced printer makes always intrigued me. It's not the ability to make the print itself that's hard. It's seeing the differences between and among very closely spaced tonal values. Lightness perception refers to this as articulation. In this book, I've defined this hard-earned skill as the ability to create presence.

Over the 30 or so years since Minor's death, I have carried on a more sophisticated program of what I call Tonerobics–learning the perceptual skill of seeing presence. It's sort of like playing scales on a piano, but with visual black and white tones instead. To access the image files you will need for these exercises, visit my website to download them for free (www.georgedewolfe.com).

By the time you finish these exercises you will understand intuitively that there is a visual vocabulary of tone that exists in the image and is created by the action of light alone, independent of the subject. You will also have a sound knowledge of how to create those tones at will with whatever technique you choose. Working with these

Tonerobics Exercises

Before you begin, go to www.georgede-wolfe.com and click on Teaching. You will see a link for Downloads and PDFs where you can access all the files you will need to perform the following exercises.

Exercise 1: Print out file 1 and cut the 255 patches into individual pieces with no border. Put them in a plastic garbage bag and shake vigorously. Arrange all the tones in the order in which they were first printed. Do not look at the original file or its printed version while doing the exercise. Stop after 30 – 45 minutes. The gaps in the grayscale are your weak points in perception.

Exercise 2: Open file 2 in Photoshop, an image of what is called the "fundamental error" in visual perception. Select the middle gray inside of the smaller square of either black and white larger square in the image. Using the Brightness/Contrast control in Photoshop (Image > Adjustments > Brightness/Contrast), adjust the Brightness control until the two grays match perceptually. The thing about the "fundamental error" in vision is not that it occurs, but how we find an effect that corrects it in a photograph. This is your introduction to finding the problem first, then correcting it.

Exercise 3: There are 8 exercise sets in Exercise 3. Work on each one separately. Using only the Curves tool (Image > Adjustments > Curves), correct the first image in each set (a) to match the second image in set (b).

Exercise 4: Open files 4a and 4b, called "George's Shot from Hell." Use any method at your disposal in Photoshop to match 4a to 4b. This one will take you a while.

Exercise 5: Download all the files in sets (a) and (b) for Exercise 5 and open them in Photoshop. Match the first to the second in each pair using only the Curves tool. This should help you with progressively harder articulation problems. This exercise shows you that the problem is a perceptual one, not a technical one.

"scales" and "arpeggios" is as necessary for mastering black-and-white printing as learning actual scales and arpeggios is to mastering music.

Dealing with the luminance image from the camera has caused the greatest among us to wring their hands in despair in both the traditional and digital darkroom. The great photographers have mastered the process and created masterpieces by turning the image into something that was seen and felt—luminosity, the perceptual image—rather than just the "babble of voices at a cocktail party," as Ed Land referred to it 30 years ago.

I've shown in Part I of this book that this "babble of voices" can be silenced and how the clear, still tones of the masterpiece can emerge. In Part II, I'll show you how to create a workflow to implement the ideas we've covered so far, and I will demonstrate the workflow I currently use for black-and-white printing.

Exercise 6: This is my edge detection exercise. Download and open file 6 in Photoshop. Increase the tonal value of each square until the tonal value indicates a just perceptible edge separation between the two. Now reverse the process.

Exercise 7: Open the files for sets (a) and (b) in Photoshop. Match the sharpness and blur of each image set using any method you choose.

Exercise 8: This exercise is about emotion scales. Tonal values can also represent emotions and feelings all by themselves without content. In Photoshop, open file 8, a simple grayscale, and try to adjust each tone in relationship to the others to represent anger, or joy, or happiness, or hope, or other human emotions. Only do one emotion per image. This is hard, but worthwhile. Seek expression until the scale is right. Don't look at the tones; feel them. This exercise is the basis for creative and expressive work in black-and-white photography.

Exercise 9: This exercise examines key value scales. What is your key value and how would you find it? One way might be to look at the histograms of 50 – 100 of your black-and-white images to get a rough idea of tonal distribution. Another might be to arrange the gray patches in Exercise 1 into scales that please you, and then try to emulate them. Lastly, and my favorite, is to find a master painter you like—not a photographer—and analyze their grayscales. Then, go out and try to duplicate that grayscale in your own work. This exercise will open the world of black-and-white expression to you.

Featured Artist: Huntington Witherill

Author's Note:
Huntington Witherill has been a friend and colleague of mine for many years. He is one of the best black-and-white printers in the United States and started digital printing around the same time I did, in the mid 1990s. His work has a clarity and dignity that only preeminent artists display. He is a true master.

Situated along the western edge of the city of Grand Junction, CO, the Colorado National Monument remains one of my favorite photographic haunts. Preserving one of the truly grand landscapes in the American West, the Colorado National Monument's sheer-walled canyons, towering monoliths and easily accessed viewpoints make it a photographer's paradise.

I made this photograph in 2005 using a Canon 20D camera fitted with a 24-105mm L-IS-USM lens. Using the lens at 24mm, the exposure was ISO 100 at f/8 with a shutter speed of 1/60 second. The shot was handheld, and the lens' image stabilization feature helped to secure a sharp image.

Despite the fact that it was never my intention to present this image in color, as it was envisioned as a black-and-white from the start, I always shoot my original images in color because of the increased control one can achieve through selective filtration of specific areas in the image when converting to black and white. Immediately prior to converting to black and white, I made several color adjustments in Photoshop to allow for the most advantageous conversion.

Once I had converted the image, I made use of the same three tools I always use in Photoshop for achieving selective tonal control and adjustment: the Curves tool (employed as a separate adjustment layer for each localized contrast adjustment), layer masks (to selectively separate out the portions of the image to receive the Curves adjustments), and the Graduated Fill tool (allowing me to quickly mask-out areas of the image where I do not want the specific adjustments to show). In this case, there were twenty-seven separate Curves adjustment layers introduced into the image, each with its own layer mask.

Once all of the tonal adjustments were completed, I flattened the image and copied the background layer. I then employed a noise reduction filter (Imagenomic's Noiseware Professional) on the copied background layer to reduce the overall noise present in the image, and I added a layer mask to control specifically where that noise reduction would be introduced (mostly in the sky and the deep shadow area in the lower-right).

Next, I used the Clone/Stamp tool to remove an out-of-focus tree branch present in the lower right of the original image. Then I flattened the layers again and created another copy of my new background layer. To this layer, I applied a small amount of high-pass sharpening, selectively introduced through yet another layer mask to prevent the sky from being sharpened. Finally, I flattened the image one last time and saved the finished file as a grayscale PSD file.

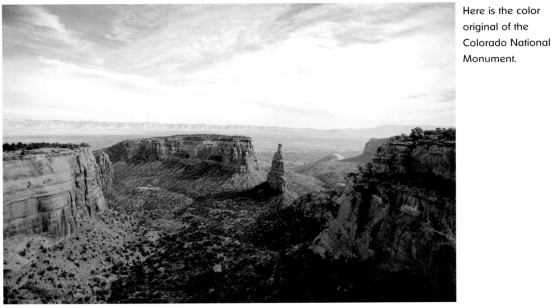

Here is the color original of the Colorado National Monument.

©Huntington Witherill

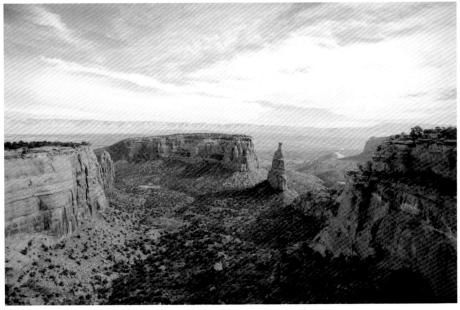

This is the black-and-white conversion of the original.

©Huntington Witherill

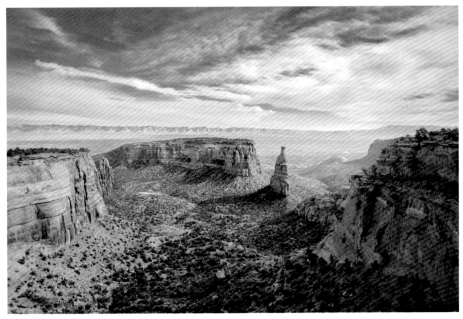

Here is the final rendition of the image.

©Huntington Witherill

Image Workflow

section 2

How to Create a Workflow

The term workflow has become a buzzword in the digital photographic community that has come to mean the process by which we edit and prepare an image for printing. There are as many kinds of workflows as there are photographers but, where printing is the final output, all of them have to take into account the qualities of the print. In black-and-white photography this means brightness, contrast, sharpness, edge, and defect control.

In science, a workflow is a series of linear steps that must be done in order to accomplish an experiment accurately, consistently, and, perhaps most importantly, to ensure its repeatability (verifiability). In the printing industry (from which I borrowed the term 14 years ago to apply to digital inkjet printing), a workflow means much the same as it does in science; it is a series of linear steps followed in order to produce excellent and consistent results.

What I see happening in many digital photography and printing workflows is disturbing to me. There is no rhyme or reason to the way they work. They start anywhere they want and jump from one tool or technique to the other seeking the perfect image. Anyone watching this performance (including the person doing it) cannot repeat it successfully, and the result is confusion, befuddlement, and dissatisfaction with digital photographic printing from inkjet printers. This "sandbox" workflow, as I call it, is the curse of Photoshop and Lightroom. It permeates the Photoshop education industry and creates nothing but confusion and misunderstanding (as well as bad prints). What makes this possible is that in Photoshop and Lightroom and other editing applications, you can start anywhere and go back to something you did previously and adjust it. My advice? Don't even go there.

Scientists, traditional photographers, and commercial print production folks need a linear workflow in order to produce excellence, consistency, and verifiability, but when artists hear the word "linear," they call "time out," or worse. The new term that has crept into the digital lexicon is "nonlinear" (aka the "sandbox") workflow. Start anywhere, do anything, then go back and fix it if you want to, without regard to the end result. While this is the way many artists want to work, the end result is often mediocre in quality, non-repeatable, and inconsistent. Few will follow these long and complicated routines in Photoshop except the artists themselves plying their own secret sauce. I once saw a 14 step sharpening technique demonstrated with Photoshop. Why?

If you watch a real artist, they all have a workflow, however weird looking, and it is repeatable, consistent, and produces excellent results. The quality that sets a real artist apart, however, is that their workflow incorporates their vision and intuitive sense to such a profound degree that the vision is not verifiable, not repeatable by anyone else. Authentic vision is the quality that separates these artists from the purely mechanical step-by-step linear workflow that scientists and commercial printers use. A real artist moves in a forward direction in a piece of work, even if it forces a return to previous steps to fine-tune a masterpiece. The difference in this case, though, is that returning to previous steps is a linear progression, not a nonlinear one, and is incorporated as part of the workflow every time.

The workflow I present in this book is a guide. Let me repeat that: **The workflow I present in this book is a guide.** It is mostly linear, but includes returns to previous aspects of editing as part of the workflow. These "returns" are sequential, because the iteration (back and forth interruption) necessary to produce a masterpiece requires that we make fine corrections, especially in slight overall and fine adjustments at the printing level. This is an artist's workflow, one that is predominantly linear in nature, but that also allows for the authentic abilities and peculiarities of the artist necessary for the creation of a black-and-white masterpiece.

This is a place to begin thinking about the type of workflow you might make for yourself. I have included the photographs of some of the best printers in America at the end of each chapter, illustrating the different workflows they employ. I think you'll find these highly interesting as well as fun.

chapter|three

A closed loop workflow means you do everything yourself. With rare exceptions, the difference between an artist and a plain photographer is that an artist makes the prints themselves and is hands-on involved with every aspect of the process, from image capture to finishing. A photographer may take the picture, then delegates other duties to assistants or service bureaus. The difference here is critical to understand. My experience with the history of photography shows that the very best prints were made by the artists themselves, not an assistant or anyone else. These people, like Edward and Brett Weston, Ansel Adams, Oliver Gagliani, Paul Caponigro, W. Eugene Smith, and many others are artists in the true sense of the word. All made their own prints. A masterpiece is a creation of the individual artist's authentic genius. No one can match the quality of a print produced by the artist who took the picture. Once the learning curve is passed, you'll find that a closed loop workflow is the only path for creating a masterpiece.

Certainly, there are exceptions to the closed loop workflow. I bend this rule in some areas, most notably scanning negatives and some production framing for shows. There is no question that a drum scan from a service bureau is superior to a scan we can make using a dedicated film scanner or a flatbed. If the quality of extremely large size demands it, I'll have a drum scan made of a negative. Otherwise, I'll stick with the excellent Epson V750 scanner (available from www.epson.com) or the Microtek M1 combination flatbed and film scanner. I also might bow to my professional local framer, whose trust is beyond reproach, because the time constraints involved for me to undertake this enormously time consuming process myself are easily circumvented by her successful handling of the framing once the crucial design stage for the work has passed.

A third exception is profile making. Making your own profiles is very expensive, time consuming, and difficult. I prefer, after having tried to make my own, to get one made by a professional who does it every day, or use the nearly perfect profiles made for the ColorByte ImagePrint RIP software (to my mind, the best in the business).

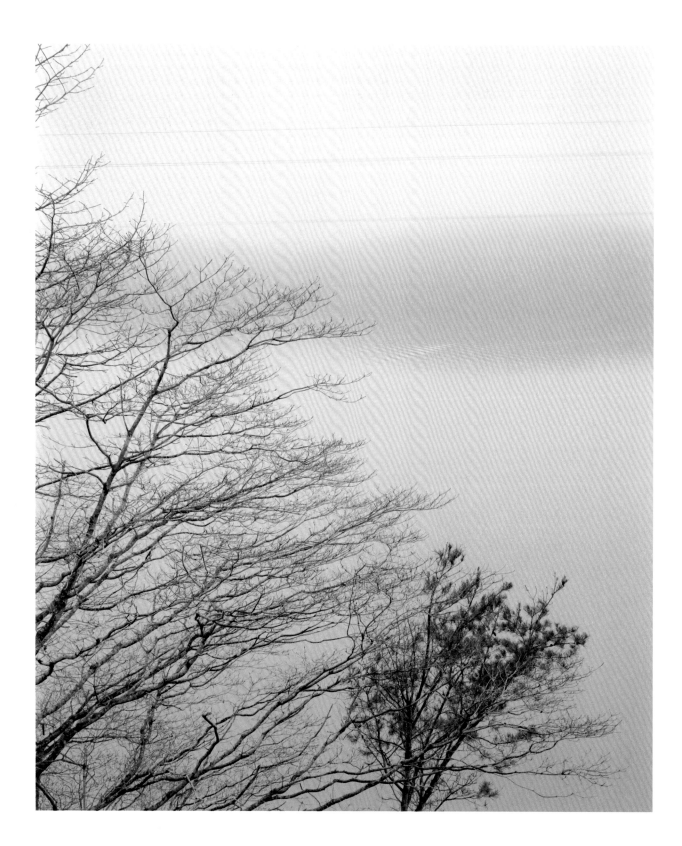

How to Design a Workflow

In designing a workflow that will work best with your artistic process, consider the following:

- What is the end result? What do you want to accomplish?

- What are the essential features of the final result?

- How can those features be controlled? What technology is available to accomplish this?

- What is the easiest and most efficient way to control the features without sacrificing the quality of the end result? What works well and what doesn't?

- Which features affect others? Which feature adjustment methods affect others? (Once identified, these should be put first in the workflow.)

- Design a framework for the workflow around the features and test it.

- Continue to change methods as technology changes without redesigning the basic concept of which features need to be addressed when; simply adjust the way you manipulate them with any new tools made available to you.

- Refine your process.

Standards

Base your end result on a standard, or make one up. I used the photographs of Ansel Adams, Edward Weston, and Gene Smith as my standards to print from when I first started in photography. Now I use the black-and-white conversions of the great master painters. You need to find your own standard. Here's a hint: Pick a master in the field—not just some geeky bozo who knows Photoshop really well but can't photograph their way out of a paper bag. Learn only from the best.

Workflow Design Tip

With respect to linearity, the major steps in your workflow should be:

- Global adjustments
- Broad adjustments
- Local Adjustments

...in that order. Overall global adjustments must be made first because they influence broad adjustments, which in turn affect local adjustments. Individual techniques reside within these three categories. Remember: global first, broad second, local last.

Tasks

Designing tasks and skills for each feature of your final output is the heart of any work-flow. For instance, I needed to find a way in Photoshop to solve Edwin Land's challenge of separating the illuminance image from the reflection image (see page 21). Since I understood what happens in the human eye and brain when processing the percept, I was able to first invent a crude workaround, and later I developed the PercepTool plugin for Photoshop that accomplished the algorithm better (see page 57). Similarly, I worked in the early years of digital photography to mimic the Zone System of traditional black-and-white photography. I developed a mask system that was included in the "Tips and Tricks from the Experts" section of the first Adobe Photoshop CS. It was eventually developed into a plugin called Optipix.

LightZone is a Photoshop plugin that accomplishes a similar purpose in a different way, as does HDR processing in Photoshop. Clyde Butcher is a classic example of this way of working. Clyde develops procedures for making inkjet prints from Photoshop that mimic with amazing exactness all of the tools he used in the wet darkroom. The results are masterpieces, to be sure. Most of these techniques are of his own invention. They were made in response to a problem that needed to be solved in his workflow (although Clyde shuns that term). My friend Dana Strout, one of the best black-and-white printers in the country, once said to me, "The light simply must come out of the print." He has the standard for that somewhere in his head. Dana uses only Levels and Curves in Photoshop to accomplish "getting the light out of the print." His workflow is simple, direct, and efficient.

Conditions

Constraining each task to a condition is, perhaps, the hardest part of the workflow to determine. Most of the time, a condition's job is to limit the number of steps in the task to the least number possible, preferably not more than two or three. I once sat next to a very experienced photographer at a seminar at the PhotoPlus show in New York. He was working on an image in Photoshop on his laptop. There were 120 layers on his photograph. I leaned over to him and said, "I can teach you how to do that in four layers." He said it changed his life. Creating constraining conditions is the efficiency part of building a task. My favorite example is this:

Task:
Hammer a nail into a board.

Condition:
Do it in two hammer blows.

Standard:
The nail head is flush with the surface with no ding marks on the wood.

If you put a little thought into how you want your photograph to look, you can design a workflow around that goal with tasks and techniques that are self-invented or borrowed and revised. Every technique that you see out there in the vast Photoshop world was someone's response to a problem in workflow.

Applications

The workflow for this book uses two image-processing software applications: Photoshop and Lightroom. However, there is no reason why you could not use Aperture, Nikon Capture NX, Photoshop Elements, Paint Shop Pro, Capture One, Bibble, Painter, LightZone, Iris, iPhoto, or any other program used for image processing. The reason I choose Photoshop and Lightroom is twofold: Firstly, Photoshop is the standard image-processing software of the world; secondly, Lightroom is the easiest, most convenient, and fastest processing, editing, and photo workflow software ever made. Used together, with as simple tools as possible, these two applications offer us the ability to make a black-and-white masterpiece less labyrinthine in nature. I use very few third-party plugins with Photoshop, but the ones I do use really make a difference in the final result.

Black-and-White Workflow Overview

Here is a typical black-and-white workflow using Photoshop and Lightroom:

- **Inputting Images**: Since the Lightroom workflow was invented specifically to archive and store images, we will be using it instead of Photoshop Bridge as a storage place for images, as well as using its interface to put all images into the computer (though using Bridge is an option, if you prefer).

- **Global Image Adjustments:** Make all global image adjustments in Lightroom rather than Adobe Camera Raw or Photoshop. Global adjustments include contrast, brightness, grayscale conversion, pre-sharpening, and others.

- **Broad and Local Adjustments:** Broad adjustments are made to particular areas in the image, such as uneven or bright edges, that need to be corrected so that the image looks "balanced." Lightroom now includes both the ability to apply broad adjustments with the Gradient Filter and local adjustments via the Adjustment Brush in the Develop module.

Keeping it Simple

This book is not about Lightroom and it is not about Photoshop, therefore I have not included many intrinsic software details that some photographers might consider important or even critical. This book is about the process of creating a masterpiece, and I believe in simple workflows, not complicated ones. I use Lightroom and Photoshop, but I could have used Aperture, Nikon Capture NX2, or Painter, and I may yet! If you want the whole story on Lightroom, I heartily recommend Martin Evening's book, The Adobe Photoshop Lightroom 2 Book, published by Adobe Press. Martin is thorough. He tells you everything you want to know about the inner workings of Lightroom.

I have also included third-party software plugins as part of the workflow outlined here, namely Noise Ninja and PercepTool. Neither one is necessary to make a masterpiece; they just make the workflow significantly easier and more veridical. Noise Ninja is from Picture Code and PercepTool is my own creation. You can download PercepTool from my website, if you wish. It is only $19.95, but it will change the way you photograph and process your images.

• **Noise Removal and Optimization:**
After making adjustments in Lightroom, open the image in Photoshop. Noise removal is best accomplished with a third-party Photoshop plugin, such as Noise Ninja, NeatImage, NoiseWare Professional, or others. The reason for using a third party plugin for noise removal is that, to me, both Lightroom and Photoshop do an unsatisfactory or clunky job of noise removal. The third party software is much, much better. After noise removal, perform image optimization with the PercepTool (available on my website, www.georgedewolfe.com). Optimization using the PercepTool accomplishes what has heretofore been extremely hard to do in either traditional or digital photography: It transforms the captured luminance image into the luminosity image that we saw.

• **Fine Tuning and Cleanup:** I usually find after using the PercepTool that the image needs fine tuning in local areas and may need improvement in grayscale separation. For this purpose, I use the History Brush and Gradient Map tools in Photoshop. I also use the History Brush to do local softening and sharpening of edges in this step. Most digital files can then be cleaned up by removing spots and dust with the Clone tool and the Spot Healing Brush.

• **Printing:** To print your image, reopen it in Lightroom and print from the Print module.

Note:

Updates to this workflow will be periodically posted on my website (www.georgedewolfe.com) as the need arises.

Featured Artist: Lydia Goetze

This Bengali woman lives a few feet above the monsoon waters of coastal Bangladesh. To help her family, she secured a small loan to buy a dozen chicks. As her flock grew, she sold eggs and chickens in her village, paid off her loan, and saved enough to buy her family a milk cow. Her children now eat much better and are able to go to school.

"Bengali Woman" Workflow:

1. I scanned the original 35mm color transparency at 4800 ppi and saved it as a TIFF file.

2. Then, I imported the file into Lightroom.

3. I converted the image to grayscale, setting the white and black points with the Exposure and Blacks sliders.

4. I slightly increased contrast with the Clarity slider (for midtones).

5. To remove the color noise, I used the slider in the Detail panel.

6. I then cropped the image to remove the edges of the slide.

7. After making the necessary adjustments in Lightroom, I exported the file to Photoshop.

8. I made a copy of the background layer to work from.

9. Using the History Brush, I slightly darkened the bottom of the image.

10. I then used the Clone/Stamp tool and the Spot Healing Brush to clean the image up. (I removed the light bulb and some distracting white glints on the right of the image, as well as slightly enhancing highlights in her eyes.)

11. Next, I flattened the image and converted it to 32 bits.

12. Using the PercepTool, I enhanced the whole image, reconverted to 16 bits, and saved the image.

13. In Photoshop, I then set the desired image size and sharpened with Filter > Sharpen > Unsharp Mask.

14. After saving my final image, I printed using ColorByte ImagePrint software.

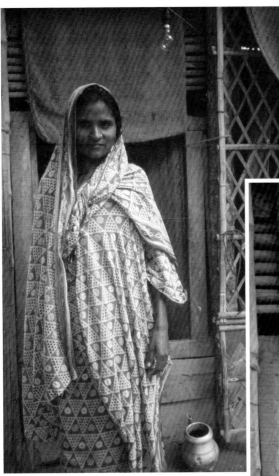

Here is the original color slide of the image.
© Lydia Goetze

Author's Note: When you see this photograph up close and personal, it is stunning in its beauty and presence. It is Strand-like in quality, but goes beyond that to another dimension, offering a mysterious and graceful glance at a young woman. It is a masterpiece beyond many photographers comprehension.

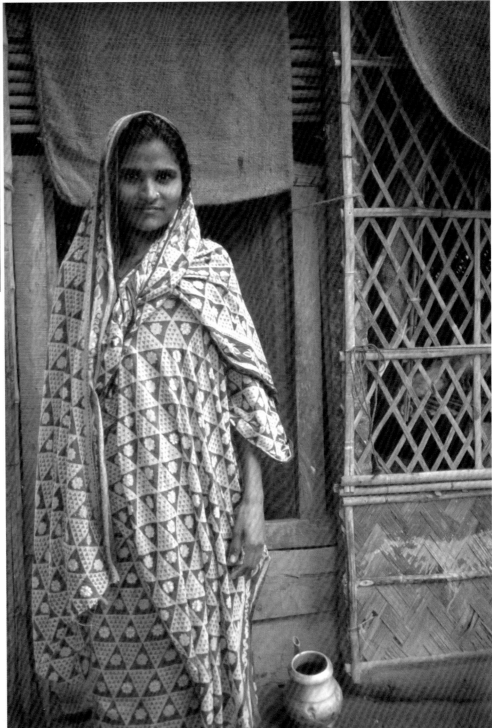

This is the final black-and-white image after adjustments were made in Lightroom and Photoshop. © Lydia Goetze

chapter|four

In this section, we will limit our discussion of the Lightroom and Photoshop software programs to the operations needed to produce black-and-white prints of very high quality and consistency. We will use only three of Lightroom's modules: Library, Develop, and Print. In Photoshop, we will make a specific selection under the Preferences option.

Customizing Lightroom Modules

One of the great features of Lightroom is the customizable side panel. Each module has two panels on either side of the main viewing window and a toolbar below the window, all of which can be customized to fit your needs and make them easier to work with. What this means in this case is that we can get rid of many of the tabs on the panels that we don't specifically need to make a black-and-white masterpiece. Remember that a master artist uses simple tools, not complicated ones. To add or remove a tab, right click (or for Mac, hold the Control button and click) on the tab you want to hide and uncheck it in the popup that follows. To return tabs to the Panel, recheck them.

To remove items in the toolbar, click on the down arrow at the end of the toolbar and uncheck any items you don't need. To return items to the toolbar, click on the down arrow and recheck the items you wish to reactivate. Notice that the Print toolbar cannot be changed in Lightroom 2. In the other modules, I've eliminated everything that isn't absolutely necessary to the black-and-white printing workflow.

Here are figures illustrating the three panels we'll be using. In each, I have removed any unnecessary tabs to facilitate a simpler workflow.

Photoshop Preferences

To change your Photoshop preferences, go to Photoshop > Preferences, where we'll change only one thing: the number of History States. Once you have accessed the Preferences window, choose the Performance panel. The default number of History States is 20; change it to 40 and close the Preferences window.

To change the number of History States, go to Photoshop > Preferences > Performance.

Change the History States drop down menu selection to 40.

Palettes

I like to work from palettes in Photoshop rather than the menu bar, and there are really only four palettes you need to accomplish most of the tasks of making a fine black-and-white image. Those palettes are History, Layers, Actions, and Brushes. To set up the palettes we'll use in the workflow, first make sure that all palettes in the dock or on the desktop are put away and closed so that none of them show anywhere. To close all of the palettes, click the red dot in the top left corner of each palette.

Next, go to Window in the Menu bar and open the Layers, Brushes, Actions, and History palettes by checking them one by one. Drag them to the extreme right into the dock. A light blue vertical line will show up along the right edge to indicate the dock; drop the palettes when this blue line appears. To close palettes from the dock, click once on the palette name and once again to close. Click the middle gray bar to collapse and click the upper dark gray bar to make it into an icon.

To open palettes from the main menu bar, click on Window and select each palette you'd like to open.

When docking the palettes, a blue vertical line will appear on the right side of the screen to indicate the dock. Drag the palettes until you see this blue line, then drop them.

Left
Bracket Key
[

Right
Bracket Key
]

The left bracket key reduces brush size and the right bracket key enlarges it.

Brush Size Shortcuts

If you use a Wacom Tablet or Cintiq, which I highly recommend, you can program the left and right bracket keystrokes with the Wacom Pen tool so that the process of increasing the or decreasing the brush size becomes even easier. This can be done by changing the vertical clicker on the pen itself. To do this, go into the Wacom Preference panel (at the bottom of the System Preferences window) and change the top side of the clicker to the right bracket key (you need to scroll down to Keystroke on the clicker popup) and the bottom part of the clicker to left bracket key. The brush size will then be controlled from the pen and not the keystrokes themselves. It saves hours of time and frustration and allows you to act more like a painter.

Setting Up the Brushes Palette

The workflow for the black-and-white master print requires only two brushes—one soft and one hard. By eliminating all the brushes except these two, you can save yourself much misery and headache. What do you do about size? Use the right bracket key] on the keyboard to increase size and the left bracket key [to decrease size.

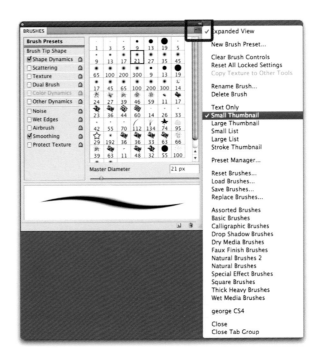

1. Open the Brushes palette and select the History Brush from the Photoshop CS4 Toolbox to activate the brushes in the palette.

2. Click the three horizontal lines in the upper-right corner of the Brushes palette and choose Small Thumbnail.

3. In the main Brush window, place your cursor in the top left brush box (Hard Round 1 pixel brush). Hold down the Option/Alt key and the cursor changes into a little pair of scissors.

4. Click and Hard Round 1 pixel brush disappears. Keep clicking in the same place until you get to the Hard Round 19 pixel Brush. Go to the next brush to the right of 19 and start clicking again until you get to the Soft Round 21 pixel brush. Go to the brush to the right of 21 and click until all the other brushes are gone. Only Hard Round 19 and Soft Round 21 should remain.

5. Double click on Other Dynamics on the left side of the Brushes palette. In the window that appears, set the Opacity Jitter Control to Pen Pressure. Click once on the Brush Presets in the upper left of the palette and this will return you to the regular Brush window.

6. Click the three horizontal lines in the upper-right corner and choose Save Brushes. Type "B&W Printing" (or whatever you want) in the Save dialog box and click Save. You have now set up your two Photoshop brushes for all the work you'll do for this workflow. Dock the Brushes palette with the Layers and History palettes.

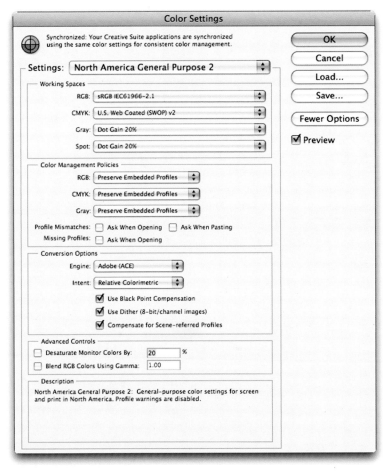

Here are the default Photoshop color settings.

These are the Photoshop color settings adjusted for
black-and-white printing in conjunction with Lightroom.

Color Settings

Since Photoshop and Lightroom must work together as
seamlessly as possible, the color settings in Photoshop
must be adjusted accordingly. The default color space of
Lightroom is ProPhoto RGB, so we'll want to set the
Photoshop color settings to match. To do this, select Edit >
Color Settings from the Photoshop menu bar. Change
sRGB to ProPhoto RGB and Dot Gain 20% to Gray
Gamma 2.2 in the Working Spaces box. In the Color
Management Policies box, use Preserve Embedded Profiles
and check all the Color Management Policies checkboxes
for Profile Mismatches and Missing Profiles. Use
Perceptual Rendering Intent instead of Relative
Colorimetric Rendering Intent. Checking these boxes
allows you the most control over how you let images enter
Photoshop. Save these settings by clicking Save, name
your saved selections (i.e., "B&W Printing"), and click
Save, then OK in the next window.

Customizing and Saving the Workspace

In Photoshop, there are many ways to customize palettes, keyboard shortcuts, and menu items. These settings can be very personal in nature. The adjustments made here reflect how I personally use Lightroom and Photoshop for black-and-white printmaking. Feel free to add or subtract to these controls as needed to fit your own particular workflow.

1. On the options bar (which is right underneath the main menu bar in Photoshop), go to the extreme right end and you will see the Workspace drop-down menu. Scroll down to Save Workspace.

Essentials
Basic
What's New in CS4

Advanced 3D
Analysis
Automation
Color and Tone
Painting
Proofing
Typography
Video
Web

Save Workspace...

Save Workspace

Name: B&W Printing

Save

Cancel

Capture
☑ Panel Locations
☑ Keyboard Shortcuts
☑ Menus

2. In the window that opens, check the boxes for all three spaces: Palette Locations, Keyboard Shortcuts, and Menus. Type your name in the space provided and click Save.

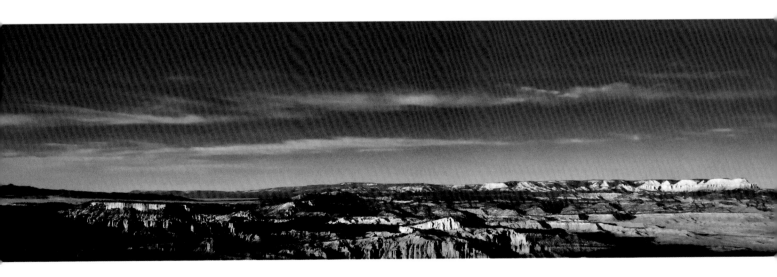

Featured Artist: Rob Lester

Rob's Image of the Berlin Wall made in the early 1960s is a master example of how to manipulate tonal values to create mood—in this case, a very lonely and sinister one. Rob scanned his Rolleiflex 120 Kodak Panatomic-X negative on the Epson V750 Pro scanner at 4800 ppi 1:1, with no adjustments in the scanning process. He then imported the image into Lightroom.

For global adjustments, Rob made simple manipulations to the Basic sliders in the Develop module so that no clipping occurred. He then worked with the four sliders of the Detail tab, using photographer Martin Evening's instructions for sharpening (available on the Internet), after which he exported the image to Photoshop.

In Photoshop, Rob first balanced the image with the Gradient tool, applying a Black Soft Light Gradient to the lower two thirds of the image. The foreground wall was erased at 100% opacity to let the distant areas provide atmospheric depth. He applied a White Gradient to the upper third of image. He then faded this gradient (Edit > Fade) and retouched with the Eraser tool to achieve varying degrees of opacity in the foreground and background. Rob prints with the Media Street GQ2 ink set and Royal Renaissance paper—two very fine products.

"I created local adjustments utilizing the History Brush with Multiply, Color Burn, Screen, and Color Dodge modes and very low opacity settings. I also did work on the buildings to separate planes with additional contrast and value changes. I enhanced building edges and the "dinosaur teeth" (tank traps). I used Color Dodge on the foreground to slightly lighten the reflected sky in the puddles. I blended the stress lines visible in parts of the sky using the Spot Healing Brush.

A personal note on cleanup: I do spotting with the Healing Brush and the Stamp Tool at different times during the workflow. I often use cleanup as an opportunity to peruse my effort on the image close up, looking for potential problems. I always complete lens and distortion corrections using the Transform Command, and I use Scale, Warp, Distort, and Skew to correct these kinds of flaws prior to any image size or cropping changes. If you crop an image before you correct distortions, you may be left with parts of the image you wanted to keep being cropped out."

Here is the original image of the Berlin Wall. © Rob Lester

This is the final image after Rob applied his Lightroom and Photoshop black-and-white imaging workflow. © Rob Lester

Inputting Images

chapter | five

Most photographers are, by now, familiar with shooting in RAW format with a DSLR (digital single lens reflex) camera, and I will not be covering RAW file basics here. (If you do want to learn more about RAW files and processing them, check out another Lark Books publication called RAW Pipeline, by Ted Dillard.) What I do want to discuss is getting your images safely into Lightroom and storing them there rather than using Adobe Photoshop Bridge. (You could also use Bridge, but I prefer to use Lightroom because it is made especially for this purpose.)

Our image input workflow begins in Lightroom, which performs global image adjustments nondestructively (i.e., the original image is left untouched and adjustments are made by a set of coded instructions). We then continue in Lightroom with broad and local image adjustments before exporting the image to Photoshop to perform noise reduction, optimization, and some fine-tuning. After that, we return to Lightroom for printing. (Refer to the last chapter for details on this basic workflow.) While it seems that everything I discuss could be done in Photoshop, believe it or not, the workflow from Lightroom to Photoshop and back makes the printing and final iteration process much easier and faster.

Lightroom and Adobe Camera Raw share the same image-processing engine. You can see this when comparing the programs' various controls. They appear very similar to one another in their interfaces. However, I prefer the Lightroom interface to the Photoshop one. It's just easier to use. That's why I use it in the workflow I'm presenting to you here in this book. Note that if you want to view Lightroom settings in Camera Raw (or vice-versa) or share them between the two applications, you must first set the Preferences of both Lightroom and Camera Raw to read Sidecar XMP files.

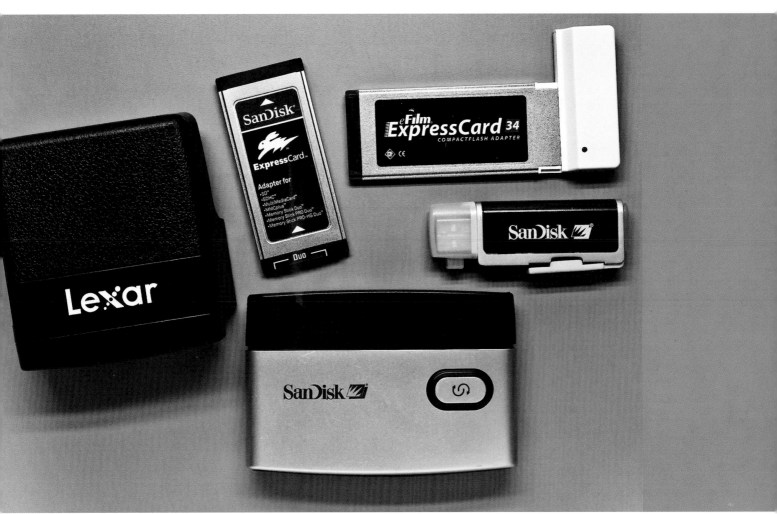

Use a card reader or a PCMCIA card adapter to transfer your images to your computer rather that plugging the camera in directly to the USB port or allowing imaging software to import them.

From Camera to Computer

After long and hard experience, this is the way I transfer my images to a computer. It is safe and foolproof. Transfer your files using a FireWire or USB card reader, or a PCMCIA card adapter. The other ways, such as downloading directly from a camera to the computer with a USB cable or letting Lightroom, iPhoto, or My Pictures import them from the camera are simply not as safe and foolproof. Your images could be damaged, destroyed, or lost. Remote capture with software for client use during shoots is also problematic for the same reason. To avoid problems, use the following steps when downloading your images to a computer.

1. Plug your card reader into the computer and insert the memory card into the correct slot. If you are using a PCMCIA card adapter, most instructions say to insert the card before inserting the adapter into the PCMCIA slot on your laptop. An icon (such as the one above) will show up on your desktop on a Mac and on the My Computer interface in Windows.

2. Double-click on the icon and navigate through the basic organizational folders until you find the files themselves.

3. Create a new folder on your desktop and label it using whatever naming convention works best for you, such as the date or the name of the location or event where the images were taken.

5. Physically drag all of the files to the folder on your desktop and wait until the transfer is complete.

6. Immediately create a backup of this folder of images to an external hard drive or a CD, DVD, or Blu-ray disk.

7. Drag the folder on your desktop to the appropriate folder on your computer where you keep your image files. I have a folder entitled "Working" that I keep on the main computer hard drive. I then place new folders of images inside the "Working" folder and put an alias of it in the dock on my Mac. Windows has a similar capability.

4. Click once in the window that holds all the files and type Command A on the Mac or Control A in Windows to select all of the files.

Transferring Files into Lightroom

Open Lightroom by double clicking on the LR icon. In the upper right, there are five module choices. Click on the Library module, then follow these steps:

1. Click the Import button in the lower left of the screen. This will allow you to import the folder with photographs directly from your desktop, or any other place on your hard drive. Lightroom can keep the photos in the same folder with the same name, leaving the originals where they are.

2. Choose "Add photos to catalog without moving" from the File Handling drop down menu and click Import. This is the import method I use 98% of the time.

3. You can toggle back and forth between grid (thumbnail) and loupe (larger single image) views using the two icons at the lower left of the viewing area. You can also double click on an image to enlarge or reduce it.

4. To view your image set without the information panels, click on the small arrows at the very left- and right-most edges of the screen, centered vertically. You can also press the Shift and Tab keys to toggle back and forth between viewing the image set with and without the information panels. You can enlarge the thumbnails using the Thumbnails slider at the bottom of the central viewing area.

5. To make a collection of a few images to work on further, in Grid mode, click when the cursor is over an image and a small circle appears. The images you select will be placed under Quick Collection in the Catalog tab on the left pane of the Library module. You can also select a number of images and type the B Key to enter them into the Quick Collection.

6. When you have selected a group of images in the Quick Collection, choose File > Save Quick Collection (or Option/Alt + Command/Control + B). Give it a name and check Clear Quick Collection after saving. The folder with the images is now saved under the Collections tab on the left Library panel.

7. To work on a photo, click on it once to select it.

The Simple Way

The Quick Collection is a very simple way of sorting and archiving images, and there is a really interesting story behind it. I was asked personally by George Jardine at Adobe several years ago to be on a new Adobe product development team to make software especially for photographers—Adobe Lightroom. I asked him why he wanted me, thinking of all the people other than myself who were qualified to be one of the original 15 photographer members of the team. (The other 35 members were engineers.) George said, "You are the simple guy." I replied that there might be trouble with some of the other more complicated members of the team, but he said that he needed a "simple guy" in the mix to use Occam's Razor when necessary. I agreed, and the fracas commenced.

I won some and lost some debates in the development of the Develop and Print modules. The other modules I didn't touch with a 10-foot pole... with one exception: the Library module. The archiving and sorting in the Library module is a jungle of metadata, keywords, witchcraft, and wishful thinking, not to mention top-of-the-line engineering. The word "library" is the key here. Metadata was invented by librarians to catalog books, which is a great thing, I suppose, but I am not a librarian and I don't want to be. I am a photographer.

The single greatest problem with storing and archiving images is finding the one you want when you want it. The problem with the current metadata system used in Lightroom is that, in order to find an image, you have to either know where it is or keyword it. In other words, you have to sit down and type in the name of every single image you take. If you consider the time it takes to do this, you'll probably never want to start down that road. It is the single roadblock (read "pig sitting in the middle of the road") to sorting and archiving photographs. Until it is solved—and it is a manifestly difficult problem to solve—we need to resort to other nefarious means of cataloging. The Quick Collection is one such way. It is the one time I made a foray into the Library module development debate, and I needed to put my chainmail on before I entered.

Adobe, realizing that a simple method was as valuable as the complicated one, made a workflow for saving to the Quick Collection using the B Key (or the little round circle on each image in the upper right of the thumbnail), and then saving to a folder in the Collections tab with a name that you could find easily. It is a nearly perfect, simple solution to sorting and archiving images. The problem of naming every file quickly is still a phantom issue out there to solve in the future, but it will be solved. Until then, for those of us who like simple solutions to complex problems, the workflow I've given in this book is the best we can do. (I donated my chainmail to the Smithsonian.)

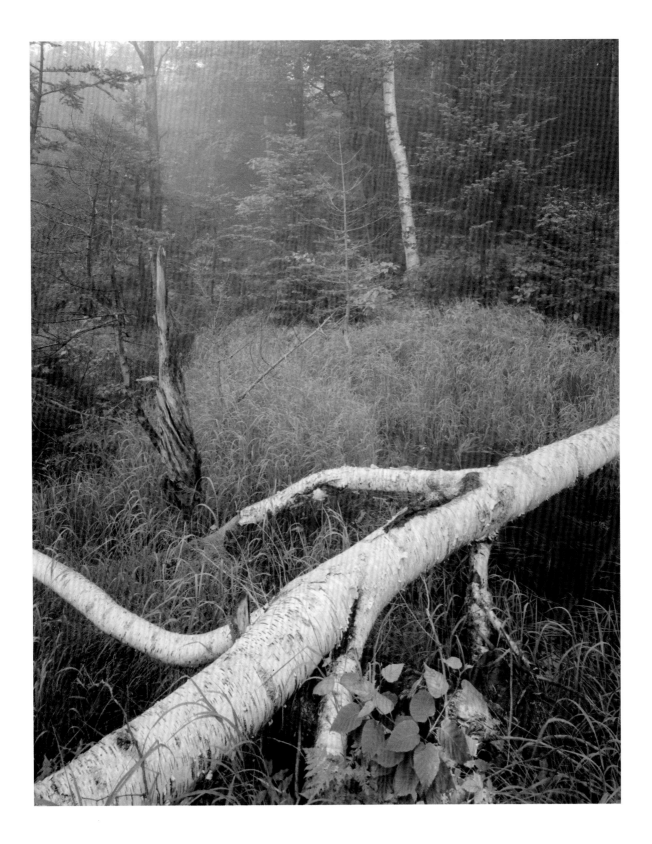

Finding Your Masterpiece

A masterpiece comes from somewhere down deep inside and is the result of years of searching and practice in photography. When I go out to photograph, I am always trying to create a masterpiece. I am constantly looking for images that reflect my feeling about the world. Mostly, I'm looking for the mysteries inherent in the reality before me. The subject of mystery in an image is another interesting discussion, perhaps the topic of another book (and the major topic of my Contemplative Photography Workshops), but suffice it to say that mysteries are all I really look for anymore. It's more about feeling than seeing, and it comes from intuition and experience.

I practice mindfulness when I am photographing. Mindfulness is an ancient skill that allows you to be present here and now in the moment, the place where the image will be. It allows my mind to be calm and my awareness to be open and empty to anything. This practice helps me see things fully, both the things we can see and sense—the mysteries. My belief is that if I can see and feel the image at the same time, there is a good chance that something really good is there and that a photograph should be made. The moment I look through the viewfinder, I know if the picture is a masterpiece or not. It's as simple as that. A masterpiece is not something you create in Photoshop unless you are a compositor and a montage photographer. At its root, a masterpiece is a simple act of responding authentically to the world in a moment of time. I only manipulate my images in Lightroom and Photoshop to transform what the camera captured into what I actually saw and felt. Who decides whether a photograph is a masterpiece or not? The photographer who made the picture does. Don't pay any attention to the critics, not even to ignore them.

The workflow I present in this book is about manipulating a black-and-white image to bring out its presence, one of the major characteristics of a masterpiece. It's about learning to see the qualities that can create presence and enhance it. It's about making something great and beautiful, and it's my way of authentically expressing what I feel about the world. In the next chapter, we will delve into the Develop module, where the real work begins.

```
If you gain something,

It was there from the beginning.

If you lose something,

It is hidden nearby.

- Ryokan, an ancient Zen master -
```

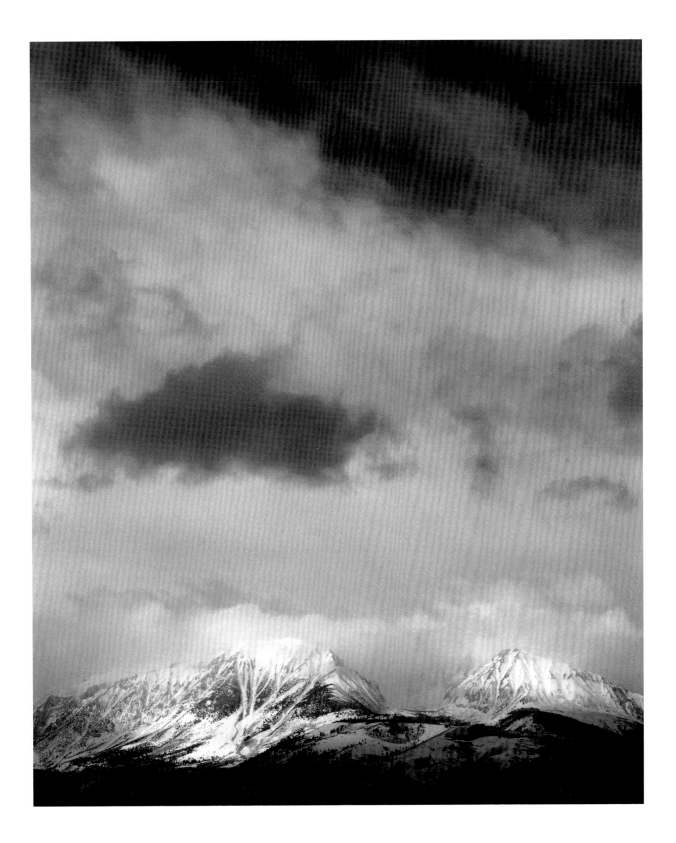

Featured Artist: Dana Strout

The original image was scanned by my wife on her Microtek Artixscan 1800 at 600 dpi in a glass carrier. Then, I saved it on a disk and opened it up in Photoshop, converting the grayscale image from 8 bits to 16 bits. The scan had a bit of a black border so I rotated the image half a degree counterclockwise to square it up. Using the Marque Tool, I cropped out the black edge. I then made a copy of the image and saved it as a new file.

The next step I took was Levels adjustment. I moved the black slider to the edge of the histogram then did the same with the white slider. Now the image parameters were essentially set. Next, I moved the center slider back and forth until I liked the sense of the image. Then I used the Rubber Stamp tool to spot the image and clean it up.

After that, I went into Curves and made two adjustments. I was looking for a sense of light coming out of the image, so I tied down the low end with a point on the curve and adjusted the remainder of the curve up just a little. The image looked basically like I wanted it to at that time, but the door was a little dark. So, I made a copy of the image layer and, using the Magic Wand tool, I clicked on the dark part of the door to select it. I opened up Levels and moved the center slider in until the door had the right density.

The original platinum image had no dodging and burning, not even edge burning. The image was technically simple to print, but very hard to get the sense of light I was looking for. With Photoshop, I did exactly what I did in platinum printing; I made print after print until I got one I liked. In my opinion, I don't care what they say about the magic of "what you see is what you get"; until you get the print in your hand and it dries, you don't know what you will get. So, I just print until it's right.

Author's Note:

Dana's photograph is one of my favorite masterpieces. It is part of his Greek Portfolio, a handsomely crafted and bound limited edition. I was standing next to Dana when Paul Caponigro pronounced this print, "Exquisite!"

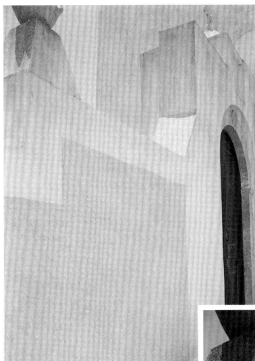

This is the original image.
© Dana Strout

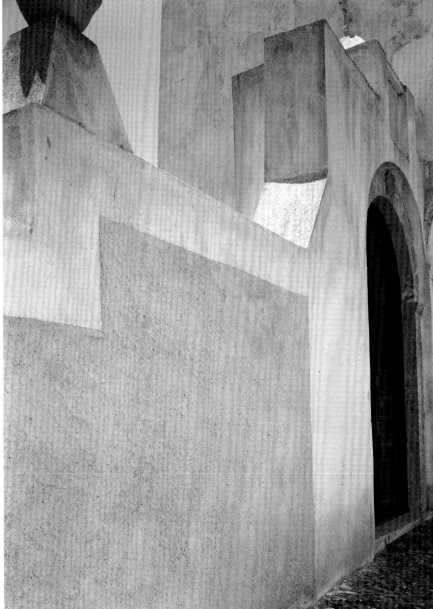

Here is the final adjusted image. © Dana Strout

chapter|six

The ideal progression of an image-processing workflow is to accomplish global adjustments first, broad adjustments second, and local adjustments last. Even though in Lightroom we can seemingly start anywhere, the reason for sticking to this order of events is that if we apply local edits first, those areas of local adjustment will get fouled up and accentuated to unacceptable degrees by the overall global enhancements. The workflow process from global to broad to local has been worked out in agony by the blood of many photographers. The differences in our individual workflows are in the details.

The black-and-white master print workflow detailed in this book is designed to produce the highest possible quality black-and-white prints with consistency. The workflow is a sound one, and has the ability to help you achieve a masterpiece if your photographic vision is up to the task. A photographer's artistic vision is absolutely the most important aspect of image making; the difficulty of the technical aspects of image making pale in comparison. Quite simply, if you can't see what to adjust, you can't fix it. Let's explore this further by looking at a photograph in the Lightroom Develop module. See first, then use the sliders.

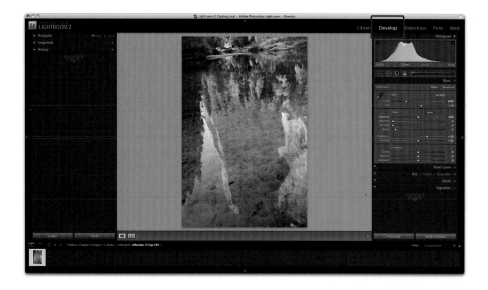

Preparing the Image for Evaluation

1. Open an image in Lightroom and click on the Develop module tab in the upper right of screen. The image should be displayed as full frame.

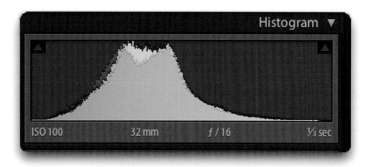

2. If the histogram is not visible in the upper right corner of the page, click on the arrow to the right of the word Histogram to make it appear. The histogram is a graph of the relative amount of shadow (left), midtone (center), and highlight values (right) in your image. We can use the histogram in conjunction with the image itself to diagnose global image problems.

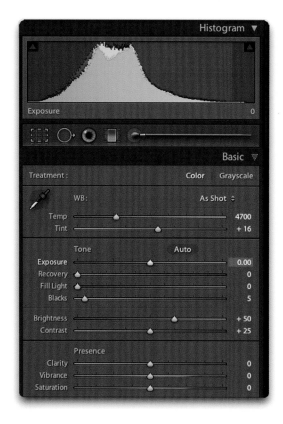

3. To access the Basic options for the Develop module, click on the arrow located in the Basic tab.

4. Under the Basic tab, click on Grayscale. This turns the image into black and white.

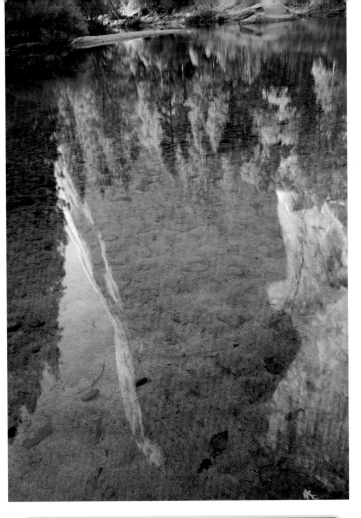

The Histogram and the Basic Tab

The first thing to notice is the overall brightness and contrast of the image. Examine both the image and the histogram when making this observation. The goal in correcting the brightness and contrast first is to give us a baseline of what the image is going to look like.

In the image at right of El Capitan reflected in the Merced River, the histogram shows a normal exposure with no clipping at either end. It looks rather flat and dull to me. It also appears that the camera was tilted during exposure, something I should have seen, but didn't. The scene was a compelling one and it took me sometime to compose the right angle of view. I wanted an image of the reflection and the riverbed underneath that seemed to be texturing the wall of the mountain. The light was very bright, making the whole area glow. I wanted to represent this feeling, and the textures and shapes that made it, in my image.

In examining this image, the first thing that struck me was the lack of contrast. I didn't want to go too far with it, as too much contrast would destroy the feeling of the light. However, before addressing the contrast issue, the first thing to do was straighten the image out with Crop Overlay. To access Crop Overlay, click on the rectangular dotted line icon, the leftmost underneath the histogram display (or under the Histogram tab if you don't have your histogram showing).

This image has a normal exposure, as illustrated by the histogram.

I used Crop Overlay to straighten out the slight tilt in the image.

When you click on Crop Overlay, Lightroom surrounds the image with eight adjusters, one in the middle of each side and one at each corner. If you put the cursor by one of the corners, a little double arrow shows up that allows you to rotate the image. When you get what you like, double-click inside the image and the cropped version appears. The original is still there, though, and you can get it back by clicking on Crop Overlay again.

Now let's go back to deal with the contrast. In this case, we want to achieve greater contrast without clipping the highlight or shadow detail. Press the Y key before you begin your adjustments. This allows you to compare the image your adjusting, on the right, and the original grayscale image, on the left. You can also click on the "Y/Y" icon in the lower left corner of the imaging area to change your before and after viewing options.

You want to avoid clipping in the global stages because you want all of the information the picture has available to you. To increase image contrast, you can either move the contrast slider to the right or—and my personal preference—move both the Exposure slider and the Blacks slider to the right. Take the image up to the clipping point; the little triangle in the upper right of the histogram display will light up. Then, back off from that clipped point until the image visually looks good in the high values. You can hold down the Option/Alt key while you do this to actually see the clipped area or click on the triangle in the histogram display and the clipped area will show up in red.

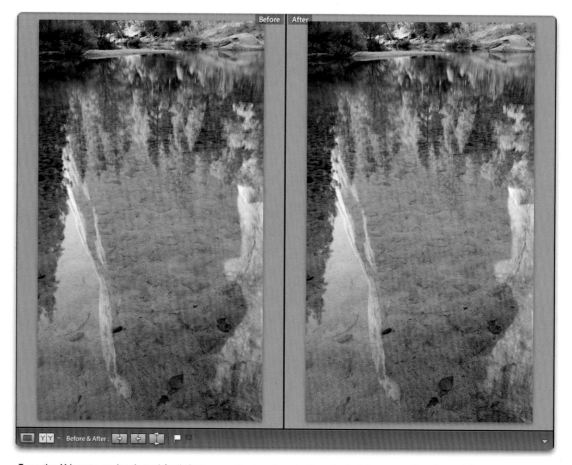

Type the Y key to go back and forth between viewing the single adjusted image and a view of the original beside the adjusted one.

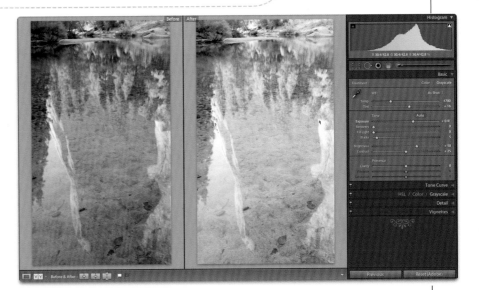

In this step, I pushed the Exposure slider to the clipping point, as seen in the adjusted image on the right. You can see that the small triangle at the upper right of the histogram display is lit up in warning, and the clipped parts of the adjusted image are shown in red.

I followed the same procedure for the Blacks slider. For this slider, the clipping point is illustrated on the left side of the histogram. Move the Blacks slider to the right to move the black values on the histogram to the left. Move it and watch until the warning arrow lights up on the upper left of the histogram display. Then, take the slider back a bit until the image looks good to you. The change in the image I was working with in this example is very slight. However, don't be tempted to clip your highlight or shadow values at this point, even though the image may look better to you that way. There are still more adjustments to be made, so you should preserve the image information rather than clipping it.

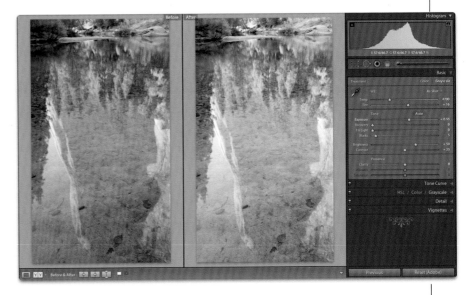

Here, I brought the Exposure slider back some to avoid clipping and the warnings disappeared.

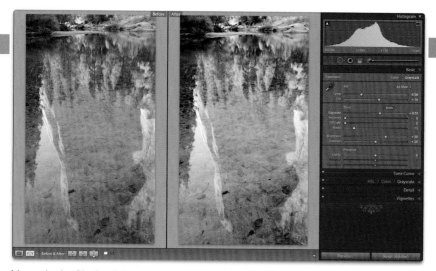

I brought the Blacks slider to the clipping point here, as indicated by the warning arrow lit up in the upper right hand corner of the histogram display.

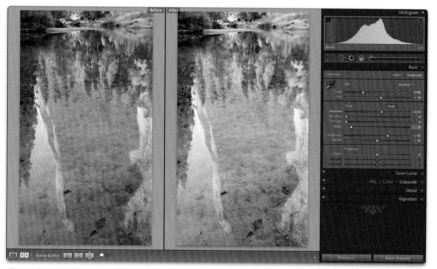

Even though the image looked good with some of the shadow values clipped to complete black, I brought the Blacks slider back out of the clipping range to preserve the image information for further adjustments.

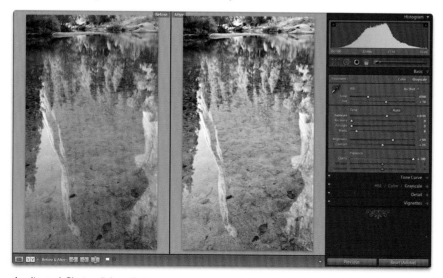

I adjusted Clarity slider all the way to the right, causing a fairly respectable increase in the midtone contrast as compared to my image after adjustment using only the Exposure and Blacks sliders.

Compared to the original black-and-white cropped image of this scene, the adjusted one looks like it has slightly more contrast... but does it look good? Does the light give the image a sense of presence? Not yet. The midtones still look too flat. So, still working under the Basic tab, the next thing to do is adjust the Clarity slider. (Since this is a black-and-white image, the Vibrance and Saturation sliders are grayed out.) Adjust the Clarity slider a little bit to the right (it's right below the contrast slider); it's meant to help the midtone contrast.

Later in this chapter, we'll work with the other sliders in the Basic tab with some other images. For the current example, however, the next step is to utilize the Tone Curve tool. The grayscale in this image isn't quite right yet. The lower midtone values need to be darker, and we still need a little more contrast.

Tone Curve

Just below the Basic tab is the Tone Curve tab. Tone Curve works like Curves in Photoshop, but it also has sliders that can adjust portions of the curve and a Target Group mode that allows you to place the cursor on a point in the image itself and adjust that general tonal area of the curve. I use the Tone Curve when I can't seem to get the highlights and shadows just right with the Basic tab tools. By carefully adjusting the Darks and Shadows sliders, you can fix low or high contrast shadow problems; by adjusting the Lights and Highlights sliders, you can adjust high and low contrast highlight problems.

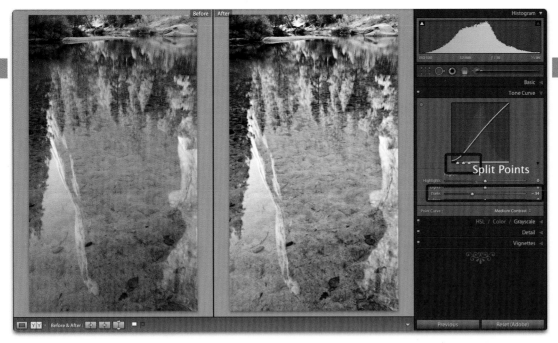

The Split Points arrows are located at the bottom of the curve display. I moved all three of them as far left as they would go before adjusting the Darks slider. Now the image is starting to show presence.

The low midtones and the shadows in my El Cap image are too high in value. By lowering the values below the midpoint of the curve, I brought those values down and darkened the midtones. Then, by steepening that area of the curve, I increase the contrast a bit. To do this I had to do two things: I restrained the dark end of the curve (so that only the deepest shadow areas were affected) by dragging the three arrows (called Split Points) at the bottom of the curve as far left as they would go; then, I adjusted the Darks slider to the left until I liked what I saw. This caused some minor clipping of the shadow areas, but only in a very small area of the image where the shadows fall under the small trees in the upper left.

Next, I adjusted the Lights slider a little to the right to increase the contrast from the light end and slightly lighten the higher midtone values. Click on the little square at the top left of the Tone Curve tab to see the image before and after that adjustment. At this point, the image is really starting to show the presence I was looking for. We will explore the Tone Curve and its many image-enhancing capabilities a little further with other images in this chapter, but for now let's stick with the image at hand and move on to the next step in turning it into a masterpiece.

The Grayscale Tab

The next step to fine tuning global adjustments for a black-and-white image in Lightroom is the Grayscale tab. Click on the arrow for the HSL/Color/Grayscale tab in the Develop module right below the Tone Curve (or you can just click on the word Grayscale). HSL and Color will be grayed out and Grayscale options remain. What you'll see is a panel that says Grayscale Mix with eight color sliders. This tool takes the place of the Channel Mixer tool in Photoshop and it works far better than any other color-to-black-and-white conversion tool (though I am also pleased with the results of the new Nik Silver Efex Pro conversion software; it adds time to the workflow, but it converts color to black-and-white very well indeed).

Each one of the Grayscale Mix color sliders represents an original color the image had before you converted it into grayscale under the Basic tab. Dragging the sliders to the right increases the brightness of that original color area (or areas), and sliding to the left decreases the brightness. Some

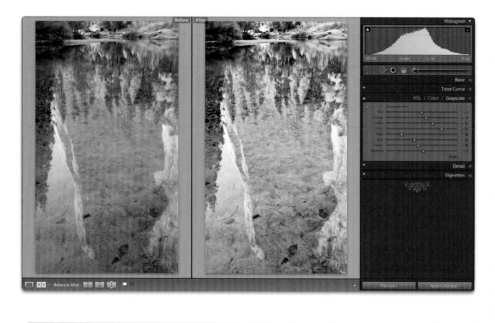

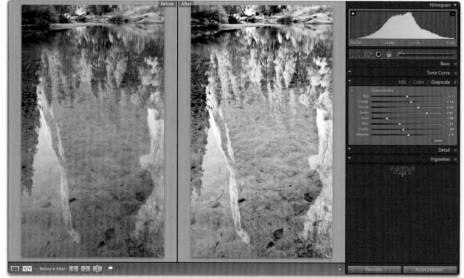

Here you can see the image before (top) and after (bottom) adjustment with the Grayscale Mix sliders. What an amazing difference the adjustments made in the light.

objects in the image may contain one or more colors and you may need to go back to the color image to see where the colors actually were, but I usually just end up experimenting with the sliders. For instance, most blue skies can be rendered much darker by decreasing the Blue slider, making the picture look as though it was taken with a red or yellow filter in traditional black-and-white film photography. Adjusting these sliders allows us to fine tune the grayscale until we get close to what we want.

You can also engage the Grays Target Group control by clicking on the circle icon in the top left corner of the Grayscale Mix panel. Click once then place the crosshairs cursor on the area in the image you want to darken or lighten. Click and hold on that area and move the mouse away from you to lighten that original color or towards you to darken it. This works especially well when an image area contains more than one color.

My El Cap image has many different colors, which is one reason I chose it for this first example in the workflow. As I adjusted the sliders, I found that red had little influence, but that increasing the orange, yellow, and green sliders had a tremendous impact on the foliage and some of the rocks. I reduced the blue to kill the glare of the sky without ruining the sense of the light, and the purple and magenta sliders helped me to define the foreground.

That is as far as I usually take my global adjustments. I'll discuss broad and local adjustments in the next chapter. However, I want to go through these global adjustments with a few more photographs so you can see that you don't necessarily have to do things in the order in which I did them on the El Cap image. Each picture has its own personality. We'll stay in the Develop module and use the Basic, Tone Curve, and Grayscale tabs, but we'll use them slightly differently for each of the next set of images.

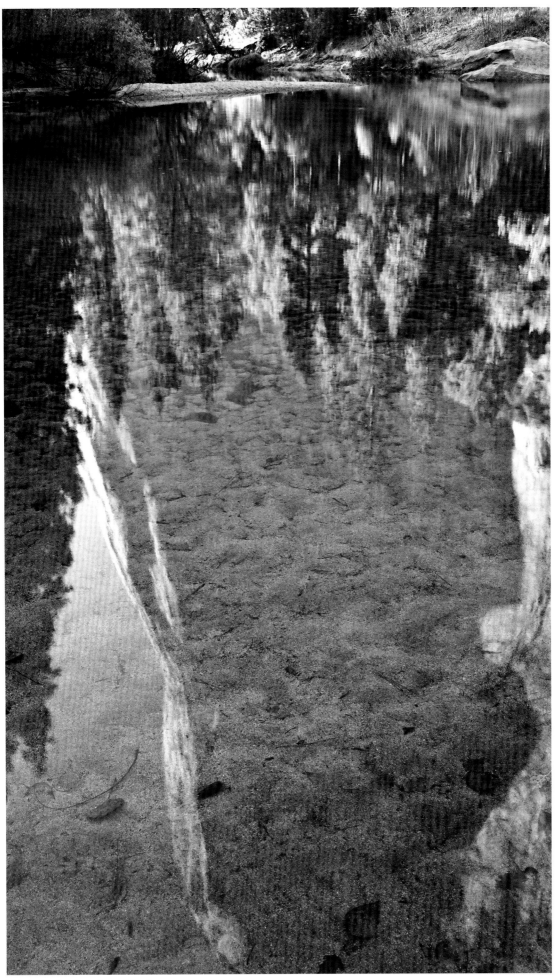

This is the final version of the image.

Dusk at McDonald Lake, Montana

I could barely see this image enough to take it, but I could see it, and figuring that, I composed and clicked the shutter. What I saw and felt was form drifting into emptiness, a strategy used by the ancient Chinese landscape painters 2000 years ago. I envisioned this image in that ancient Chinese style—long and horizontal and, in this case, with about a 1:2 aspect ratio. The main problem to address here was accentuating the contrast and the forms, but not so much that they would be starkly black and white. In preparing to make adjustments, I knew that well-separated gray tones blending into one another would bring the form and emptiness out, so that's what I tried to do.

In the case of this image, since the original shot was basically a monotone blue, adjusting the grayscale sliders would have had little effect. To get the images of the mountains fairly distinct and yet still merging into the fog was the illusion I was after. Too much contrast and the picture would have been ruined. I needed just enough midtone separation, not a full spread of values from black to white.

Here is the original grayscale conversion in Lightroom.

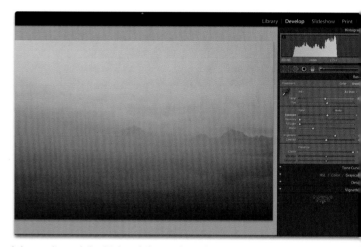

I then adjusted the Lights slider to the right and the Darks slider to the left to increase the contrast in the midtones even more, leaving the highlights and shadows alone.

I attempted to increase the contrast slightly and separate the gray values by dragging the Clarity slider as far right as I could.

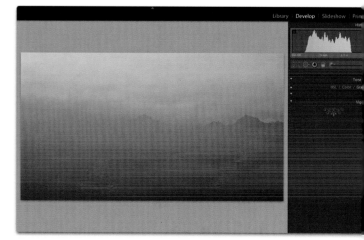

Lastly, I cropped and rotated the image slightly and fiddled with the Exposure and Blacks sliders, then the Tone Curve to get just what I wanted.

Leaf

I have always been fascinated by the designs made by rotting leaves in the forest. Here is a good example of what can be done with an image that already translates into a fairly good grayscale conversion to make it into something even more present.

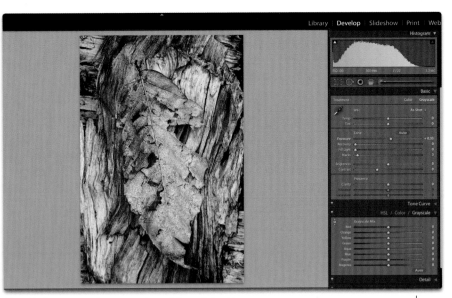

Here is the grayscale conversion of the original image.

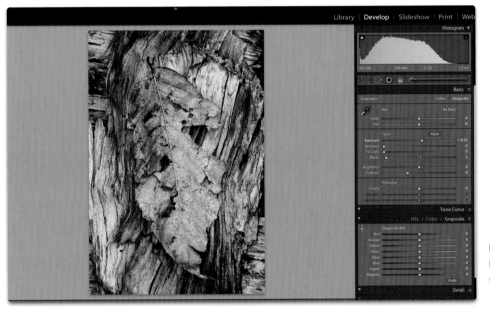

I just barely moved the Exposure slider to the right to increase it.

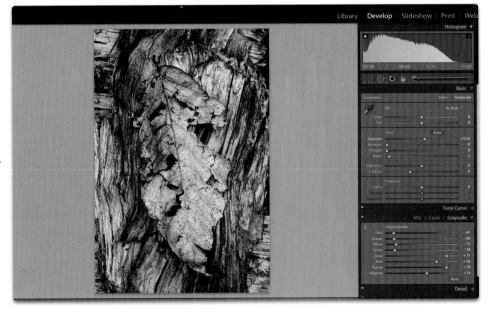

The only other global adjustments I made were to the Grayscale Mix sliders under the HSL/Color/Grayscale tab. I made some huge movements to those sliders in an attempt to separate the leaf from the log using the base colors rather than the contrast separation tools. It was really the only global choice I had to give some presence to the leaf.

Statue

This was a hard image to evaluate for adjustments. My feeling was that I'd have to see a print of it before I could really tell whether the image had the presence of the marble statue. If it's too white, it will look chalky; if it's too gray, it will be just plain blah. The difference in an excellent print of this statue and a poor one is very small. You have to be right on the money for a subject like this, so take time to analyze with care.

The first thing I do to evaluate a high key image like this one is to change the background behind the Lightroom display to white. To do this, right click (or Control click with Mac) on the background behind the stat-

ue and choose White. This will help to view the white and gray tones correctly since marble is not pure white; it is shades of gray from middle gray all the way up to very light gray.

The best marble photography I've ever seen is that of Clarence Kennedy. His grays are always high in value and close together in separation. They start at about the tonal value of Caucasian skin and go into a very light gray that appears almost white. The presence of his images makes you feel like you are looking at the real marble sculpture.

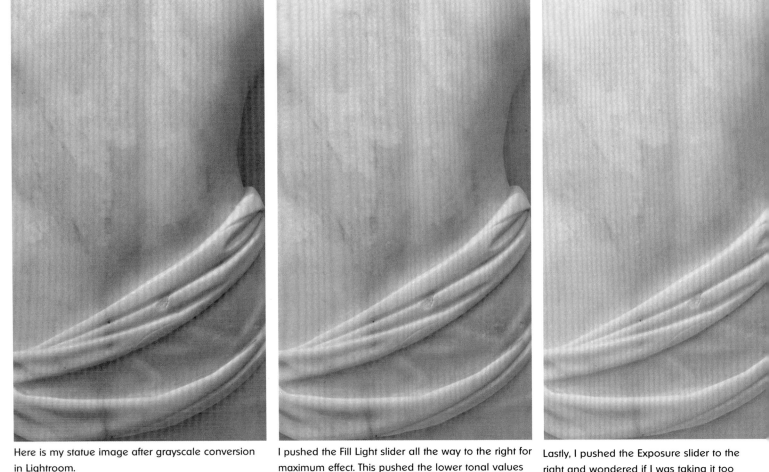

Here is my statue image after grayscale conversion in Lightroom.

I pushed the Fill Light slider all the way to the right for maximum effect. This pushed the lower tonal values up towards the high ones, giving the marble a better sense of presence. I also moved the Clarity slider a little to the left to help make the tones smoother.

Lastly, I pushed the Exposure slider to the right and wondered if I was taking it too far. What do you think? Only a print will tell... probably many prints.

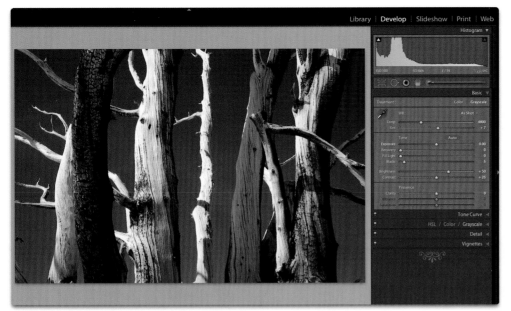

Here is the grayscale conversion of the original image.

I moved the Recovery slider a bit to the left to reclaim the white texture in the highlights, drew back the Blacks slider to open up the shadows, and increased the value on the Clarity slider for better midtone separation.

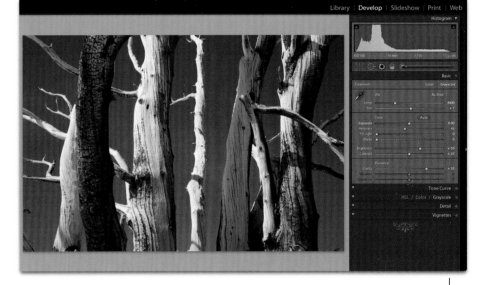

Bristlecone Pine

The bristlecone pine grove in the White Mountains on the eastern side of the Sierra Nevada range is a sacred place to me. This image struck me almost at once, with the gnarled branches against the very dark blue sky. The play of negative space and the range of tonal values were incredible, and the light was brilliant and almost blinding. As you can see by the image and the histogram, there was really very little to do to perfect this piece except lessen the contrast slightly and use the Grayscale Mix sliders to bring out the sky and the yellow parts of the trees.

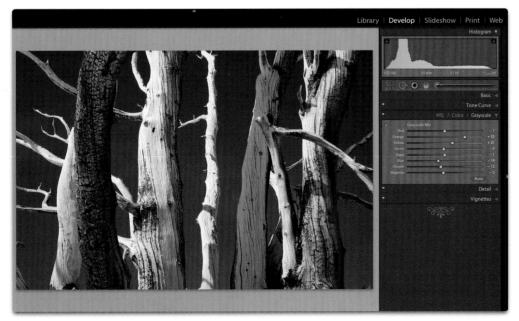

Lastly, I used the Grayscale Mix sliders to enhance the yellow areas from the original image and make the blue sky just a little darker to give it more impact. This gave the image real presence, capturing the way the scene really felt to me. I love this photograph.

Apple

This photograph was a pure study in the many ways one can use to increase contrast. It required great effort in seeing and diagnosing the global needs to perform the adjustments correctly. This is a great example of difficult global adjustments.

This is the original color image. It's yellow and red because I had my camera set to automatic white balance, which only goes down to 3700 degrees Kelvin in color temperature. The light I photographed the apple under was more like 2200 degrees Kelvin, so the color is off. Tungsten (3200 degrees Kelvin) is the closest preset in Lightroom, so I selected it here by clicking on the double arrows beside As Shot under the Basic tab.

I tried to restore the original color by sliding the Temperature slider to the left until the image looked good to me, then I used the White Balance Selector (the eyedropper icon) to pick a gray area in the image and clicked on that area to zero in on color balance

Here is the grayscale conversion after the white balance adjustment.

This image needed a lot of midtone contrast, so I worked with the Exposure, Blacks, and Fill Light sliders. I also cranked the Clarity slider all the way up.

Adjusting the Tone Curve and the Lights, Darks, and Shadows sliders further enhanced the midtone contrast.

I then used the Grayscale Mix sliders under the HSL/Color/Grayscale tab to enhance the contrast even more.

Finally, I went back to the Tone Curve and increased the contrast a bit more because it still looked a little flat to me.

Increasing Dynamic Range

I started experimenting over 10 years ago with ways to create a broader dynamic range in digital images. The problem is this: The image sensor on your camera only records about five f/stops of useful detail. Any more and the highlights, shadows, or both get blown out to white and/or go to black with no detail. I've found that by combining two or more images with different exposures (images shot with the camera set on a tripod), you can achieve a broader dynamic range.

A friend of mine, Chris Russ, and I invented a plugin for Photoshop called Optipix, which facilitates the combining of images (up to 30,000 if you want!). This was long before what is now known as HDR compression in Photoshop. Optipix is still manufactured and now works in 32 bits. In my opinion, Optipix is better at combining images for optimizing dynamic range than Photoshop.

For the purposes of this book, I'll show you a really neat way to combine images starting in Lightroom, then going into Photoshop, and returning to Lightroom to go through the global adjustments workflow we covered in this chapter. Once you import the images into Lightroom, export the images you want to combine from the original imports, combine them in Photoshop, and return to Lightroom to continue with the workflow. Don't do anything to these images before you combine them! Don't even change them to grayscale at this point.

Sunset is a perfect example of a scene you might want to enhance the dynamic range of. We'll use this for our example here:

1. Import into Lightroom a series of exposures taken on a tripod and bracketed at 1-stop increments. I usually do anywhere from three to nine exposures depending upon the scene being photographed, and I've occasionally made 15. Select all the images you want to combine.

Note:

If you want to buy a copy of Optipix, or download a demo, go to www.reindeer-graphics.com.

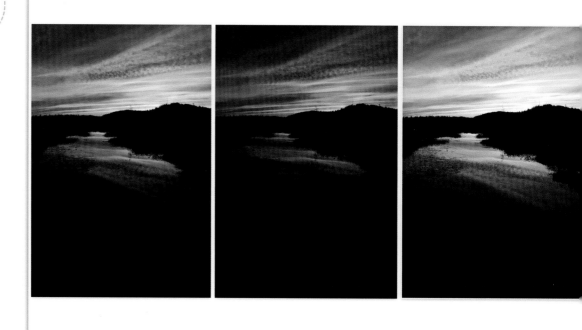

2. In Lightroom, go to Photo > Edit In > Merge to HDR in Photoshop. Wait for the images to process. The more images you have, the longer this step will take.

3. This is the screen that will come up in Photoshop. Do not touch anything at this point; just click OK. The image you are viewing is in 32 bits. This means that it has 1023 levels—for all intents and purposes, infinite.

5. In the window that appears, adjust the Exposure (highlights) and Gamma (shadows) until you get as much detail in the image as you can get. You are not looking for perfection here, just detail. When finished, click OK.

4. After clicking OK, you'll have to wait again. When an image finally comes up, go to Image > Mode > 16Bits/Channel.

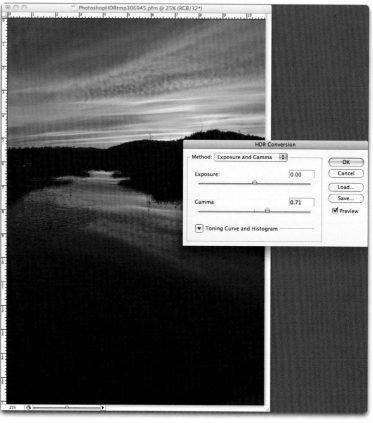

6. Close the image and click Save. Do not click Save As. This procedure will return the image back to Lightroom.

7. Here is the HDR processed image back in Lightroom and ready for global adjustments. Notice that the histogram is unclipped. You now have all the detail you want to make a beautiful black-and-white image.

Featured Artist: Clyde Butcher

Clyde Butcher is one of America's greatest black-and-white landscape photographers. He approaches his workflow in an entirely different manner from anyone else I know. What he does with Photoshop is amazing.

Clyde scanned the negative in as a negative because scanning it as a positive sometimes corrupts the shadows. His workflow on this image is complicated and involved, but he used a system of gradients with a Foreground to Transparent Linear gradient, Levels control, and History Brush adjustments similar to the ones explained in the workflow in this book.

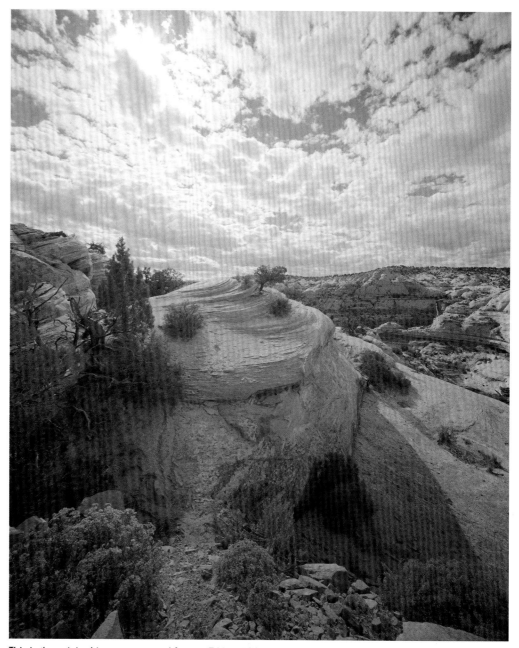

This is the original image, scanned from a T-Max 100 11x14-inch negative (approximately 28 x 35.6 cm). © Clyde Butcher

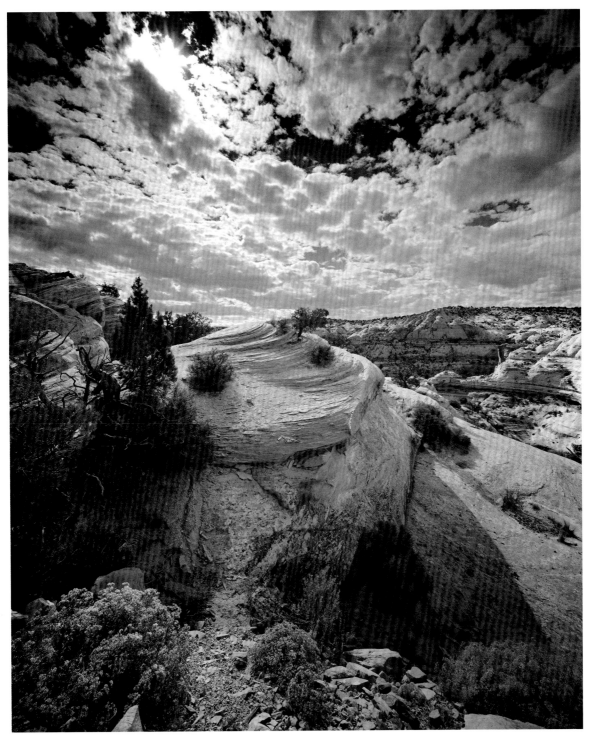

This is the final adjusted image. © Clyde Butcher

chapter | seven

Adjusting broad areas of an image is fairly straight-forward, but adjusting local area problems tests the mettle of even the greatest master photographer. I use a gradient of some kind to fix broad areas that are "out of control." The tool for this in Lightroom is the Graduated Filter (located on the tool strip just below the Histogram in the Develop module, fourth in from the left). For many of the local adjustments, I use the Adjustment Brush (found just to the right of the Graduated Filter).

While most lightening (dodging) and darkening (burning) of local areas can also occur in Lightroom, heavy duty local adjustments such as outlining, edge softening, and others are best done in Photoshop where there is infinitely more control and ease of use. You might even want to leave the local correcting entirely for Photoshop. Try both programs and use the one that's best for you.

You Are Here

Take a moment to orient yourself to where we are in the workflow:

- Global adjustments

- Broad adjustments

- Local adjustments

- RAW pre-sharpening

- Photoshop (noise reduction, PercepTool, Gradient Map, local fine tuning, edge control)

- Printing using Lightroom

In this chapter, we will explore the application of broad and local adjustments using Lightroom, as well as cover the task of RAW pre-sharpening, which is applied in Lightroom, before we move on to the next chapter on Photoshop.

A Word About Perception

As I have mentioned, the way Lightroom and Photoshop are designed, it is necessary to make global before broad and the local corrections to maintain the best image quality. Otherwise, the broad and local adjustments you make will become exaggerated by any global adjustments you apply afterwards. The perception algorithm in the brain, however, works somewhat backwards from this paradigm. With that in mind when I begin my work on an image, my method is to try to have the best of both worlds; I do all I can with Lightroom and Photoshop, then I apply the PercepTool to those adjustments.

Broad Adjustments

I call these types of adjustments "balancing" because they balance the image visually and encourage your eye to stay in the photograph. An unbalanced photograph lets your eye drift out of the picture in any direction, depending on where the problem is. Imbalances like this often exist in the corners or sides of images in areas that are too bright or too dark. The best way to determine whether or not your image needs balancing is to stare right at the center of it. If something on the edge or in a corner is pulling your eye toward it, the picture is unbalanced and needs to be adjusted in that area.

The Graduated Filter

The tool I use for image balancing is Lightroom's Graduated Filter, the fourth tool in from the left on the tool strip below the histogram in the Develop module. I use this tool in slider mode to make one adjustment at a time. (See the images and caption, below, to locate and access the two Graduated Filter modes—button mode and slider mode.)

Click on the Graduated Filter icon in the tool strip to access its options. You can work with the Graduated Filter using either the effect sliders or the effect buttons. To switch back and forth between these two, click on the white square just below the word "Edit" in the top right corner of the Graduated Filter panel.

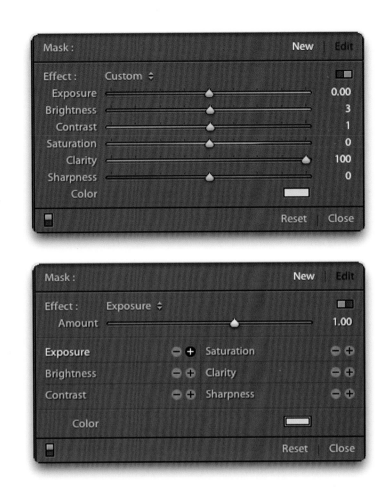

The Exposure control adjusts the image brightness of a local area, but be aware that it can clip the highlights and shadows if you're not careful. The Brightness control works in basically the same way as Exposure but doesn't cause clipping and helps mostly the midtones. Contrast adjusts local image contrast without clipping. Clarity separates the midtone values using a different algorithm than Contrast. The Sharpness control sharpens or blurs a local area; when in slider mode, dragging the slider right of center sharpens and dragging left of center blurs. Let's take a look at an image example.

When using the Graduated Filter, the mode that I find gives me the most control for balancing the image is using the effects sliders (top), not the effect buttons (bottom). The sliders allow you to do more than one adjustment at a time.

Here is the original grayscale conversion of the image.

This is the image after global adjustments have been made.

I took a photo of some beach stones near my house in Maine, converted the image to grayscale, and applied global adjustments. The next step is to look at the center of the image and notice whether or not your eye is drawn out to any problem areas. What I see are several distracting edges and corners. The upper left corner is too bright and needs more midtone contrast, and the bottom needs a little darkening. The upper right of the image could also use just a touch of darkening, and I suspect that the whole left side is too light and lacks contrast. It will take three or four gradients to adjust what I see that is wrong with the image.

When starting broad image adjustments, I usually work from the most glaring problem to the least, so in this case, we'll start with the upper left part of the image. To make a gradient, click on the Graduated Filter and make sure you are in slider mode, and make a slight adjustment. For example, to darken the upper left of the Stones image, I dragged the Brightness slider to the left to about -30 or so. Place your cursor on the image; it will become a little + sign. For this adjustment, I

moved it to the upper left corner of the image, clicked and dragged it from the corner just past that big rock in the top left, and released. This created the gradient.

Once you've made the gradient, you can add additional corrections to it by adjusting the individual sliders. For instance, the top left corner is too bright and doesn't have enough midtone contrast, so I used the Clarity slider to increase it. I used Clarity instead of Contrast in this case because Clarity is great at focusing contrast separations on the midtone areas, which is all I think I really need here.

Note:

To show and hide the gradient, type the H key. If you don't like the gradient and want to discard it and try again, make sure the gradient is visible and hit the Delete key. The little button on the gradient goes up in a puff of smoke.

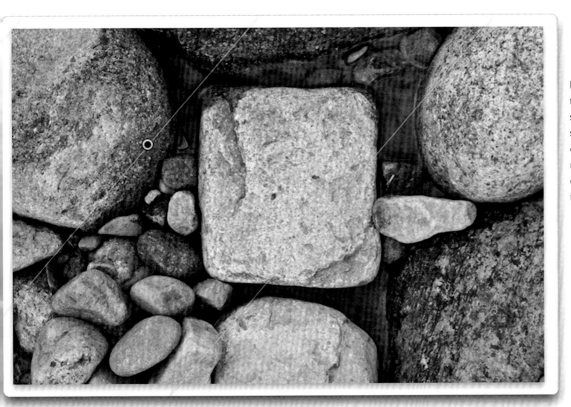

Here's my correction with the amount I adjusted shown in the sliders. The sliders increase their effect by sliding to the right of middle and decrease when sliding to the left.

Effect :	Custom ⇕		▭
Exposure			0.00
Brightness			− 54
Contrast			2
Saturation			95
Clarity			100
Sharpness			0
Color			▭

Now for the bottom of the image, which is too light and needs contrast like I applied to the upper left. To accomplish this, I pulled back slightly on Brightness and maxed out the Clarity. Basically, this is the same thing I did to the upper left of the image.

The last gradient to apply was for the upper right part of the image, which needed the same procedure as the other two gradients but not to the same degree. Notice that the effect of the Brightness and Clarity are not as strong as the first two gradients to the upper left and the bottom.

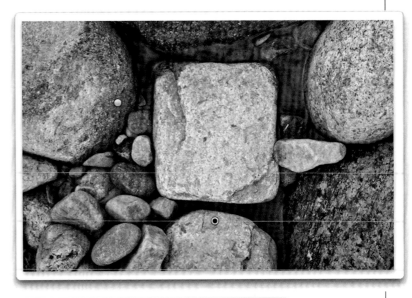

Effect :	Custom ⇕		▭
Exposure			0.00
Brightness			− 39
Contrast			1
Saturation			0
Clarity			100
Sharpness			0
Color			▭

Here is the image with the corrected bottom section and the slider positions I used to make the adjustment.

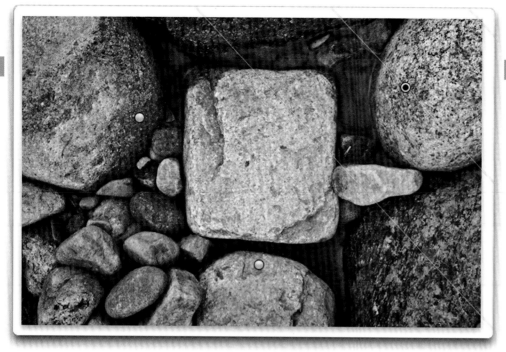

The gradient I applied to the upper right corner followed the same procedure as the other two gradients, but the effect I was going for was not as strong.

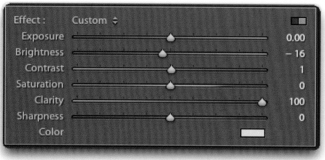

Lastly, after adding the three gradients, I noticed that the image was flat. So, I opened the Tone Curve, increased the Lights slider slightly, and decreased the Darks slider to give the image better overall contrast. (I already adjusted the Clarity slider to 100% in my global adjustments.

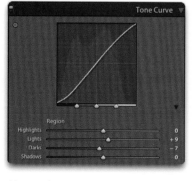

Here is the image with all the broad adjustments applied, plus a touch up via the Tone Curve.

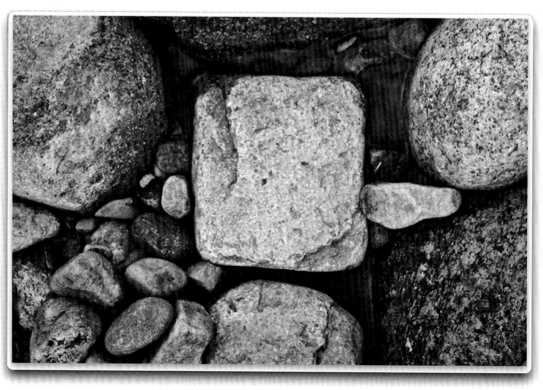

More Examples

The steps outlined above are all you really need to know about making broad adjustments to your images in Lightroom. Now let's look at some more examples to familiarize you with the steps and tools involved. I made this next photograph during a pouring rainstorm near Tesuque, New Mexico. I jumped out of the car, set up the camera, and made the image in less than one minute. A state trooper stopped a few yards behind me, wondering what I was doing, but decided I was harmless and drove on.

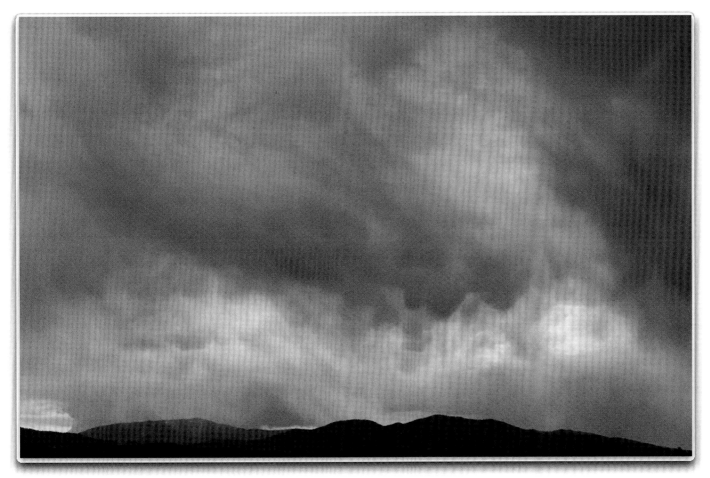

Here is the original image converted to grayscale.

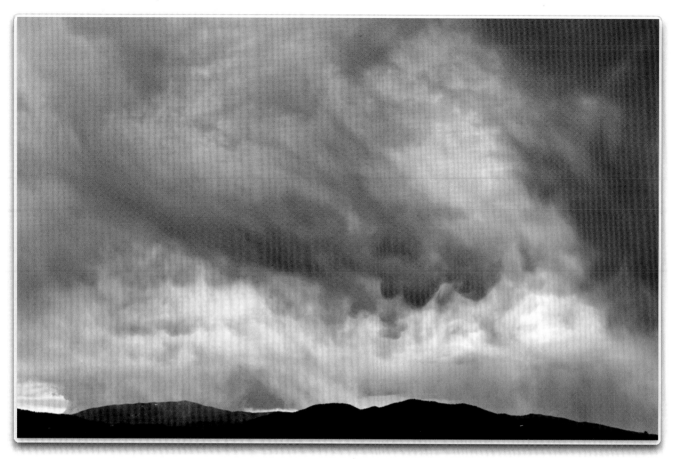

I made global adjustments using the Clarity and Contrast sliders.

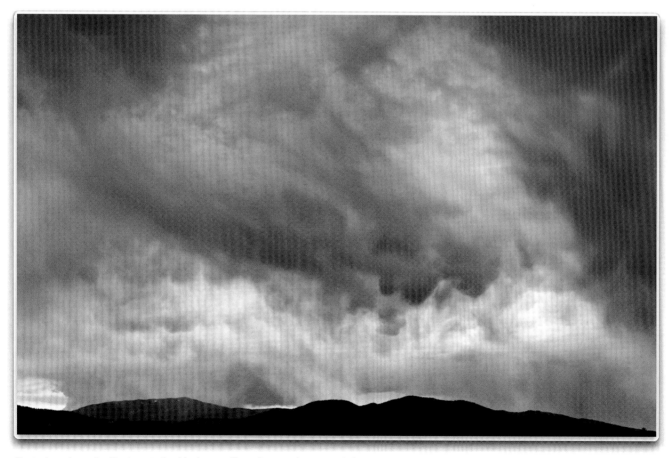

To start my broad adjustments, I added a small gradient to the upper left to darken that area.

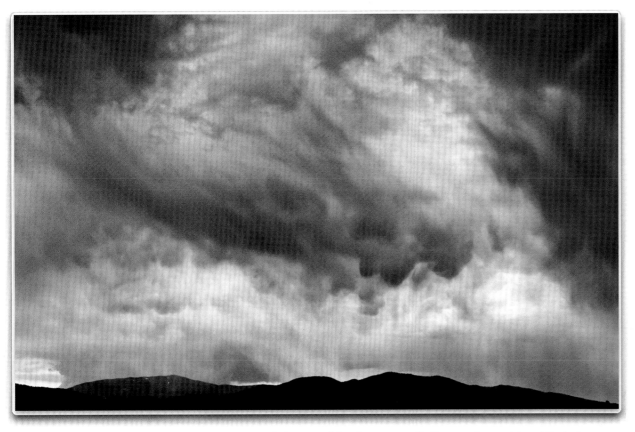

The final gradient added the much needed contrast and clarity to all but the very small, silhouetted mountains at the bottom.

This next example shows how much balancing can be done with the Graduated Filter; it can actually reveal something hidden in the image. I was cruising the islands near Southwest Harbor in Maine and the day was overcast and dull. When I made this image, I could see into the depths of the water and the reflection in the near distance, but it didn't show up in the RAW file or the grayscale conversion. Even with global corrections, the near distance is still weak in contrast and brightness. The sky is also flat and needs slight darkening and some contrast enhancement.

Here is the grayscale conversion of the original image.

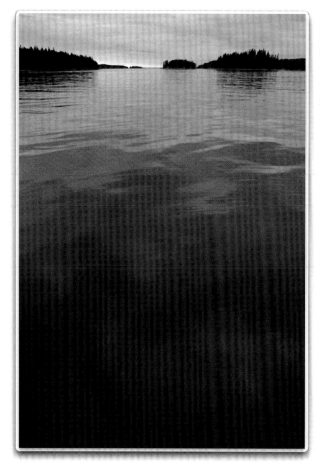

I created a gradient from the bottom to the black islands at the horizon using the Brightness, Contrast, and Clarity controls to reveal the dark part of the water in the near distance. (I had already made global adjustments to this image.)

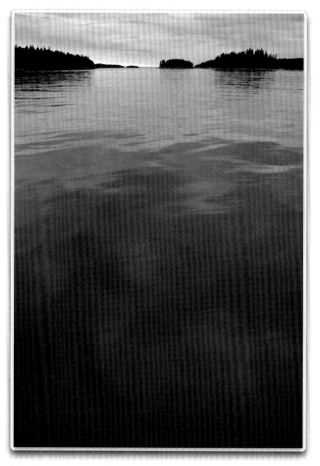

Next, I made a small gradient over the top of the image to increase contrast and lower the brightness slightly to give the sky more presence.

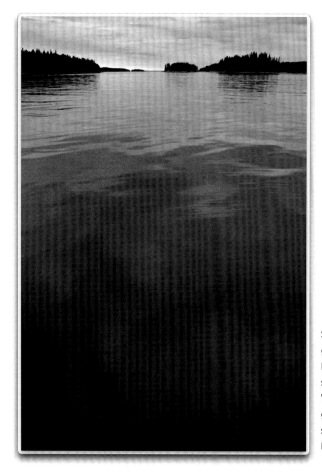

Sometimes, after many broad adjustments, the global adjustments are skewed slightly in brightness or contrast. Here I corrected this slight contrast problem with the Tone Curve. What is revealed is the wonderful pattern and grayscale of the water in the foreground, something I did not see in the camera image, but felt when I was photographing it.

Here is the grayscale conversion of my Dee Peppe portrait

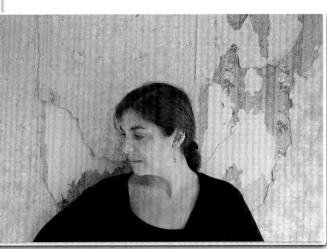

The balancing of this image has almost entirely to do with the background wall. I used a total of six contrast, brightness, and clarity gradients to accomplish this. It took a long time to get it just right.

The photograph of Dee Peppe is one of a collection I've made over the years called Contemplative Portraits. I have no idea why I make images of people, but I think it has something to do with the local environment, the person's character, and the light. So I try to concentrate on seeing and enhancing those things. The problems with this image are manifestly difficult, so I've chosen to illustrate it for that reason. I'll also use it as an example for local corrections so you can see how it is improved further by those adjustments (see pages 139 – 141).

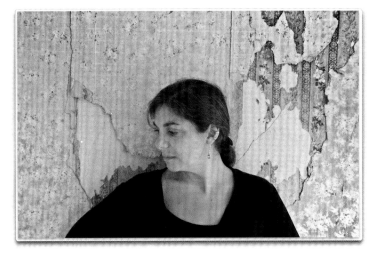

I made global adjustment to increase contrast and used the Grayscale Mix sliders (under the HSL/Color/Grayscale tab) to bring out her face and some of the wall details.

Finally, I applied five gradients to the sides and corners with decreased brightness to subdue the background slightly because it was a little bright. The picture was by no means finished at this point, so read on to see how I applied local adjustments to complete it.

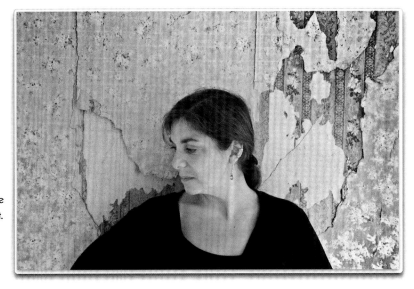

Local Adjustments

Local adjustments are a matter of perception and awareness, whether you are using Lightroom, Photoshop, LightZone, Viveza, or any other image-processing software. If there is one place where image processing seems like Zen practice, it is here in the visual, intuitive realm of local adjustment. The software applications that have the ability to control small local areas are all stellar in their performance of this task. All have their strong and weak points, and you have to decide which program you prefer by trying them out.

The ability to see and correct a miniscule local problem separates the good photographers and printers from the mediocre. The essence of a great black-and-white print is the articulation of its grayscale, which creates presence in the image. Learning the skill of seeing small areas of gray tone in the image that are discomforting to you and being able to correct them is the hardest task to perform in black-and-white printing.

The people who I find have the greatest ability at this are ones who spent many years in the wet darkroom making black-and-white prints. They developed the treasured ability to see the miniscule, the unimportant, the obscure, and the ways light plays in the print. If you haven't been a black-and-white printer all your life, the exercises at the end of the second chapter will be good ones to help you learn this difficult skill (see pages 58 – 59).

Before Lightroom, I used Photoshop's History Brush tool for local adjustments (explained in detail on page 160). The latest version of Lightroom, however, incorporates an Adjustment Brush tool that makes it possible for us to make many of the local corrections we previously had to apply in Photoshop inside Lightroom itself, thus preserving the non-destructive workflow for which Lightroom is so famous. So, we'll work as far as we can in Lightroom on "locals," then fine tune in Photoshop later.

A local adjustment is almost always applied with a brush. In Photoshop, this is either done on a layer or mask or with the History Brush. In Lightroom, this is accomplished using the Adjustment Brush. Whether you're adding or subtracting, erasing or painting, a local tool is a brush tool. Enter the Wacom Tablet. For applying local adjustments, it is the only game in town. I have several of all different sizes. My favorite for photography is the 6 x 8-inch (approximately 15 x 20 cm) or 6 x 11-inch (approximately 15 x 28 cm) size. Painters usually need a larger one, like the 9 x 12-inch (approximately 23 x 30.5 cm), and I carry a 4 x 6-inch (approximately 10 x 15 cm) to workshops on the road because it's small and lightweight. My favorite tablet that Wacom makes is the Cintiq, a screen tablet where you can actually paint on the image itself. All of these devices use a pen tool to draw with on the screen. (See page 78 for an explanation of how to set up the Wacom pen tool for use with Lightroom and Photoshop.) Once you get used to this tool, you'll never go back to a mouse for making local corrections.

The Adjustment Brush

The Adjustment Brush in Lightroom uses the same sliders as the Graduated Filter. What is different is that it is a brush, and can be adjusted in size by the side clickers on the Wacom Pen (see page 78), using the left [and right] bracket keys on the keyboard, or with the brush size slider. To use just the brush, click on the letter A just above the Size slider in the Brush panel.

The Feather Adjustment slider shows one circle in the cursor when set to 0 and two concentric circles with feathering applied by moving the slider to the right. I usually leave the feathering at 100%, and I rarely go lower than 50%. The Feather at 100% makes a soft edge transition from the center circle to the edge of the outer circle. The Flow slider works just like the Layer Flow slider in Photoshop, and the number keys adjust the degree of flow just like they did in Photoshop.

The Density slider works like the Opacity slider in Photoshop's Layers Palette. I have always preferred using the Density slider to the Flow slider. With successive applications of the Density slider, you have better control of the Adjustment Brush in building up hard to manage areas. Flow has always acted like an airbrush to me. If you have ever tried to use a real airbrush, the learning curve can be quite challenging. I've been using one for 30 years for other art endeavors in my life and it takes a lot of skill to master. What I have a tendency to do here in Lightroom is set the Flow at 50 – 100 and adjust the Density slider to 50 or less for most local area adjustments. You're going to have to experiment with this, as it is not really intuitive.

Auto Mask helps you employ the brush tool by color so that you don't go outside the lines of that color. To access Auto Mask, click on the letter B just above the Size slider in the Brush panel. This brush option is very

This is the Adjustment Brush panel.

helpful for painting blue skies. With Auto Mask, you need to set the Feather slider to 0 to keep from going outside the color you're trying to paint on. Auto Mask takes some getting used to, but it is a very useful tool once it grows on you. It's like using a brush and a mask at the same time, so you have to get your head around that idea first, I guess.

The Erase button is for erasing mistakes your brush adjustments. Click on Erase (above the Size slider in the Brush panel), adjust your brush size, and apply. To delete an adjustment, click on the circle button that appears in the adjustment area and press the Delete key.

Darkening and Lightening

Of all the things that I do to a photograph, I find explaining local controls the most difficult. I can tell you that the two main problems are seeing what you have to do and knowing what you want to do once you see it. Making local adjustments is an iterative process that goes back and forth, back and forth, until you get it right. Even Ansel Adams, one of the preeminent printers of his day who made copious notes and diagrams of his local adjustments, told me once that, "I stop burning and dodging when the little voice inside says stop." While this isn't much help to a photographer who is just learning how to use local controls expertly, it is the way most of us do it when we have years of experience. The fundamental question here is how to learn to see what we need to adjust.

Black-and-white local controls deal primarily with two issues: light or dark, and sharp or soft. This is a good place to start. Ask yourself when looking at an image that has been corrected with global and broad controls, "What needs to be darkened? What needs to be lightened? What needs to sharp? What needs to be soft?"

We will work in Lightroom for darkening and lightening, then go to Photoshop for sharpening and softening. The reason for this, as of this writing, is that the sharp and soft controls with Lightroom's Adjustment Brush are weak and don't do as good a job as can be accomplished with tools in Photoshop. This will probably change in the future, so keep an eye out for Lightroom updates.

The idea of thinking of local areas in terms of brightness is the key to understanding how a photograph can have presence. Presence is prominent when the local areas of gray values are articulated (varied and separated) well. This is a fundamental fact of human vision. So, no matter how large or small the global contrast range in an image, it is this articulation of local areas that builds presence. To begin the darkening or lightening process, start by breaking up this local adjustment task into two steps:

1. Lighten and darken areas that are large.

2. Lighten and darken areas that are small.

Here is an example. Look at the images on page 135 closely. In the large local adjustments image (middle), the picture looks almost too light in places where I have lightened very dark areas to bring out detail that I thought ought to be brought out, and I haven't really darkened much at this stage. In the small local adjustments image (bottom), I brought back some of the forms and shapes of the canyon wall by darkening and lightening small areas to increase articulation and create presence.

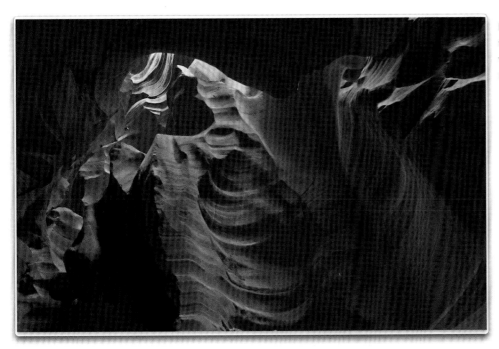

Here is an image of mine taken at Antelope Canyon with global and broad adjustments applied.

I then applied local brightening and darkening adjustments to the largest local areas first.

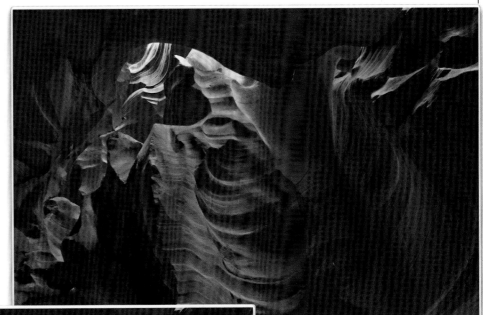

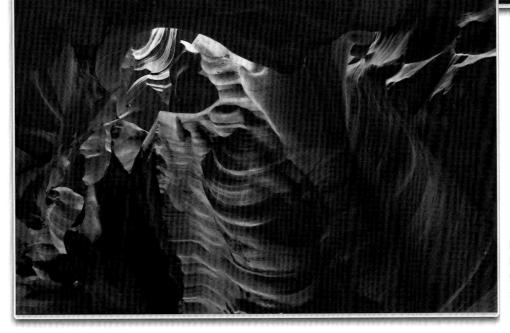

Next, I applied localized brightening and darkening to the smaller image areas that required it.

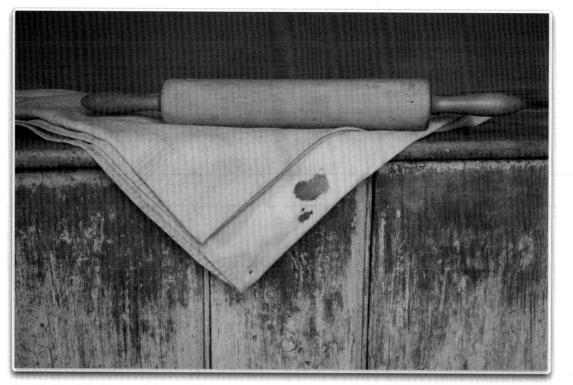

Here is the original grayscale image with no corrections.

In this next still life image, I wanted to bring out the texture of the wood and cloth while still maintaining the beautiful axial sky light coming in through the window directly behind me.

The local adjustments I made to the larger image areas focused on areas that needed more or less brightness brushed in. These adjustments were very slight—not more that plus or minus 15 on the sliders, with the Flow slider set at 50. For the smaller image area adjustments, I enlarged the image to 100% and carefully enhanced even more of the little light and dark areas and improved the texture of the wood and cloth with the Clarity slider. The background seemed a little light after all this, so I brushed in a little minus brightness there. If you're like me, you'll generate many History states while making local adjustments. They are all listed,

I made local adjustments to the largest areas of the image first.

I made the necessary global and broad adjustments before moving on to localized adjustment needs.

from the most recent image alteration on down, under the History tab on the left side of the screen when working in the Develop module. The number of History states I racked up in this image was 250, which tended to slow down processing somewhat and made me go slower. Watch out for this. Speed and processing updates to Lightroom will help this problem.

Then, I moved on to localized adjustment of smaller image areas.

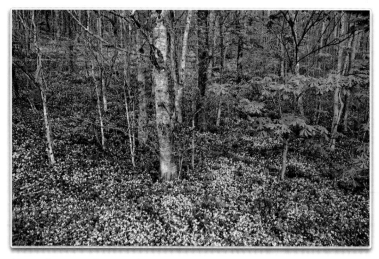

This is the original grayscale image, which already looked nearly perfect to me.

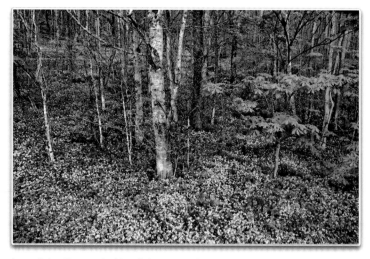

I used the Grayscale Mix sliders to make some minor global adjustments

Some pictures will fool you. This next example of a Canadian Violet in the Great Smokies was nearly perfect when I turned it to grayscale. I studied it for a long time and finally decided that I should change some of the tones of the separate objects in the scene with the Grayscale Mix sliders under the HSL/Color/Grayscale tab in the Develop module. The only local thing that needed changing after that was a slight brightness elevation of the leaves on the right side of the image. Sometimes it's just that simple, but you have to analyze the image first. See, then slide.

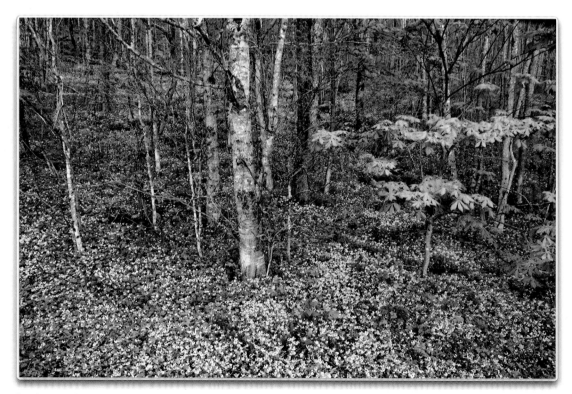

Lastly, I made local adjustments to some small image areas. Here is the final result.

Sharpening and Softening

Lets take another look at my Dee Peppe portrait and see what we can do to enhance local areas. Even after making global and broad adjustments, it was very difficult to see what needed to be done to further enhance this image. The first thing I noticed was the inadequate separation of the tonal values on the wall behind her, so I painted in 100% Clarity and Sharpness together on the wall only. Then I noticed that her face needed to be smoothed out a bit, so I used -100 Clarity and -50 Sharpen to achieve this.

The smoothing made her face lose contrast and brightness, but I remembered that, in my global adjustments, the orange Grayscale Mix slider had affected the glow to her face only, so I went back to that slider and increased it slightly to compensate for the smoothing effect. Lastly, I needed to sharpen the nearest eye, earrings, and hair to enhance them. You don't get that much from this Lightroom adjustment, even with the Clarity and Sharpness sliders both set to 100%.

Here is the Dee Peppe portrait with global and broad adjustments applied.

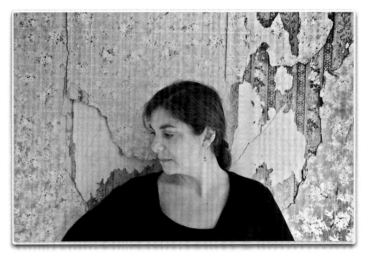

I then made a local adjustment to the wall area using the Clarity slider.

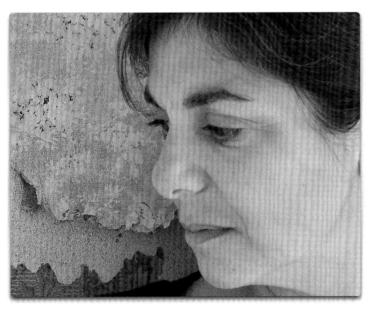

I noticed that her face needed some smoothing, shown here without smoothing applied.

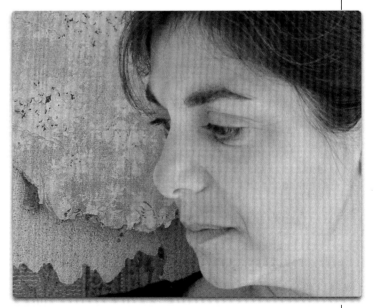

I used minus Clarity and minus Sharpen to apply the smoothing, brushing in the effect on all the skin tones, excluding the nearest eye, her hair, and earrings.

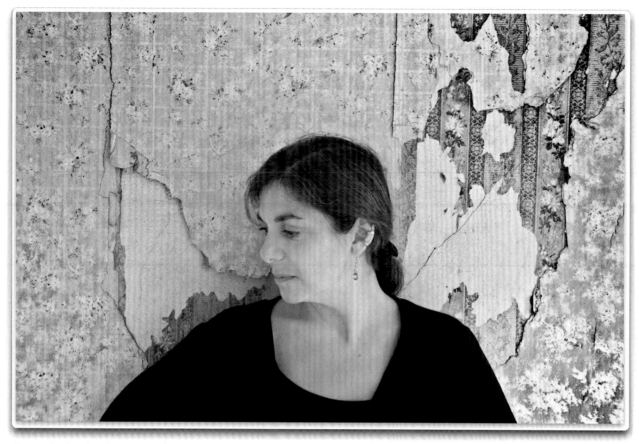

Remembering that the orange Grayscale Mix slider created a nice glow to her face, I went back to that tool and increased it a bit to compensate for the smoothing.

Next, I wanted to apply sharpening to her hair, the nearest eye, and her earrings. Here, the sharpening has not yet been applied.

This is the image after sharpening. It was not as much of an adjustment as I wanted, however, so I knew that I would need to take the image to Photoshop to complete my work.

This is the semi-final image, with all the adjustments I wished to apply in Lightroom completed. See pages 164–165 for the continuation of this image's processing in Photoshop.

Last Lightroom Adjustments

The last things I do in Lightroom before I go into Photoshop are RAW pre-sharpening and possibly some noise reduction (though this is often more efficiently accomplished through third-party software in Photoshop). RAW pre-sharpening is done in the Detail panel of the Develop module. There are basically three types of sharpening that we are concerned with in terms of image manipulation for a black-and-white fine print: pre-sharpening, local edge sharpening (and softening), and final print sharpening. We'll deal with local edge sharpening and softening in Photoshop. Final print sharpening happens back in Lightroom after we finish in Photoshop.

RAW pre-sharpening in Lightroom (as well as in Adobe Camera Raw, which has the same processing engine) basically fixes any problems that happen in the analog to digital converter in your D-SLR (digital single-lens-reflex) camera, particularly those high-end cameras that have the new CMOS sensors.

Do you ever notice that sometimes your RAW images appear to be a little soft on the camera's LCD screen, and in Lightroom or Adobe Camera Raw? Well, it is. The image is soft because the camera's RAW processor has shaved off some of that sharpness, but do not try to fix this in-camera. (I tried to boost up the sharpening in-camera in the Custom Control Panel once with disastrous results.) We can reclaim the "original focus" of our images with RAW pre-sharpening in Lightroom.

The Detail panel in the Develop module is complex in its operation. It will take a little time to learn it, and even more time to get used to it. It resembles some of the tools you remember from Photoshop and incorporates others that perfect the sharpening of individual images to an astounding degree.

When learned and applied properly, the Detail panel provides the best raw pre-sharpening available in today's market. I hope to explain the Detail panel RAW pre-sharpening tool well enough here to get you started learning and applying it all of the time. As with the other techniques in this book, see... then slide.

The very first thing you should do before we tackle the Detail panel is go to my website (www.georgedewolfe.com), download the RAW pre-sharpening TIFF file I have available there, and import it into Lightroom.

Once you have imported the image into Lightroom, click on the Detail panel with the image in Loupe View. (Press the D key to switch to Loupe View from the before and after view.) For RAW pre-sharpening, visual diagnosis of the image at 100% is critical. At 100%, you can view exactly the effect you're getting. It's not like print sharpening, where it's impossible to tell the sharpening effect until the print emerges from the printer. To view the image at 100%, simply click on the image.

In this workflow, we'll concentrate on the first two boxes in the Detail panel: Sharpening and Noise Reduction (although you'll see soon enough that the Noise Reduction tool in Lightroom doesn't do much and we'll have to rely on third party software to get it right in Photoshop). You should always try to reduce noise before you sharpen. Otherwise, you just sharpen the noise. You also have the option of noise reduction and sharpening in Photoshop, but to me, the sharpening in Photoshop is not as good as in Lightroom. I get rid of what noise I can in Lightroom, RAW pre-sharpen, then move on to Photoshop.

Download this image from my website to practice RAW pre-sharpening.

The Navigator tab is located at the top left of the Lightroom screen when working in the Develop module.

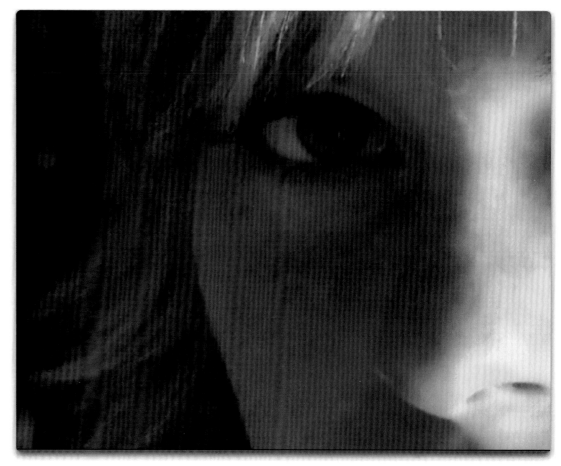

This is what noise looks like.

Noise Reduction

I tried to make the practice image you downloaded so that they each fit the view screen with both the right and left panels open at 100%. Your cursor will appear as a hand over the image when viewing at 100%. Use it to position the image of the woman. Now, locate the Navigator tab at the top left of the Lightroom screen and use it to enlarge the image to 2:1 to give you an even better look at the noise in the image. To select 2:1, click on the double arrow icon on the Navigator bar and a drop-down menu with several options will appear. Once you've selected 2:1, drag the image until you see the shadow side of the woman's face in the window. The textured stuff that looks like salt and pepper is noise.

Drag the Luminance slider (under Noise Reduction in the Detail panel) to the right until the noise disappears. This tool works okay for this particular image in Lightroom, but it won't work for many others. Even at its maximum power, however, there are still large noise artifacts that could be eliminated by a more powerful tool.

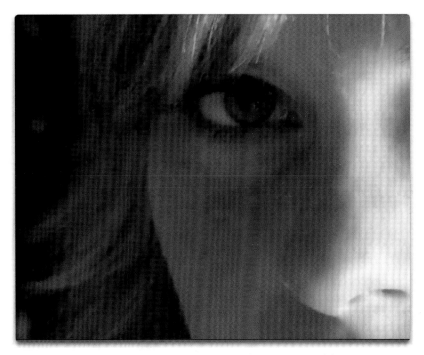

Here is the image with the noise reduced using the Luminance slider in the Detail panel.

RAW Pre-Sharpening

There are four sharpening control sliders in the Detail panel:

Amount: The Amount slider is a sort of volume control that increases the amount of edge definition as you drag the slider further to the right. A setting of 0 turns sharpening off.

Radius: The Radius slider increases the size of the edge details. Radius is a hair trigger slider; very little sliding goes a long way. I usually start at around 1.0 and vary it not more than about plus or minus 0.5 for my images. Portraits tend to look better with a low radius and landscapes look better with a higher one. My feeling is that this slider should be adjusted before the Amount slider.

Detail: The Detail slider suppresses the blooming effect that occurs when the radius is too high. Blooming, in this case, refers to the edge of the sharpening turning lighter, or white. The Detail slider suppresses all blooming at 0 and shows all of it at 100. To duplicate the sharpening effect of Photoshop's Unsharp Mask, set this slider to 100. I set it there as the first thing I do in sharpening. After adjusting the Detail, Radius, and Amount sliders, you may want to go back to Amount and increase the sharpening effect.

Masking: This is also a suppression slider. It limits the areas that are sharpened. When Masking is at 0, no limitations are in place. Adjusting to the right progressively masks off areas that are smooth and allows sharpening only to edge areas.

With all of these sliders, pressing the Option/Alt key while sliding the slider allows you to see the effects. In all cases on any mask, white reveals what is going to show and black conceals the rest. The Amount slider shows the full effect of the sharpening on a luminance (black-and-white) image when set to 100. In the RAW pre-sharpening image you downloaded, there are four differ-ent images, each of which requires a different type of sharpening. Let's work on each one separately and see why.

1. To get started on the image of the woman, I set the Detail slider to 100 and reduced the Radius slider slightly to 0.6 because it is a portrait and I wanted more smoothing than normal. I also adjusted the Amount slider to 38. (Since there is not much blooming in this image, I decided to leave the Detail at 100.)

2. I applied the Masking slider heavily at 100 because I wanted to keep the smooth facial areas smooth and the eyes and hair sharp, a standard for many portraits. I also increased the Amount slider to 75 to compen-sate for the masking. (In this case, the masking effect would've been fine at a setting of 80, but I cranked it up a bit so you could see it more clearly on the printed page.)

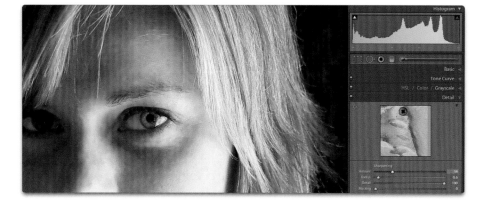

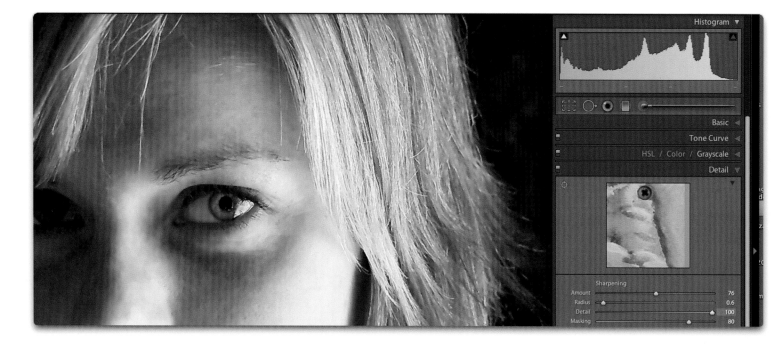

1. In a photograph like this with a lot of detail, you can usually get away with higher settings on the Radius and Detail sliders (though, as you'll see in step 3, I end up lowering the Detail slider). Here, I set the Detail slider to 100 and Radius at 1.0.

2. Next, I se the Amount slider to 25.

3. At this point, I saw that the Amount and Radius slider adjustments caused blooming, so I went back to the Detail slider, reduced it to 24, and added a little more to the Amount slider. No masking was necessary for this image, as there are no smooth parts. The difference between this final image and the image as rendered in the previous step is very subtle, so you'll need to look closely to see it.

1. Here, I began with the Radius slider set to 1.0 and Detail set to 100.

2. I added a moderate amount of sharpening, just until it started to bloom, with an Amount slider setting of 75.

3. To compensate for the blooming, I set the Detail slider to 21.

4. There are a lot of very smooth areas and many separate edge details in this image. This called for a Masking slider setting of 80, and I went back and set the Amount slider to 145.

In the images below, the top image has had no sharpening applied, while the bottom image has been sharpened. This image has an equal amount of sharp edges and smooth surfaces. See if you can do this one by yourself.

Featured Artist: Lynn Weyand

I originally made this portrait in 1980 with a Hasselblad 2x2 camera, a 150mm lens, and Tri-X negative film. In order to create it digitally, I scanned it with a 3200 Epson scanner, brought it into Photoshop, inverted it from a negative to a positive, and saved it as a PSD file. Next I opened it in Lightroom and took a good look at it to see what I wanted to do. The image was overexposed, flat, and lifeless. So, I took the following steps.

In Lightroom:

I reduced the exposure by -1.28, being sure to check the histogram for clipping.

I also reduced brightness slightly.

I set the Contrast slider to 44.

I adjusted the Clarity slider to 38.

I adjusted the upper and lower end of the Tone Curve, choosing to clip a small amount in the shadow areas.

Then, I exported the image to Photoshop:

I optimized the image using Optipix Refocus, a third party software plugin. Then, I flattened the image I used the History Brush Multiply mode to darken the wood, the shadows of the rose, the hat, eyebrows, mouth, button, and the folds of the sweater. Then I used the Screen mode to lighten the nose, rose, and knuckles. These local contrast adjustments with the History Brush produced a 3-D quality that was not there previously.

I cropped the image and used the Clone/Stamp tool to clean up dust, etc.

I then applied some final sharpening and saved the image as a TIFF.

I printed with Colorbyte ImagePrint software:

This is one of the series of portraits I have taken of my daughter with the hat, starting at age five and up to her current age of 40. I find that these portraits have universally reflected the ages and stages of life.

Author's Note:

Lynn studied with Oliver Gagliani for many years. I have always been singularly impressed with her portraits, both emotionally and technically. This portrait is one of my favorites.

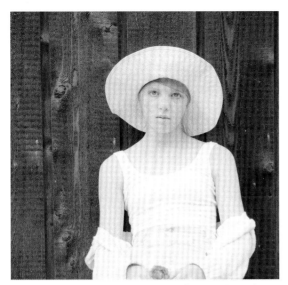

This is the original grayscale image. © Lynn Weyand

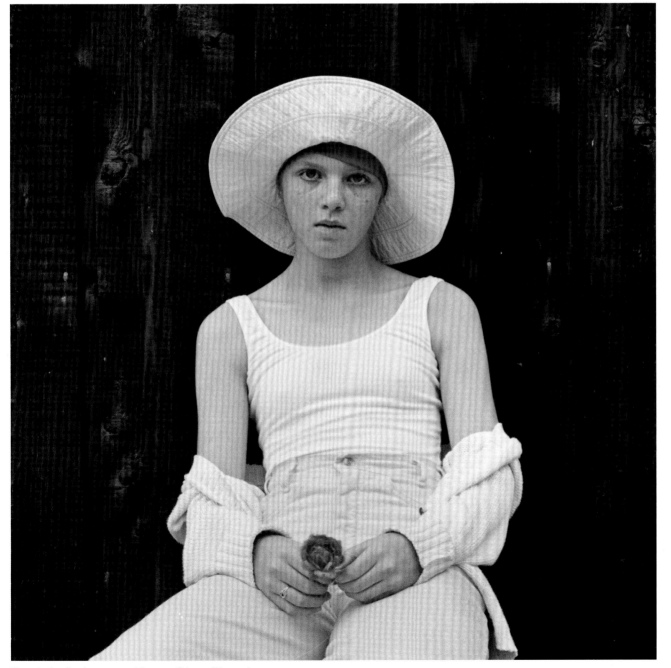

Here is the final processed image. © Lynn Weyand

Optimization and
Fine-Tuning In Photoshop

chapter eight

So far, we have been able to make adjustments to an image in a nondestructive way in Lightroom, which was designed especially for that purpose. We are fortunate to be able to get this far in the adjustment process without destroying the original. Now, we have to abandon that paradigm and wander into Photoshop to optimize and fine-tune the image. The reason for this is that Lightroom is not yet the robust correction tool it needs to be for the complete refinement of an image. We have to use Photoshop (or another equally strong program, such as Corel Painter) to make a masterpiece. I am confident that Lightroom will evolve to be an application that is capable of making a masterpiece in the future. One of the things that would help this would be the release of a Lightroom Develop module SDK (software development kit). This would enable third party developers, like me, to invent different modules (like plugins in Photoshop) to improve the fine-tuning of local controls, like noise reduction and others.

In this chapter, we will concentrate on difficult problems, noise reduction being the first of these. If you have achieved it in Lightroom, don't do it here. My feeling is that, even though Lightroom's noise reduction is weak, depending on the needs of the image, it can work just fine. If it does work in Lightroom, or if there isn't any noise in the image, don't adjust the noise in Photoshop. Get as far in Lightroom as you can and finish off in Photoshop.

Our most important black-and-white imaging tool in Photoshop for this workflow is the PercepTool plugin, which mimics the perceptual operation of the visual cortex of the brain. It is impossible to render this procedure manually in Photoshop to the degree that the brain processes the luminance image from the eye. The mathematical functions involved in this transformation are staggering. The PercepTool was developed with the latest imaging technology from machine computing and lightness perception science. Its development alone took three years.

After using the PercepTool, we'll slightly refine local adjustments, outlining, and edge quality with the History Brush. Then, we'll analyze the articulation of each highlight, midtone, and shadow framework and adjust those. Lastly, we'll clean the image of dust and defects and return to Lightroom for printing. Why? Because Lightroom's print engine is better than the one in Photoshop, and the workflow is so much easier.

Exporting from Lightroom to Photoshop

1. In Lightroom on the main menu bar, go to Lightroom > Preferences > External Editing. In the upper dialog box, select TIFF for File Format; select Pro Photo RGB for Color Space; select 16 bits for Bit Depth; select None for Compression. Close the dialog box.

Note:

My dialog box shows these external editing preferences for Photoshop CS4, so you may see a different dialog if you are using another version of Photoshop.

2. Control click on the photo (or right click with a PC) and choose Edit in Photoshop. Lightroom will make a copy and the image will open in Photoshop. You can also export the image into Photoshop by typing Command E (or Control E with a PC).

Noise Ninja

At this point you may choose to use Noise Ninja (www.picturecode.com) to remove image noise if Lightroom noise reduction was unsuccessful. There are other good noise reduction applications on the market, but this is the one I use. To use Noise Ninja:

1. After the image opens in Photoshop, double click on the Zoom tool (magnifying glass icon) and set magnification to 100%. Navigate through the image by pressing the spacebar and clicking once and dragging the Hand tool that shows up as a cursor. Search for noise. If you don't see noise, skip this noise reduction step and go on to image optimization. If you do see noise, as in this image, you need Noise Ninja. Go on to step two, below.

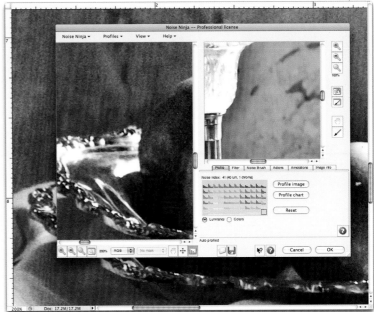

2. From the main menu bar, choose Filter > Picture Code > Noise Ninja. At this point, Noise Ninja will do one of two things: It will either run a noise profile of the image before it opens, or it will open automatically to the Noise Ninja window. This can be changed in the Noise Ninja Preferences tab.

3. If Noise Ninja hasn't profiled the image when opening, click on Luminance in the Noise Ninja window. Then click on Profile Image and hit OK. Noise Ninja is applied to the image.

Note:

My dialog box shows these external editing preferences for Photoshop CS4, so you may see a different dialog if you are using another version of Photoshop.

4. Now select Edit > Fade Noise Ninja. Slide the Opacity slider to the left if the noise reduction is too much. In this example, I reduced the slider to 85 because the image was slightly softer than I wanted. That's it!

Optimizing with the PercepTool

I developed the PercepTool as a result of years of research in lightness perception. This tool basically takes the flat 2-D image we get from the camera and makes it into an image that mimics closely the perception of the human brain. The PercepTool plugin is available for download from my website, www.georgedewolfe.com. When you download the plugin, specific instructions for installing are included.

Because of the nature of Photoshop, the sliders will seem jumpy, as I have chosen to work around a proxy preview in a dialog box and give you a real time preview in the main window where the real image is. In this particular scenario, the Photoshop software developer kit does not allow us to both update the image immediately while also sliding the sliders, so the effect appears jumpy. This is normal because of the way Photoshop works. The big advantage here is that it works in 32 bits (as well as 8 and 16 bits) and you get a correct preview as you are working, which is extremely important for work with the PercepTool.

Here's how the PercepTool works:

1. With the image you are working on open in Photoshop, go to File > Scripts > PercepTool.

Note:

The PercepTool interface illustrated in this book may look different from the final version of the plugin, but it will function the same.

2. When the PercepTool interface appears, the defaults will be Perceptual Effect: 50, Gamma: 1.0, Saturation: 100.

3. Adjust the Perceptual Effect slider first. For most images, 65 to 90 will be enough. You will see more of a change in low and middle key images than in high key ones. The Perceptual Effect tool is the main function of this plugin; it mimics closely how the brain interprets what the eye sends to it.

4. Adjust the Gamma slider second. I've found that a Gamma of .75 - 1.0 seems to work the best for most images.

5. A Saturation slider is included, but it's not necessary for black-and-white images so set the slider to 0.

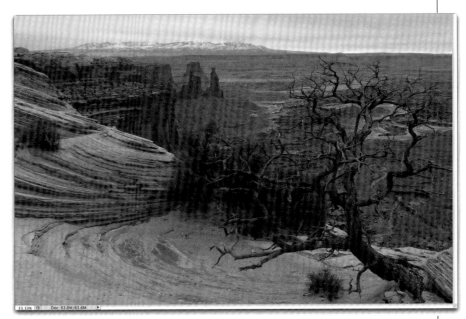

Here is an image that I imported from Lightroom and adjusted with Noise Ninja.

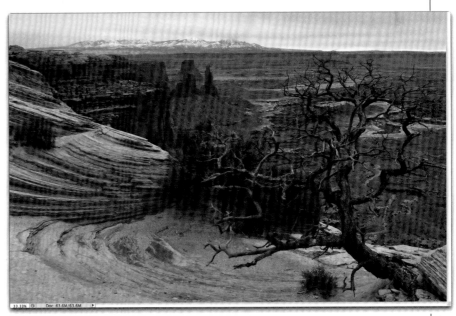

Here is the same image after applying the following PercepTool settings: Perceptual Effect at 75, Gamma at .86, and Saturation at 0.

In the first chapter, I showed several exam-
ples of what the change from the luminance
to luminosity looks like. Here are a few more
such examples.

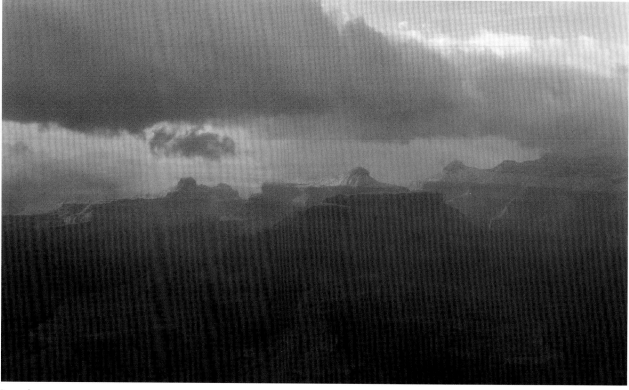

Luminance

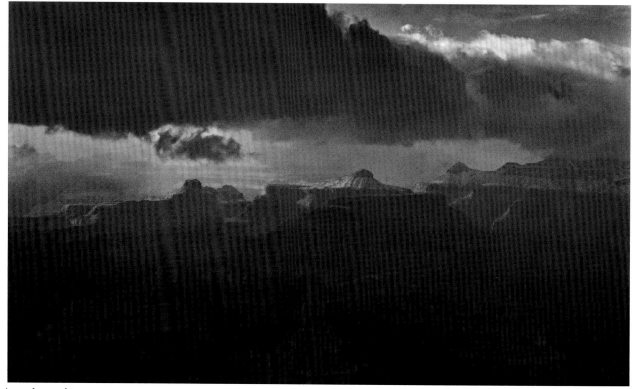

Luminosity

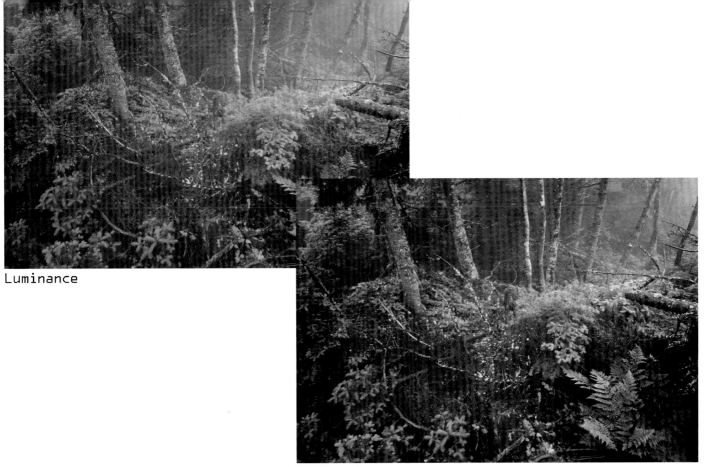

Luminance

Luminosity

Luminance

Luminosity

Fine-Tuning with the History Brush

Here I'm going to demonstrate the use of one tool that does many things: the History Brush. The History Brush is the tool of an artist. When painters make a brush stroke, or when photographers make a print, they move forward in a positive, courageous way. They rely only on intuition and craft to bring them to the final, successful destination that is the painting or perfected print. If the artwork doesn't turn out the way they wanted, they erase it, cover it up, or throw it in the trash-can and try again. They may do this once, twice, or twenty or more times until the work is finished. It is a matter of iteration, going back and forth, back and forth.

The key to this process is perception; it's not a technical trick. If you can't see the problem—be it with brightness, contrast, soft-ness, sharpness, or any other image element—then no technique in the world will make your print better. Not one. This is the basic problem I face every time I teach Photoshop and Lightroom in a Master Print workshop. Even after I emphasize the fact that percep-tion and problem diagnosis are more impor-tant than any technique, people still don't get it (even intelligent people), and they end up with what I call "Advanced Photoshop Syndrome," wondering why their photo-graphs don't turn out well. If you just get this one idea out of reading this book, then I have done my job.

Applying and refining one or two tech-niques to a myriad of printing problems is the best way to learn about perception. This gives you a yardstick by which to measure success, and you don't have to worry about how many tools you know. I know a photog-rapher who uses only Levels and Curves and his photographs hang in major galleries. His greatest asset is that he was a black-and-white photographer for 30 years and he knows tonal values up one side and down the other, so he can see everything that hap-pens in the print.

The History Brush, truly the only local tool you'll need in Photoshop, is such a pow-erful solution to almost all local image prob-lems that I rarely use selections and masks anymore. The History Brush is faster, more intuitive, more artist- and photographer-friendly, and easier to use than the host of tools meant to accomplish the same thing, especially layer masking. The History Brush allows you to "paint" in a correction based on your perception in precisely the place you want to paint it instantly and positively. It enables the manifestation of an artist's mark of authenticity in the work.

The way to build a masterpiece is with simple tools and precise control, and the History Brush is just the thing to accomplish this. It uses the image itself to make a local adjustment. This is different from the correc-tions made with masks and layers, where the corrective effect is drawn out of thin air.

The History Brush is located on the tool bar in Photoshop.

This is what the History Brush options bar looks like.

Basic History Brush Technique

My History Brush tool technique consists of the brush itself used on a background copy of the original image. The History Brush uses the first snapshot (at the top of the History palette) to paint the image with itself in various blending modes with different opacities. I employ the brush using only the Mode and the Opacity settings on the History Brush options bar. My favorite modes are:

Multiply — darkens (burns) a local area

Screen — lightens (dodges) a local area

Color Dodge — lightens small areas of extreme bright white

Color Burn — darkens small areas of extreme shadow

Difference — darkens extreme highlights

Soft Light — increases contrast in local areas that have both light and dark values

Let's start with a detailed example. Here is the original grayscale image. This produce merchant caught my attention immediately, and the only camera I had with me at the time was a Leica D-LUX 3. I love the clarity of the images this point-and-shoot camera gives me, and I especially love its 16:9 image format. This was a handheld shot. Unfortunately, the highlights on some of the white objects were clipped, but they are very small in the image and I was confident I could correct them to an acceptable degree.

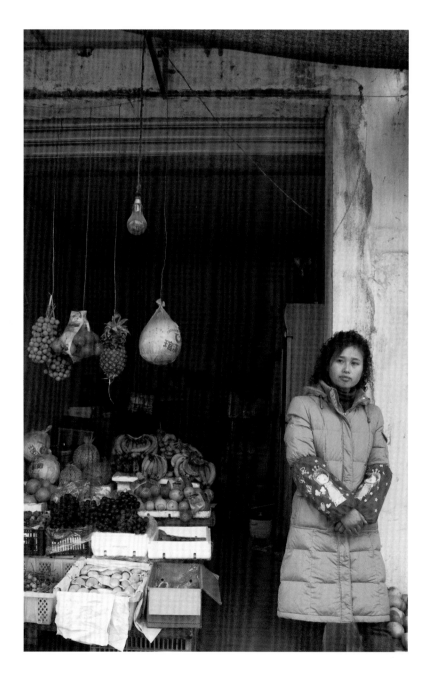

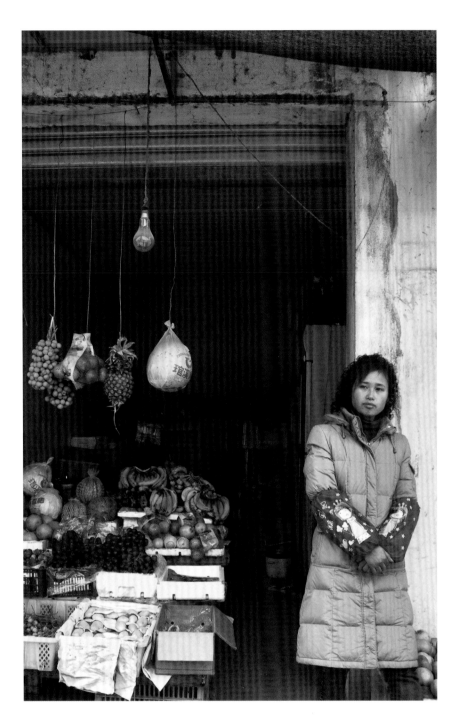

Here is the image after adjustment in Lightroom and application of the PercepTool. This photograph represents a complicated but interesting problem in local control even though much has been accomplished already with Lightroom and the PercepTool.

The first thing I do to diagnose an image at this stage is to blur it and stand back and look. I applied a Gaussian Blur and literally stood back from the computer screen about 7 – 10 feet (approximately 2 – 3 meters) and really looked at the blurred image against a black screen.

This process of standing back, looking, evaluating, and refining local problems can take some time, but it's effort well spent. Occasionally, I'll make a large print of the blurred image to get an even better look. Every great printer goes through an evaluation stage at the local control level. It's crucial to the presence of the print. The critical questions to ask when looking at the blurred print are:

• What local areas are too bright or too dark?

• What local areas need to be more three-dimensional and life-like?

Here's what I saw in terms of necessary local adjustments for my photograph of the Chinese merchant:

1. The central object is too light and needs to be darkened.

2. Foreground objects on left are to light.

3. The woman's coat needs more form; it's flat and lacks contrast.

4. The woman's face needs to be lightened.

5. The background objects need more separation and brightness.

6. The top of the image could use some lightening and a slight contrast boost.

Here's how I made the History Brush adjustments:

1. First, I made a background copy of the image by typing Command J (or Control J for a PC).

2. Next, I darkened the central object using the Multiply mode at 15% opacity.

3. To darken the foreground objects, I used Difference mode at 4% opacity.

4. Then I used Screen mode to lighten the highlights on the woman's coat and Multiply

mode to darken the shadows at between 15 – 25% opacity.

5. I used Screen mode to lighten the woman's face.

6. I separated the objects in the background by brushing their highlights with the Screen mode and their shadows with Color Burn mode at 3% opacity.

7. I lightened the top of the image was with Screen mode at about 15% opacity and used

Soft Light mode at 15% opacity to increase contrast slightly.

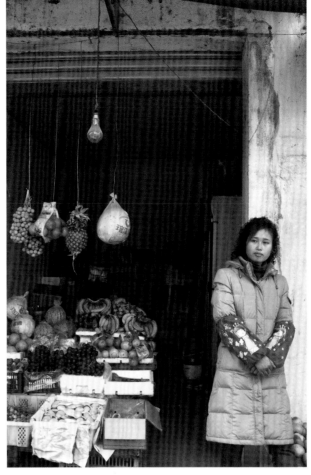

Here is the image before the History Brush corrections.

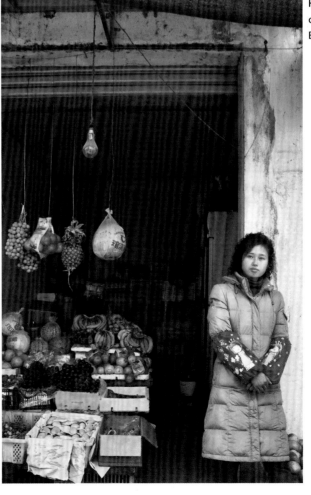

Here is the image after the initial History Brush adjustments.

At this point, the image looks pretty good, but I still had some work to do. The whole bottom is now too light, so I used Multiply mode with the History Brush to darken it a bit. This provided a better representation of the light fall-off from the overcast sky. The only other help the image needed from the History Brush was a little modulation and separation (I call this articulation) of the produce on the left, some details in the woman, and the cracks on the wall. A little later in this chapter, we will adjust for the edges and the outlines in the image.

Here are the final touches on the Dee Peppe image that we've worked on throughout the book. The diagnosis had mainly to do with articulating and balancing the wallpaper background. Notice the transition from the original grayscale image (above), to the image after adjustment in Lightroom and application of the PercepTool in Photoshop (right), and finally to the completed image after local adjustment with the History Brush (bottom).

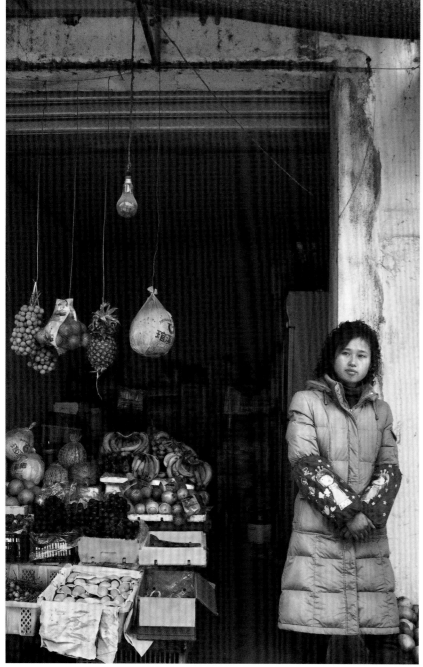

Here is the image after completing my History Brush adjustments.

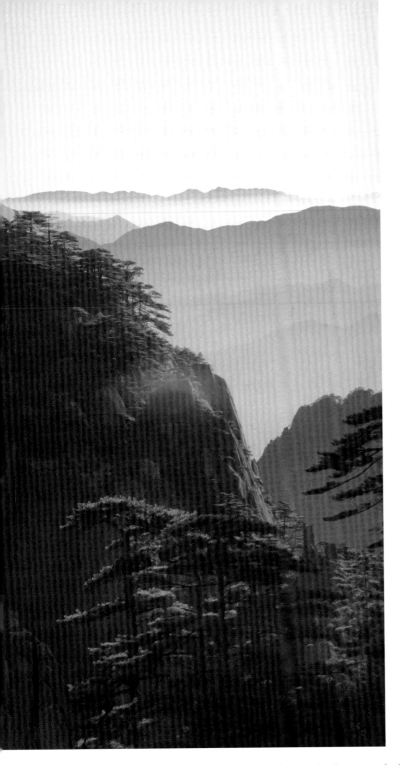

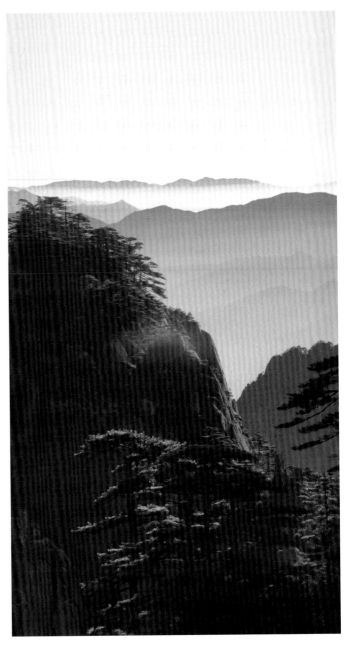

Here is the image after adjustment in Lightroom and application of the PercepTool.

This is the original grayscale image of a landscape in Huangshan, China. The essential local concern in this landscape is the separation and definition of the planes inherent in the image, from the trees in the foreground to the distant mountains. The second concern is articulating details prominently in the first two planes and successive softening of the receding planes in the background.

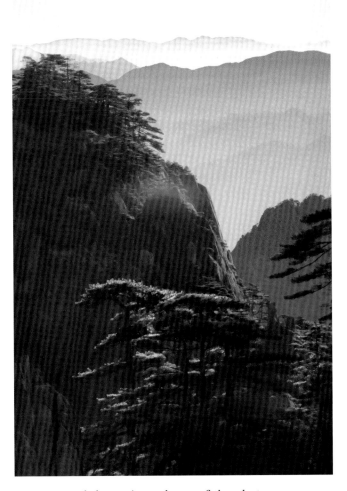

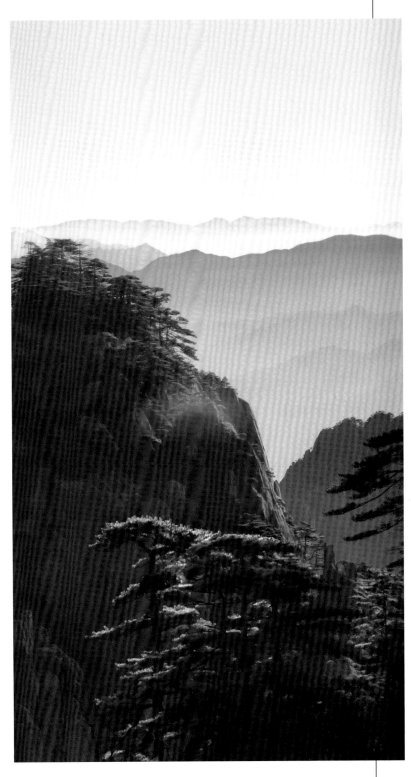

I wanted the various planes of the photograph to be distinct, yet fading visually into the distance. The basic idea in this kind of local control is that you want the foreground planes to have more distinct detail than the others behind it. So, what I did was make the detail stand out in the foreground trees and only add shadows, but not highlights, to the next plane. This allowed some obscurity of the second plane. The other planes received little or no highlight and shadow treatment, but were faded progressively to lighter tones. I used only the History Brush in Multiply and Screen modes at various opacities. There are literally hundreds of brush strokes and the process took over an hour.

To finish up, I used a technique that I will describe in detail on pages 168 – 169. What I've done is selectively sharpen the edges of the three front planes and soften the edges of the ones that are farther away. This selective sharpening and softening of edges increases the feeling of depth in the scene.

Softening and Sharpening Edges

I learned the importance of edge control one weekend when I was visiting renowned American illustrator James Bama at his home in Cody, Wyoming. Jim said to me, "George, it's all about edges... all about edges." I've spent the last three years making sense out of what he showed me in his own work that weekend. Like many illustrators, Jim almost always works from photographs. He has boxes and boxes of them on his shelves. He uses them as a starting point, but what he comes up with in the final painting looks more real than any photograph I've seen. The edges are the tools he uses to indicate depth, and he alters edges with both soft and hard strokes depending on whether he wants them to recede (soft brush stroke) or advance (hard brush stroke). I've been able to duplicate this effect by using the History Brush in its traditional mode and using the Opacity slider to control the softness or hardness of the brush strokes. To set up the History Brush for sharpening and softening edges:

1. Open a photograph in Photoshop and choose Filter > Sharpen > Smart Sharpen from the main menu bar.

2. Set your parameters to Amount: 300, Radius: 0.3, and Remove: Lens Blur.

3. In the History palette, click on the little camera icon at the bottom of the palette. It creates a snapshot underneath the original one (at the very top of the palette). Double click on the words in the snapshot and rename it "Sharpen."

4. Go back one History State in the History palette queue.

5. Select File > Blur > Gaussian Blur from the main menu bar. Set the Radius to 10.0.

6. Make a snapshot like you did in step three by clicking on the little camera icon. Rename the snapshot "Soften."

7. Once you've established your Sharpen and Soften snapshots, using this method is easy. Check the little box to the left of the Sharpen or Soften snapshot, then select the History Brush.

8. In the options bar across the top of the screen, set Mode to Normal and set the Opacity to the desired number.

Here's the portrait of Susan we've seen before. This is the original grayscale image.

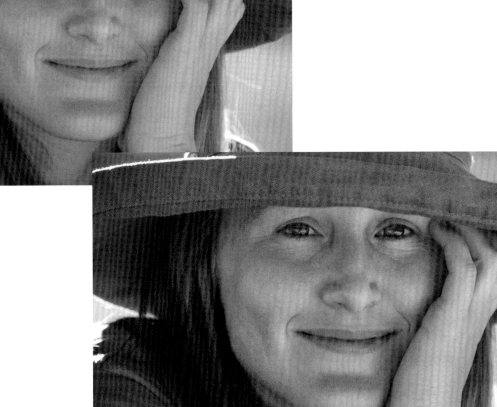

Here is the image after I applied the PercepTool.

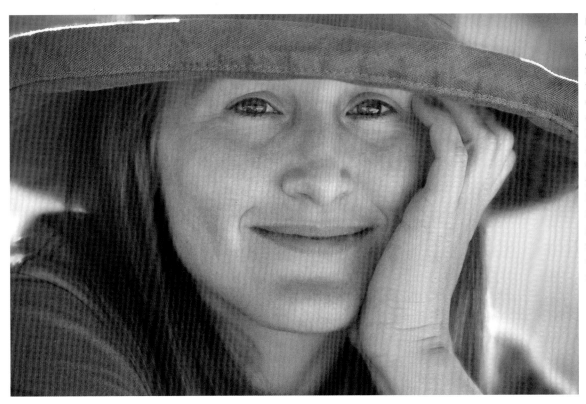

I then applied local sharpening to the eyes and the front edge of the hat and softening to the rear shoulder, some of the hair, finger edges, and facial wrinkles. The softening starts at 100% opacity with Gaussian Blur set to 50 for the background and her rear shoulder. I reduced the opacity progressively towards the front of the image, with the hand edges receiving about 25%.

Outlining

Outlining accentuates the depth of individual objects in relation to one another. It does this by working with the occlusion (overlap) mechanism that the brain uses to separate one thing from another by depth. We accomplish this by using the History Brush, usually in Multiply mode, to slightly darken around light edges. This not only separates one thing from another visually, but also acts as a kind of glue that accentuates the web of light that binds the whole image together and makes it appear whole.

Using the History Brush at an opacity of about 10 – 20% for Multiply mode, then with Color Dodge mode at 7% opacity, I outlined these onions. I used a very small brush and just went around the outside edges for the most part. Color Dodge picks out the very high highlights without bothering any of the other tones. Again, be sure to use a very small brush.

I used the Multiply and Color Dodge modes to add outlining with the History Brush.

Here's another example using the same procedure. This image required a lot of work. While the PercepTool and local controls took about half an hour, the outlining of cracks and objects to separate them from one another too twice that long. Look at the difference in the images at right.

Here are the onions without outlining.

This is the original grayscale image of the barn interior.

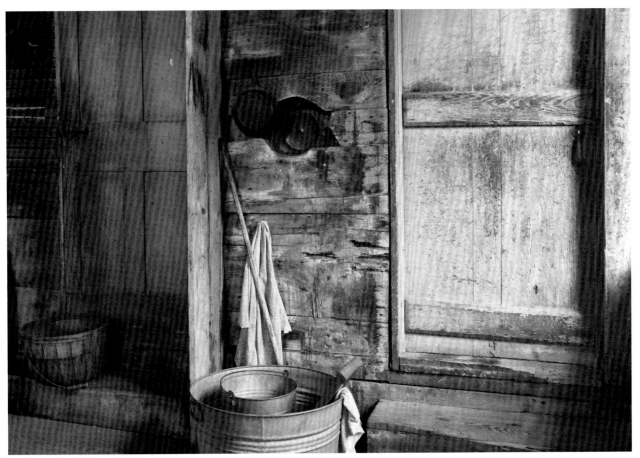

Here is the same image after application of the PercepTool, local controls, and meticulous outlining.

The Clone/Stamp Tool and Spot Healing Brush

The Clone/Stamp tool is familiar to every Photoshop user, and it is the most useful in "spotting" as we used to call it in traditional photography... i.e., getting rid of dust spots, sensor spots, and other image defects. The Spot Healing Brush is less familiar to new Photoshop users, but it makes fast work of dust and spot removal. Here's how to use it:

1. Keep the image open that you have been working on with the History Brush.

2. Click on the Spot Healing Brush Tool in the Photoshop toolbox.

3. Adjust the brush size and click once on a spot to get rid of it.

4. Flatten the image, close it, and click Save to return the image to Lightroom.

Note:

Always close then Save. Save takes you back to Lightroom for printing. Do not choose Save As!

This is an example of dust spots in an image.

se the Spot Healing Brush to target
ese dust spots.

As you can see, the Spot Healing Brush is a very effective tool.

Local Adjustments Review

Here's a short review list for how to manage local controls:

1. Blur the image and stand back from the computer screen.

2. Notice areas that need adjusting.

3. Make a list of those areas and what needs to be done to them.

4. Make the corrections using the History Brush in Photoshop.

5. Analyze the edges.

6. Correct edges by using sharpening in the front-most object edges and blur as you go deeper into the image. This is a "selective" and local process, not a global one. Use it sparingly.

7. Outline areas that need to be separated physically from one another.

Featured Artists:
James Bama and Maria Lloyd

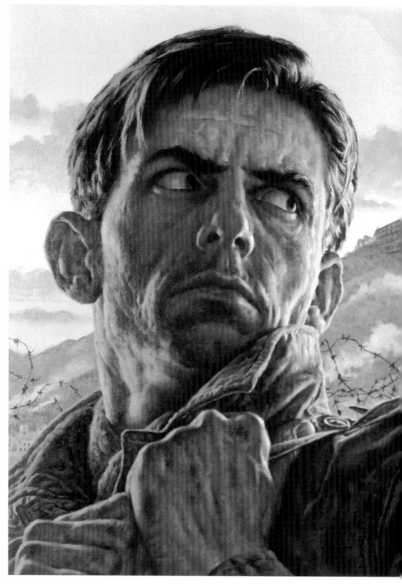
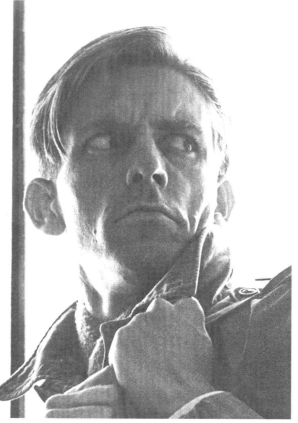

Here is the original photograph Jim used to paint from. ©James Bama. Digital image courtesy of Flesk Publications, LLC.

Author's Note:

Maria is one of my prized mentoring students who took to local control adjustments faster and more masterly than anyone I've ever seen. She works in a painterly fashion while retaining the qualities that remind you that the image is still a photograph. She employs edge control with high style.

Author's Note:

These two images show the absolute mastery of realism. The photograph is the one Jim used to paint his commissioned work, "The Man Who Hated," for the Saturday Evening Post. The other image is his final painting. His edge and local control is so good you want to cry.

Here is Maria's original grayscale image.
©Maria Lloyd

Here is the final adjusted image, which reveals her affinity for applying painterly qualities to her photographs. ©Maria Lloyd

chapter|nine

I have experimented for many years with different printing interfaces and find that printing from Lightroom is easy, accurate, and even fun. You can print from Lightroom using any printer driver that has print through capability, including the popular ImagePrint and Quadtone RIP. What I'll demonstrate here is the interface through the Epson 3800 printer driver with Advanced Black & White (ABW) print interface using Eric Chan's ABW profiles and ColorByte's ImagePrint. I work with a Mac Intel interface. Windows machines will work in a similar manner, but the interface is slightly different.

Setting Up Your Workstation

People often ask my opinion about what they should buy to set up a printing workstation. I can only tell you what works for me. The catch here is that I've tried just about everything—and I do mean everything—because that's part of my job as a photographer, educator, and consultant. So, while I am only able to offer you my opinion, it is an extremely well-informed opinion.

Monitor

My feeling is that you need a higher quality monitor for excellent black-and-white printing than for color printing. The best of these are medical monitors that cost many thousands of dollars, but the current crop of high-end LCD graphic displays (such as the La Cie 526 and the Eizo ColorEdge series) are magnificent. The reason you want a really good one is for the contrast ratio and bit depth a great monitor provides. The bit depth helps the monitor to display a wider color gamut and more gray values, and the contrast ratio allows you to see more tonal values than a traditional 8-bit LCD display. It is extremely important to be able to see as many black-and-white tones as you can, and these high-end graphic monitors, ranging from $1000 – $2500, get the job done.

Viewing Booth

Don't even ask me why you need one of these. Just buy one. It is one of the top five investments I ever made when it comes to printing quality. My current model is made by GTI Graphic Technology, Inc. (www.gtilite.com). I have the PDV-3e/D that includes a dimmer switch. You definitely want a viewer with a dimmer switch. It will at least double your ability to diagnose print quality.

Computer

I have a high-end Mac Pro Intel with 12 GB of RAM and a 15-inch (approximately 38 cm) MacBook Pro. I have wasted more time with PCs than any sane photographer should. I've had four desktop PCs and currently own a PC laptop that sits in the corner most of the time. I can also recommend the iMac as a great printing computer for beginners and intermediates (and even advanced users on a budget).

Storage

Ah yes, storage. You need as much as you can buy and three times as much as you think you need. I have two 750 GB drives inside the computer, but I could use more there. My feeling about this is that you need to store your precious "children" outside the computer, and for this I have eight different hard drives of different makes and models. I currently favor the LaCie brand terabyte drives, and WiebeTech also has very reliable external hard drives. Just look for a durable storage device with a good reputation.

As for disk storage, I use DVDs. (I'm waiting for the new Blu-ray technology to come down in price.) I save only the images I've worked on extensively to DVD. Three hard drive backup systems for all my files and a DVD disk for working images is probably overkill, but not according to Peter Krogh in The DAM Book, the bible of Digital Asset Management. My partner Lydia and I both read this book from cover to cover. I asked her one day at lunch if she was going to implement what he recommended, which I believe is overkill. "Nah," she said. "Me neither," I replied. "I'm a photographer, not a librarian." Don't get me wrong here. Peter's book is thorough and well written; I just don't think his degree of image storage is right for me. There are many photographers who will, however. The storage issue is very personal one and it requires a personal, thoughtful solution.

There is one thorny storage problem that has to be solved: You have to type in the name of each file in order to find it later. Even keywords and metadata, the common popular form of storage retrieval, have not solved this problem. I am simply not going to sit there and type every single word on every single image that I have to retrieve. I am a photographer, not a librarian. I organize by season, place, and year. I store the original RAW file and all the iterations of the print on two hard drives and on one DVD.

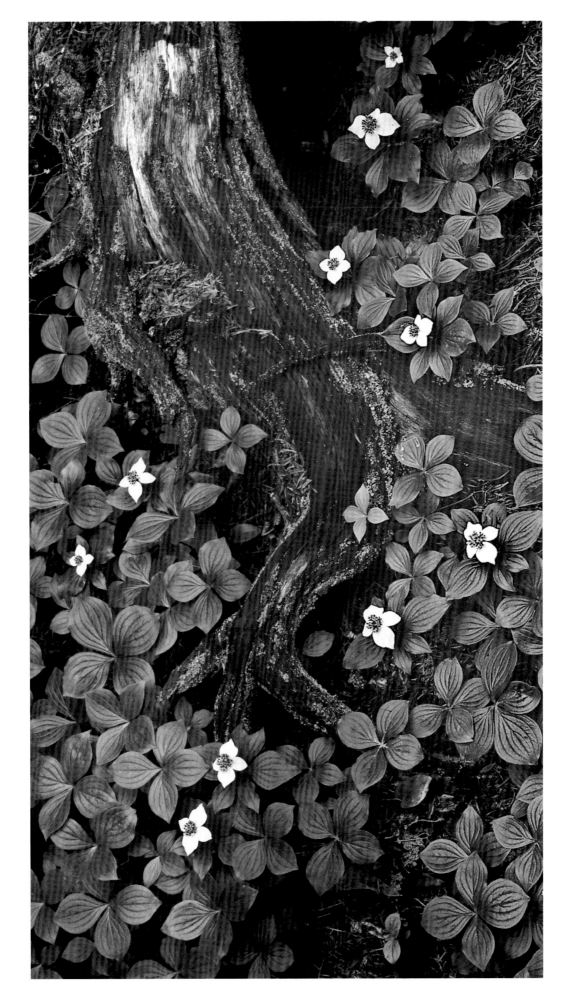

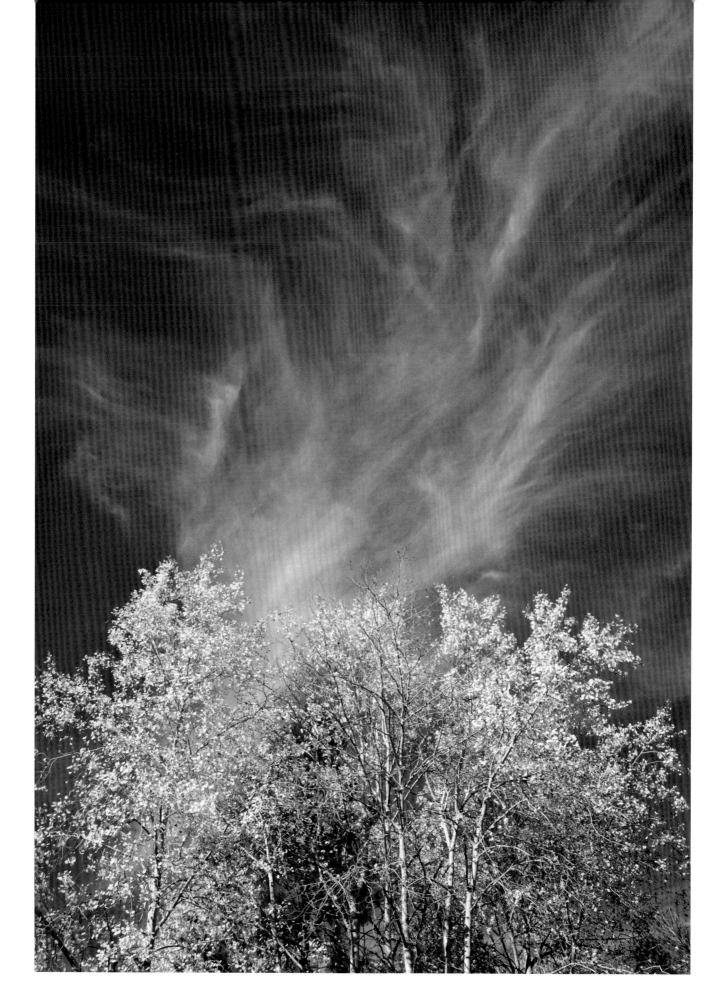

Monitor Calibrator

I've owned practically every single one of these devices, used them thoroughly, and thrown many in the trash. The one I still use with confidence is the X-Rite i1spectrophotometer (and the company's i1Display calibrator is also excellent). A spectrophotometer is simply more accurate than a colorimeter, which all of the cheap ones are. In this case, you get what you pay for.

Wacom Tablet

This is another device I wouldn't be without. I use the Intuos 6 x 11-inch version (approximately 15 x 28 cm) but carry the little 4 x 6 tablet (approximately 10 x 15 cm) around to workshops. I also have a Cintiq, the monitor you can draw on to make corrections. These devices do have a small learning curve, but once you get used to them, you'll never go back to a mouse for making local adjustments.

Scanner

Like every photographer, I have old negatives and transparencies—40 years worth. Some of these are masterpieces that need to be scanned before they can be worked on in a computer. My two current favorite scanners are the Epson V750 Pro Model and the Microtek Artixscan M1. Both are reliable, high-quality machines. If I really need a good scan, I'll send off to a service bureau and get a drum scan, but I rarely have to do this anymore.

With most scanner drivers, I've found that if I scan a negative like a negative then invert it to a positive in Photoshop I get better results in the shadows than if I do the inversion process at the scanning stage. There are only two guidelines for scanning any negative up to 4 x 5 inches (approxi-

Note:
Do not let the scanner enlarge your image. Enlarge it in Photoshop.

mately 10 x 13 cm): Scan at 100% (1:1) and scan at the maximum optical resolution of the scanner. With transparencies or large format negatives that are 4 x 5 inches and up, you can use somewhat less than the maximum optical resolution, but you'll need to experiment.

Paper Trimmer

I did without one of these wonderful machines for years, using the "hack and hew" method with a utility knife and straightedge. I now have a RotaTrim brand paper trimmer. I recommend you buy two, one for small prints and a large one for big ones. They range in size from 12 inches long (approximately 30.5 cm) to 54 inches long (approximately 137 cm).

Third Party Software

Like many photographers, I am intrigued by the Photoshop plugins that proliferate in this industry, in part because I am the developer of two of them (Optipix and PercepTool). Sometimes, I am incredibly impressed by them. Other times, I throw them in the trash. The ones I've kept and continue to use are the Nik Photoshop Plugins and Noise Ninja. The decision to buy and use third party software is a very personal thing, so do some exploring and see which ones appeal to you.

Printer Drivers

I've tested and used extensively all the important print drivers for black-and-white printing. For the Cone Piezography system (a high resolution black-and-white printmaking system–www.piezography.com), I use the Roy Harrington Quadtone RIP (raster image processor) with great success, although the Bowhaus RIP is also a good choice. The StudioPrint RIP is a great piece of software, and many swear by it, but it is complicated and only works on the PC. Media Street and MIS also make great Quadtone ink sets for black-and-white printing.

My choice for some time has been the ColorByte ImagePrint RIP. I cannot recommend it highly enough. It simply makes printing in black-and-white a joy rather than a chore. When I demonstrate this RIP in my workshops relative to whatever printer driver is native, there is not a soul who is not converted. Just buy it. I give it my highest marks.

Printer

You know, I almost forgot to include this in this list. I looked around my studio for items to include and said, "Ah, yes, the printer." I've had so many printers in my studio at one time that the place looked like the inside of the Red October. Some I couldn't even get into the studio, like the HP Z3100, a simply fabulous printer that had to stay in the living room, it was so big and heavy! Houseguests would ask me what it was. "A new nuclear device I'm working on for the government," I'd reply jokingly.

The three big contenders in the market are Epson, HP, and Canon. Let me make it clear that all of the printers now made that champion black-and-white printing as part of their workflow print very well. There is not a bad one in the bunch. What drives a photographer to pick a certain printer is unanswerable, but cost is probably the least of the fac-

tors. My first question to anyone thinking about buying a printer is to ask how large a print they would like to be able to make. This is really a more critical question than it seems. For instance, I don't like making images over 17 x 22 inches (approximately 43 x 56 cm), so I can get by with the Epson 3800, which is what I use most often. Other photographers may need a printer that makes 5 x 7-foot prints (approximately 1.5 x 2 meters).

Whatever printer you get, you need something robust. Epson's Stylus Pro line, Canon's ImagePROGRAF Graphic Arts series, and the HP Z2100 and Z3100 series are all robust industrial production printers. Another important consideration for most people is size and weight. I prefer lightweight, small footprint printers like the Epson 3800. For reasons stated above, I had to send the HP Z3100 back because it was too large and too heavy.

All of these professional printers make outstanding prints. I've used them all and can attest to this salient fact. So, pick one that fits your own personal criteria of what you want out of a printer besides good quality. It could be something as slight as choosing the Z3100 over the Epson 7880 because the Z3100 changes from matte black ink to photo quality ink automatically. You might choose one printer over another because it will pairs with the printer driver you prefer, or because you prefer that printer's interface, or because that company partners with your favorite paper brand. The list goes on.

Paper

The most frequent question I get is "What paper do you use?" The simple answer is that I use Hahnemühle William Turner and Photo Rag, and Epson Velvet Fine Art and Exhibition Fiber for black-and-white printing. The more important question is how I arrived at these choices.

Here's what happens. Every two years or so, Lydia and I do a test. We buy an 8.5 x 11-inch (approximately 22 x 28 cm) 25-sheet box of all the papers we want to test. These choices are made on an arbitrary basis—recommendations from friends, the paper's reputation, curiosity, past experience, or new releases. We throw a few old favorites in for good luck, usually ending up with about 25 to 30 different paper types. We split the paper in half and she prints two of her images and I print two of my images on all of the papers. We don't print test strips; we print real photographs. We both use the same printers and the same workflow, tried and tested over the years. Then, we mix all the prints up and put them out on the living room floor. We go through and pick the best three or four out of the bunch, looking for tonal gradation, highlight and shadow detail, color, and "feel." It might take us a week to accomplish this, off and on. We each make our own separate choices. The process is agonizing and vastly informative. The questions of longevity, out-gassing, nitrous oxide, humidity, durability, whiteners, and antibiotic additives have all been addressed by the scientific community, the paper companies, the RIT Image Permanence Institute, and Henry Wilhelm. My choices on which papers to print on are based on, "Will this paper print a masterpiece?" Nothing else matters.

Profiles and Profiling

I've saved this until last because I hope you're so tired of reading the material so far in this chapter that you'll glance over this, screw up big-time, and have to come take one of my workshops. Let me save you a lot of trouble here. Get good profiles to print with or you life will be miserable. The least expensive (and perhaps the best) way is to have custom profiles made for you. Eric Chan, for instance is one of the few profile makers on the Internet that makes good black-and-white profiles for the Epson Advanced Black & White interface. My advice to you is, when you get a profile made for a paper/ink/printer combination, go to three different places that make profiles on the web and have three profiles made of the same combination, one from each profile maker. Test them and use the one that works the best for you.

Making your own black-and-white profiles is a difficult, time consuming, and frustrating proposition, and it requires expensive equipment that most photographers can't afford. I have tried many times over the years to make my own excellent profiles and have failed utterly and miserably, and I have all the expensive equipment to show for it. My solution, and most everyone else's, is to purchase ColorByte ImagePrint, which has excellent profiles for almost every paper and printer that you would use.

John Panazzo's profiles are the best in the business. As a matter of fact, I would buy ImagePrint just for the profiles. John makes special black-and-white (called gray) profiles for all the papers you want (as well as color profiles). His RIPs and profiles make black-and-white printing the excellent craft it should be, and we owe him a debt.

Most heavy duty RIPs will have a linearization routine in them, but ImagePrint incorporates linearization in its profiles, which is why they are so good. By the time this book is published, I hope to have on my website a small application that can be used to linearize profiles for your printing environment using ImagePrint, so be sure to check for it at www.georgedewolfe.com.

Printing in Lightroom

Printing in Lightroom is, to me, much easier and produces better results than printing through Photoshop. Lightroom has a different color engine that is more powerful than Photoshop's, and the printing color space was especially designed to help the native ProPhoto RGB working space print correctly on smaller color gamut matte and glossy papers. While there is, as yet, no soft proofing (as there is in Photoshop), if you do need to make corrections, you can quickly and easily jump back and forth between the Develop and the Print modules to accomplish this. The ColorByte ImagePrint RIP, which I use exclusively to make exhibition prints, can now be used directly from Lightroom with a PTA (print through application) instead of having to export an image from Lightroom to print with the stand-alone ImagePrint application.

Although not my first choice for printing in black-and-white, the Epson ABW interface used with Eric Chan's ABW profiles does an admirable job, and the cost is free if you have the Epson 3800 printer. This makes it an attractive option for many black-and-white printers, so I'm including the workflow here.

1. Open your image in Lightroom and click on the Print module.

2. On the left side of the screen, click the arrow next to Template Browser to open that window. Then click on the arrow next to Lightroom Templates and select Maximum Size from the options that appear.

3. On the right side of the screen under Image Settings, uncheck the box next to Rotate to Fit to keep the image from rotating as you resize it.

Page Setup

Settings: Page Attributes

Format for: EPSON Stylus Pro 3800
EPSON SPro 3800 (1)

Paper Size: US Letter (Manual – Rear)
8.50 by 11.00 inches

Orientation: [icons]

Scale: 100 %

Cancel OK

Caution:

Always be sure that you have selected Page Setup setting for the correct type of feeding tray. Setting up for the wrong type may not give you access to the Epson Advanced Black & White interface.

Print

Printer: EPSON Stylus Pro 3800

Presets: Standard

Copies: 1 ☑ Collated

Pages: ⦿ All
○ From: 1 to: 1

Print Settings

Page Setup: Manual – Rear

Media Type: Velvet Fine Art Paper

Color: Advanced B&W Photo

Mode: ○ Automatic
○ Custom
⦿ Advanced Settings

Print Quality: SuperPhoto – 2880dpi
☐ High Speed
☐ Flip Horizontal
☐ Finest Detail

Color Toning: Neutral

? PDF ▾ Preview Supplies... Cancel Save

Print

Printer: EPSON Stylus Pro 3800

Presets: Standard

Copies: 1 ☑ Collated

Pages: ⦿ All
○ From: 1 to: 1

Printer Color Management

Color Toning: Neutral

Tone: Darker

Brightness: 0

Contrast: 0

Shadow Tonality: 0

Highlight Tonality: 0

Max Optical Density: 0

☐ Highlight Point Shift

? PDF ▾ Preview Supplies... Cancel Save

4. Click on Page Setup at the bottom left corner of the screen. In the window that appears, adjust the settings for paper size and feeding tray. For instance, if you are printing from the 3800 rear feeder printer with 8.5 x 11-inch paper (approximately 22 x 28 cm), choose US Letter (Manual – Rear). US Letter is the paper size and Manual - Rear is the feeding tray type. (The options for this setting will be different depending on the printer or printers connected to your computer.)

5. Next, click on Print Settings, also located at the bottom left of the screen. In the window that appears, set Color to Advanced B&W photo and adjust the print settings for the type of paper you're using and the quality. In this example, I'm printing on Velvet Fine Art paper and I set Print Quality to 2880 dpi.

6. Click on Printer Color Management in the Print Settings window. The ABW (Advanced B&W) interface will appear. Do not touch any of the sliders. Click Save.

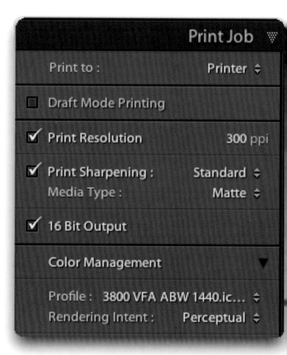

10. Click Print in the lower right corner of the Lightroom screen and the Print dialog box will appear. Click the Print button in the lower right hand corner.

7. Adjust the Cell Size sliders in the Layout panel to size the image on the paper.

8. Scroll down to the Print Job panel and check Print Resolution (the Lightroom default is 300 ppi, but some RAW images may come in at 240 ppi) and Print Sharpening (for prints up to 8 x 10 inches—approximately 20 x 25 cm—use Standard; for prints above that size, use High). Make the proper selection for Media Type. In this case, I selected Matte. Check the 16 Bit Output box.

9. Under Color Management (still in the Print Job panel), click on the double arrow icon next to your Profile options and select Other. Then choose the appropriate profile for the paper you are using in the window that appears. For the Rendering Intent option under Color Management, choose Perceptual.

Every master black-and-white printer I know uses either Jon Cone's Piezography Quadtone System or the ColorByte ImagePrint RIP. I have run tests side-by-side with both systems and the differences, visually, are so small that it's really a toss-up as to which is better. What draws me to ImagePrint is that it uses the manufacturer's ink sets and has all the best profiles for all the best papers. I don't have to change inks, and I'm not limited to specific papers like I am with Piezography. I still use Piezography on an Epson 4000 in the studio, however, but for me, ImagePrint has the edge, so that's what I'll show here.

For this next example, I'll demonstrate printing with ImagePrint in Lightroom using the Print Through Application (available from www.colorbytesoftware.com), but you can also choose to export the image to the desktop (or elsewhere) and drag it into the stand-alone ImagePrint interface. The instructions included with the ImagePrint software explain how to use the stand-alone application, so here I'll show you how to use it printing directly out of Lightroom with the Epson 3800 printer.

1. In the Print module, open a black-and-white image you want to print and click the Page Setup button in the lower left of the screen.

Page Setup

Settings: Page Attributes

Format for: Epson3800
ImagePrint

Paper Size: Letter
8.50 by 11.00 inches

Orientation:

Scale: 100 %

Cancel OK

2. In the Page Setup window, select the Epson 3800 ImagePrint Driver. (The window will show Epson 3800, and below that it will show ImagePrint.) Select the page size.

3. On the left side of the screen, click the arrow next to Template Browser to open that window. Then click on the arrow next to Lightroom Templates and select Maximum Size from the options that appear.

4. On the right side of the screen under Image Settings, uncheck the box next to Rotate to Fit to keep the image from rotating as you resize it.

5. Next, click on Print Settings, located at the bottom left of the screen. In the window that appears, click on the drop down menu that says Layout and select ImagePrint Profile Settings.

6. Under Profile, set the gray profile you want to use. In this example, I selected a gray Velvet Fine Art profile. Set Intent to Perceptual and set Quality according to the dpi of the profile, in this case 1440. Dithering DPI should be set to 360. Set the Tint Blend slider at 50 and set the MonBlkPt slider at 50.

7. Open the ImagePrint Paper Settings from the Layout drop down menu.

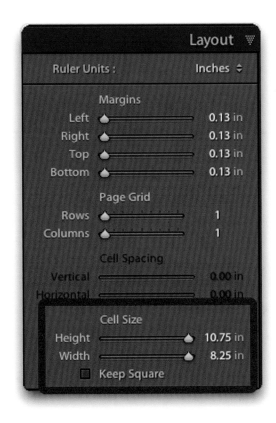

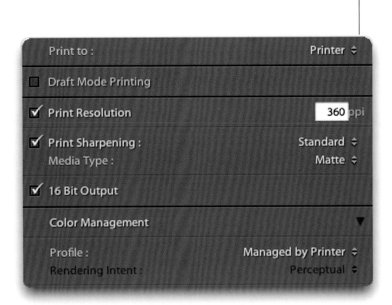

8. In the window that appears, make the appropriate selection from the Paper Source drop down menu. In this case, I selected Rear Manual because the Epson 3800 does not accept print rolls. Set Media Types to the type of paper you are using (in this case, Velvet Fine Art). Media Types is a thickness platen setting. If you are using a paper that doesn't come up in the window, use the nearest one that has the thickness of the paper you are using, then click Save.

9. Adjust the Cell Size sliders in the Layout panel to size the image on the paper.

10. Scroll down to the Print Job panel, check the box next to Print Resolution, and set it to 360. For Print Sharpening, select Standard for prints up to size 8 x 10 inches (approximately 20 x 25 cm) or select High for larger prints. Select the proper Media Type; in this case, I chose Matte. Check the 16 Bit Output box and, under Color Management, go to the Profile selections and choose Managed by Printer.

11. Click the Print button in the lower right hand corner of the screen and the Print dialog box will appear. Click Print.

Note:

For those of you who want to print directly out of Photoshop and the stand-alone ImagePrint software, you can sharpen the image for printing with the Lightroom Print module by exporting and choosing the sharpening choices in the Export dialog box. Most of the time, you'll want to use Standard.

Evaluating the Print

If you've followed the workflow do far, you should get a very good print right off the bat. Look at the print under a print viewer. Don't compare it with the monitor at first; just look at it and ask yourself immediately if it's great or not. This should be an almost instantaneous decision. If it's not great, compare it with the monitor. It should be close, all except for the paper color, which might be off. The areas that you need to fix are probably very small, so you need to find them. If you still have very large adjustments, like global or even broad areas, and you've had a lot of experience printing, then I'd say that something is wrong with the monitor calibration or the printer profile. Most of the time at these advanced stages where we are creating a masterpiece, you can trust yourself and blame the machine.

For the minor local problems that occur at this stage, you have to let the print sit for a while to see the offending details. Hang it on the wall and just look at it. Go for a walk, or have a cup of coffee, or play the banjo. Then come back and look at it again. Time and teardrops make a masterpiece. This print, long suffered over and loved, will finally give up the details out of the whole. When you find them, or they make their presence known to you, make the adjustments in local corrections with the Adjustment Brush in Lightroom. This iteration may go on for hours, or it may go on for days. When the print is done, the response is wordless. I have given you a map; you have to find the treasure.

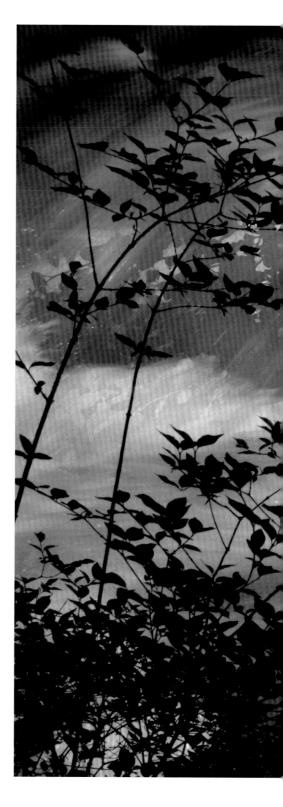

Featured Artist:
Tim Cooper

This image of a waterfall is a good example of how I tried to implement the skills of the masters. I had a very clear idea in my head about how I wanted this scene to be portrayed, but even after many visits to this location, I wasn't able to capture it. Seasonal and environmental conditions had to be just right. It is inaccessible during the summer due to National Park regulations, but that is when the water flows best. So, I needed to wait until Autumn and have heavy rains preceding the visit. An overcast day was also necessary for my vision of the scene. Finally, all of the conditions came together and, using a 75mm Nikkor lens on my Wisner Field camera, I was able to capture the shot.

After having a drum scan made of the negative, I began my work in Photoshop. A simple global increase in contrast was insufficient. This made the sky too bright, and my goal was to keep it dark and low in contrast. As with all of my imagery, I found it necessary to work locally. For me, this is accomplished by using adjustment layers and masks. This process gives me the ability to alter both brightness and contrast in individual areas at the same time. For example,

the sky has been darkened, but the contrast remains low, and the streams and falls have been brightened but they have an increase in contrast.

When making local corrections, I find the Curves tool in Photoshop to be the most flexible. To define the individual areas to be worked on, I use a host of selection tools and painting techniques, including the Magic Wand, Select by Color Range, Quick Selection tool, Channels, Simple Lasso and, of course, the History Brush.

My basic workflow includes assessing the image as soon as it is opened. I generally look to set the overall contrast first via an initial Curves adjustment layer. This step usually tells me a lot about the image. Next, I decide which areas I want to emphasize and which I would like to downplay. These areas are then individually selected and turned into masks on an adjustment layer. Along the way I will roughly set both the contrast and brightness to these individual areas. When this task is completed, I will have anywhere from three to a dozen or more individual adjustment layers, each working a specific area. This approach gives me the ability to return and make small or large modifications to any given area. Whatever your approach to your image making, it is always important to bear in mind that there are many ways an image can be interpreted. Spend time with your photos. Observe how your eye moves through the photograph. Try to direct your viewers to the most important areas by use of brightness and contrast. Experiment, and above all, have fun!

Author's Note:

Tim is one of the finest young masters in the United States. I cannot say enough good things about his work. His seeing is powerful and his craft is honed to a fine edge. His prints always glow with the mark of presence.

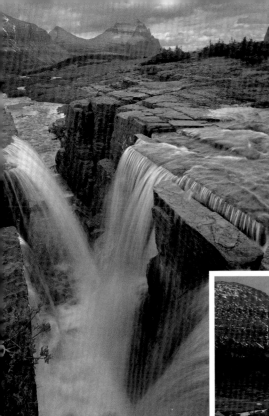

Here is the original image. © Tim Cooper

Here is the image after processing. © Tim Cooper

Conclusion

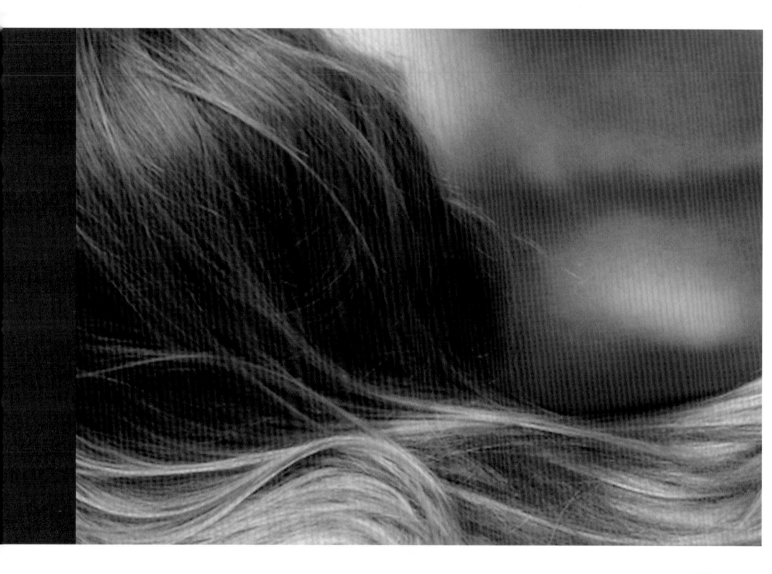

section **3**

Photographing the Known and the Unknown

The most difficult thing I have to do with students who want to make very high quality photographs is convince them that, in both means and ends, one cannot always look for rational solutions to the problems of photography. To many of you, this will sound heretical, but the truth of it manifests in many curious ways. For example, let's take black-and-white printing. How do we learn to print well? What are the attributes of an outstanding black-and-white print? Some insist that the road to fine printing is one of looking at the many great black-and-white photographs of the masters. Some even suggest that using these masterworks as guides in printing is a way to achieve mastery. Undeniably, both of these avenues are essential in the quest for print quality. Learning to print with a master at your side to guide you is also a time-honored solution, but, ultimately, we are the arbiters of our own success or failure.

We creep up on quality by degrees over months and years, continually refining the process, but it takes that first outstanding print to set us on the correct course. That print does not come from a master, it comes from us. It comes to all kinds of people, with all brands of papers, and from all types of printers. There is no formula, there is only quality. We need a model of quality that we, ourselves, have created. What is the process, then, of making this first quality print?

In recognizing a quality print, we feel intuitively that we have mirrored there on the paper our own experience of the object or event we first saw in front of the camera.

> There is a kingdom on the earth, though it is not of it — a kingdom of wider bounds than the earth — wider than the sea and the earth, though they are rolled together as finest gold and spread by the beating of hammers. Its existence is a fact as our hearts are facts, and we journey through it from birth to death without seeing it; nor shall any man see it until he hath first known his own soul; for the kingdom is not for him, but for his soul. And in its dominion there is glory such as hath not entered imagination — original, incomparable, impossible of increase.
>
> – Lew Wallace, *Ben Hur* –

The affirmation of this moment is the true reproduction of this emotion or intuition in the print. What I can relate to you about first experiences of the meaningful images in your life turned in to masterful prints is that they tend to be very small, as is the way of all great things. There is this slight inclination of a change, both in you and in the subject, a feeling of subtle calm, a certainty. It is timeless, childlike, unspectacular, and mysterious. Some call it grace.

How we perceive reality profoundly affects how we photograph and print. When I say "reality," I'm not referring to the superficial overlay of different cultural circumstances we all experience, nor am I referring to some ultimate reality. Rather, I mean to suggest that there is a reality to which we all understand and relate. And, while philosophers both ancient and modern differ greatly in the details of this "simple reality," its significance has been expressed by people of all cultures throughout time. Author Harold Pinter affirmed the nature of reality succinctly: "Apart from the known and the unknown," he said, "what else is there?"

It is important to understand that Pinter's question does not express two realities; it expresses two aspects of the same reality: the known and the unknown. These two parts are so totally intertwined that we often fail to see them both. One reason for this is the modern materialistic doctrine that only the known exists, that which can be perceived with the five senses. We photograph what is before us, i.e., what is. As a culture that separates the known and the unknown, we have a similar tendency to polarize and separate ideas and things arbitrarily, separating the otherwise inseparable. As materialists, we view the world as a physical entity, but as subjective, feeling, and conscious beings, we cannot deny that the unknown aspect of reality exists in front of us.

Photography was invented to depict reality, and reality contains both known and unknown quantities. It becomes clear, then, that when a photograph is made, it must record both of these aspects of reality. Photographs are moments frozen in time, enigmatic and ambiguous. It is the unknown, mysterious aspect of a photograph that drives its transformation into a masterpiece. As with the basic nature of reality, photography can obscure as well as reveal, and it is in this revealing and obscuring that mystery is revealed to us. By accepting the mysteries in the photographs you make, you will find yourself and your true way of photographing.

Honing Your Skills

One way to work on finding the element of mystery in your own work is to do the exercises I've listed on page 37. The secret is in binding the image elements into a cohesive whole while being totally aware of the minute elements that make up the whole. It's about awareness of what's in front of you, and paying attention to objects and the relationships between them.

Objects usually tend to be more on the known side of reality, whereas the relationships between them are often more intuitive than literal, and are therefore more mysterious. These relationships between image elements are what allow the image to work as whole, but they can be very difficult to discern. One literal method I've found to help myself see the relationships more clearly is to use the Color Range tool in the Select menu in Photoshop. It defines the perceptual frameworks of highlights, midtones, and shadows, and allows you to adjust each to articulate them better. When you adjust with this tool, you are changing relationships within the framework. What I've found in the work of the great master painters and photographers is that the relationship in one of the three frameworks (highlights, midtones, or shadows) always covers the image in a kind of chaotic web-like pattern that seems to glue the image together and yet help separate objects clearly—an amazing intuitive feat for a software tool. To access Color Range:

1. Open an image in Photoshop and go to Select > Color Range.

2. In the window that appears, click on the Select drop down menu at the top of the window where you will see options for Highlights, Shadows, and Midtones. Pick one. In the Selection Preview drop down menu at the bottom of the window, select Grayscale.

3. What you'll see in the preview and in the image itself is a high-contrast image showing the framework you've chosen in white. The rest will be black. When you click OK, this changes the framework into a selection that you can edit separately with Curves, Levels, Gradient Map, or any Photoshop tool. This is how I find and adjust relationships. It's a moderate tool at best, and I hope in the future we'll have others that can define the relationship quality of an image better.

If you want to try a more intuitive method for practicing greater awareness, I recommend the practice of mindfulness. Photography and printing are the visual capturing of a moment. The study of a moment is the discipline of mindfulness, an ancient practice that allows us to see the present moment non-judgmentally. Mindfulness brings us greater awareness, clarity, acceptance, and mental calm. It allows us to see the true nature of a moment, to see reality truly, to penetrate from the known world of the senses to the mysterious world of intuition and the spirit. It does this by allowing our perceptual sense to come to the fore while allowing our preconceptions and expectations to pass away. Mindfulness literally allows the mind to become clear.

Basic Mindfulness

Imagine a picture of a tree and its reflection in a pool of water. The tree is reality and our mind is the pool. When waves occur on the pool, we cannot see the tree clearly, as when words, thoughts, concepts, desires, and attachments cause our minds to be turbulent and we cannot see reality clearly (which is most of the time). When the pool is calm, we can see the tree clearly, just as when our mind is clear, we can see reality clearly. Mindfulness causes the pool of the mind to become mirror-like so that it can reflect reality and allow us to see what is.

So how do we access mindfulness within ourselves in order to take more meaningful photographs and make a masterpiece that reflects truth and presence? One way is to sit quietly in front of an object and practice. My first experience with this was with a seashell. The shell, in that moment, seemed to glow with a slight iridescence that was greater than before. Notice any change like this in the object's shape, outline, or tonal value, no matter how small. This is an indication, not that the subject is changing, but that your vision is changing to see reality more purely, observing both the known and the unknown.

Another way to practice mindfulness is to trust your instincts. Notice when your instinct tells you when and when not to take a picture or make an adjustment in a print. I have found that when my intuiting leads me away from the image, or tells me not to take it, that this is an indication of an important change in my vision about reality. Conversely, when my intuiting tells me to take an image or adjust a print, even if I can't see a tangible change in the print or something particularly interesting in the scene, I go ahead and make the picture anyway. Trust your senses; they are your intuition and mindfulness at work at their best. When printing, ask yourself, "What are my emotional clues to making adjustments to this print?"

Practice

If you want to practice accessing mindfulness within yourself, here is a simple meditation you can do at home that will help to clear your mind.

Choose a comfortable, alert position, sit quietly, and close your eyes.

Focus your attention on your breath. Feel your breath in your nostrils, noticing the cool air coming in and the warm air going out.

If you notice your mind drifting toward a thought, sound, smell, or taste, calmly acknowledge it, let it pass, and bring your focus mindfully back to your breath.

Practice this for 15 — 30 minutes a day for 2 weeks and you should see a definite improvement in your calmness of mind and awareness of reality. The effect is cumulative: The more you practice mindfulness, the more it calms the mind, and the more truly you will see the world around you. When the mind is united with the breath, we are able to fuse our inner and outer selves into one. With your mind focused on the present moment, unlimited possibilities for expression of that moment through photography and printing abound. My favorite book on this subject is *The Miracle of Mindfulness*, by Thich Nhat Hahn.

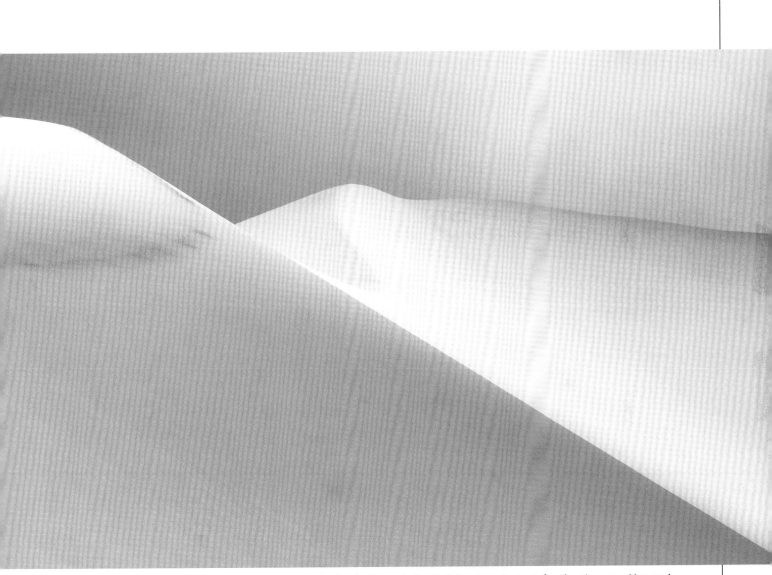

I saw and photographed this moment of mystery and grace at the Eureka Dunes in Death Valley in an instant of authentic recognition and response. I hardly did anything to the original except change it to grayscale and boost the contrast slightly—a rarity, but sometimes things just happen like that.

Portfolio: The Contemplative Landscape

Many years ago, I stood calmly on a ridge of sandstone overlooking a plain in Arches National Park. It seemed ordinary to me, this landscape of pinion and juniper and red rocks. A storm passed in the distance over cliffs rising north on the Colorado River. I have been to this desert solitude many times since. To me, it is a sacred place where I visit and reflect and be calmed.

Although the landscape appeared ordinary, I had a feeling that it contained something of a mystery that I could not see. So, I set up my camera and dutifully made an image or two of the scene before me. I moved quickly to make a rough first print out of curiosity, and the image that emerged was magical. It contained the ordinary scene surely, but it also included what I might call the "feeling" of the place more than any other image I had made of the park.

The essence of The Contemplative Landscape portfolio included here is my quest to capture both the known and unknown aspects of a landscape by combining intuition and perception. It strives to be "concept free" and allows us to engage the mystery of the world, reality, and our interior heavens. The end product seeks a wholeness out of which we can photograph and express truly what we feel about the fundamental reality that exists in front of us. It attempts to make a clean break from the accepted conventional world where we usually live and casts us into the "spiritual desert" of ourselves.

The photographs in this portfolio were made over the many years that I have practiced photography. More images of The Contemplative Landscape can be seen on my website at www.georgedewolfe.com. My partner, Lydia Goetze, and I teach Contemplative Landscape Photography workshops several times a year at various places throughout the country.

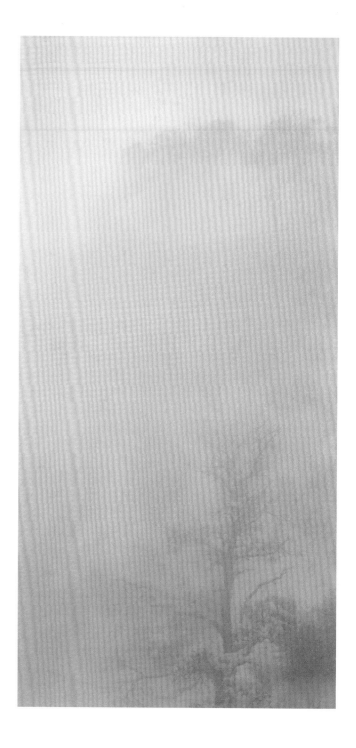

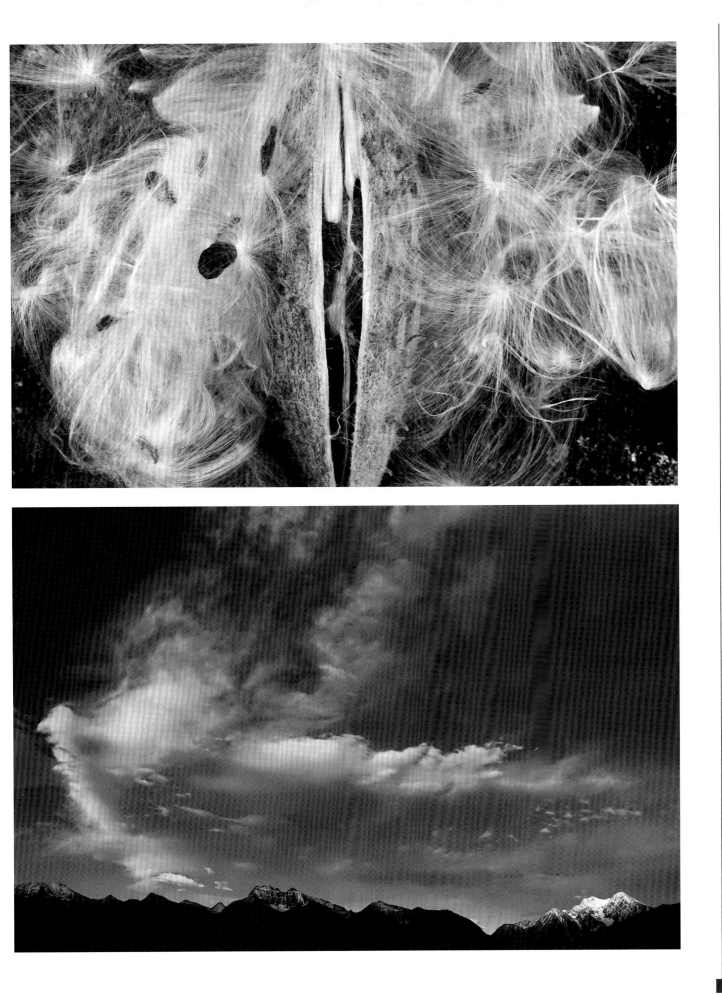

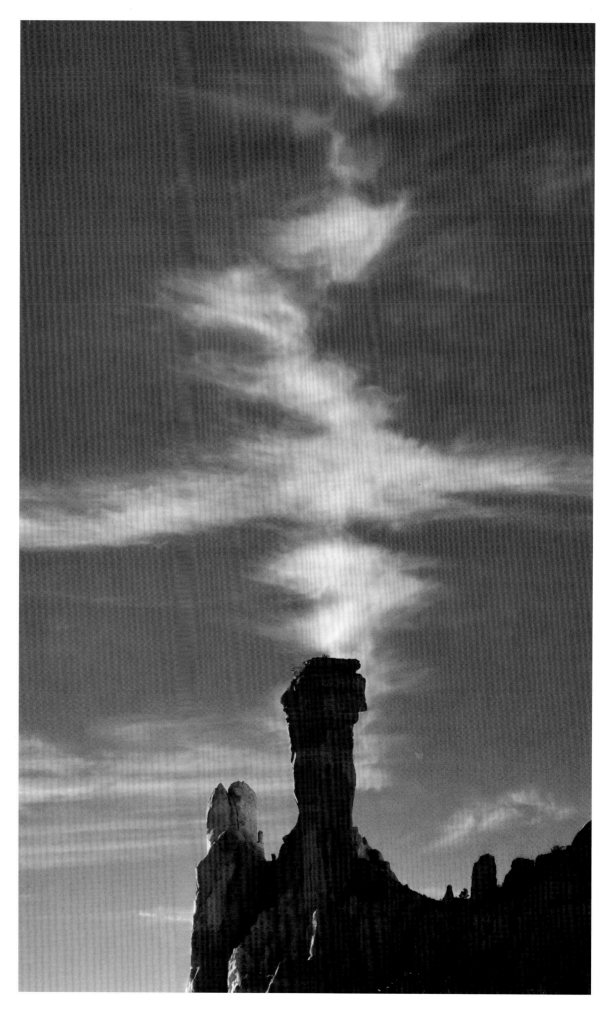

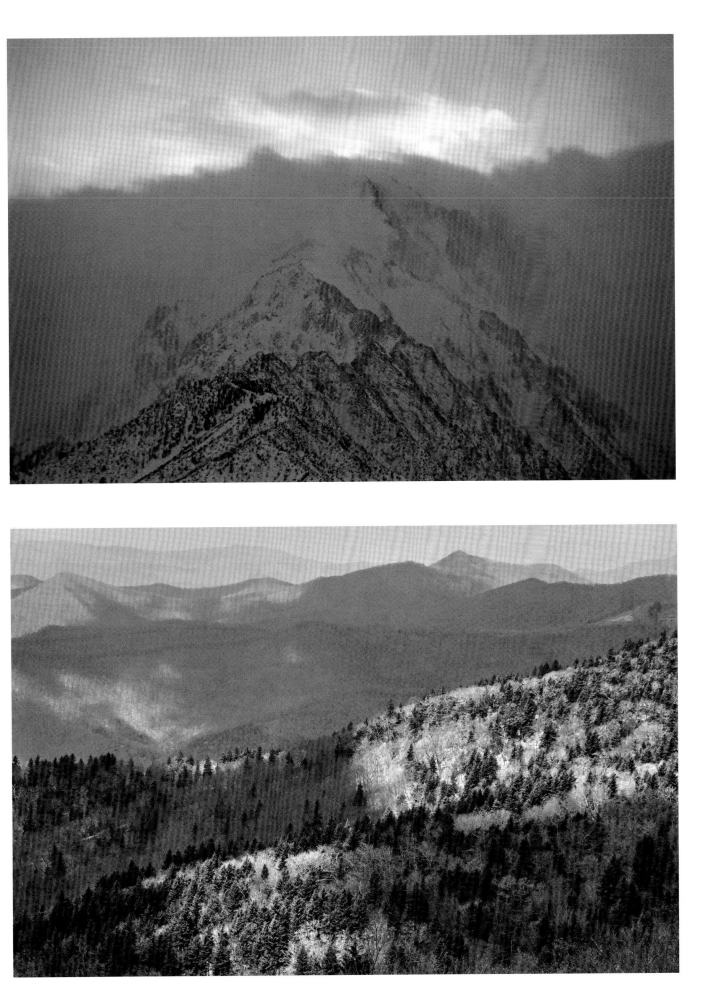

Index